Michael Archer  Guy Brett  Catherine de Zegher

# Mona
# Hatoum

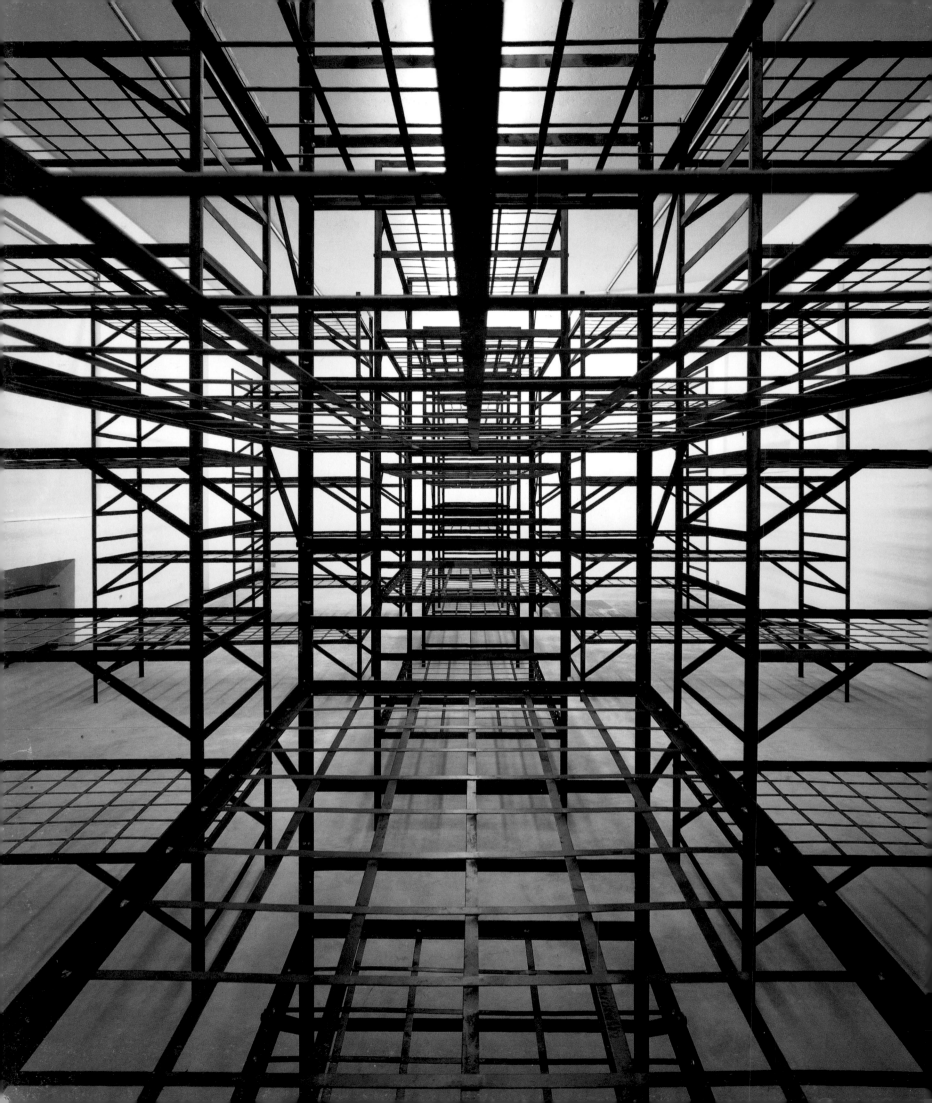

# Contents

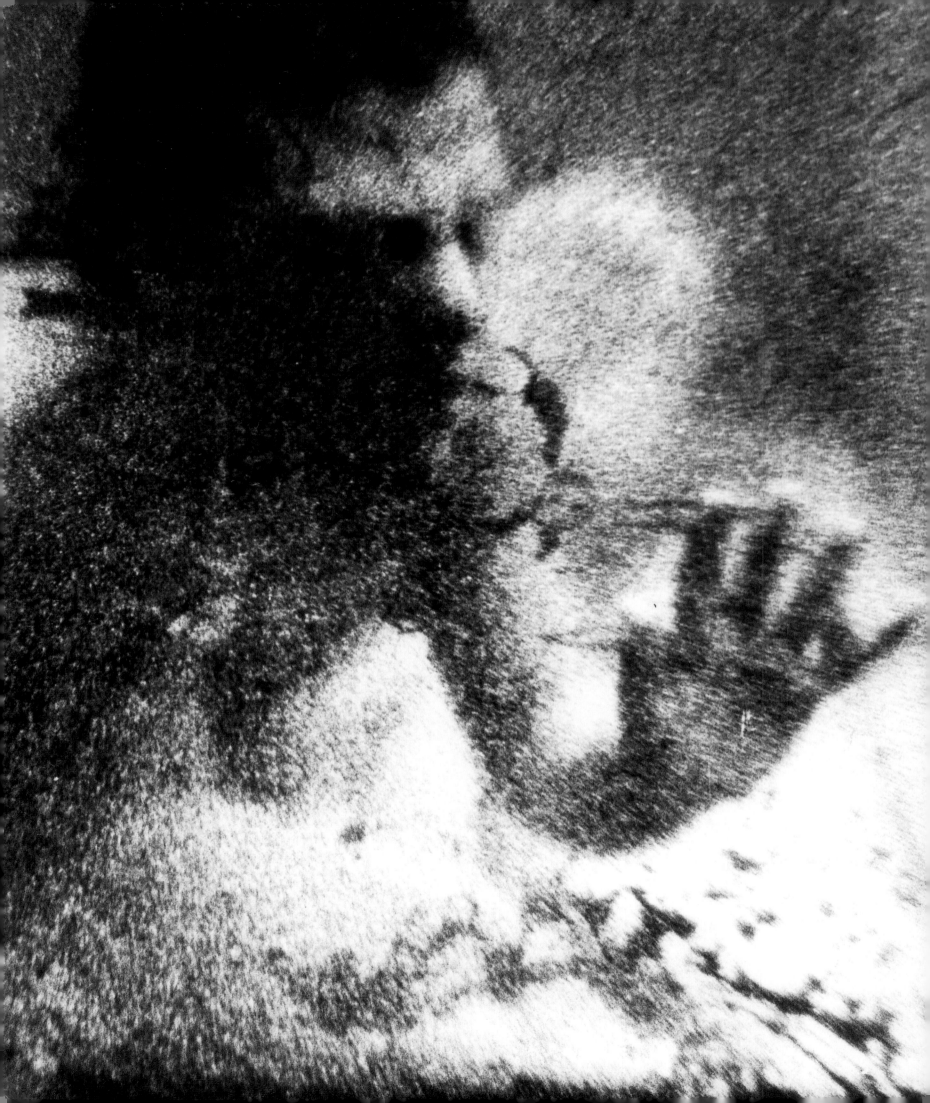

# Contents

Michael Archer in conversation with Mona Hatoum

**Michael Archer**  The basic facts of your early biography are well-documented. You were born in Beirut and came to this country in 1975. Intending only to stay briefly, you had to remain because the war broke out in the Lebanon. There are a couple of things that I'd like to explore to expand that set of very simple facts. First, the way in which you have described ending up going to art college at the Slade. You've said that, finding that you had to stay, you thought you may as well go to art school. There must have been some awareness that you wanted to do that before that time.

Mona Hatoum  **I have always, ever since I can remember, wanted to be an artist, and I always assumed that once I finished school I would go to university and study art. But my father couldn't support me through art school; he wanted me to study something that would get me a career and a job right away. I ended up doing a two-year graphic design course at the university in Beirut and then worked in an advertising agency for two years, where I was very unhappy. I was taking evening courses in anything available just to keep me going: drawing, ceramics, photography – quite a bit of photography. Eventually I decided to go back to the university for another two years, for a BA . It was at that point that I came to London for a break. All along I had been thinking that I would eventually come to England for a postgraduate course, in part because I had a British passport and thought it would make things easier. When I found myself stranded here I decided that I could do something with my stay and enrolled on the Foundation course at the Byam Shaw School of Art. At the time I thought that I may stay here for a year and then go back, but the war got worse. Anyway, I very soon realized that being able to visit the Tate and the National Gallery and seeing all these artworks 'in the flesh' would be an education in itself.**

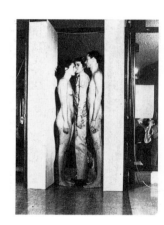

**Archer**  In discussing your work, particularly your performance and videos from the early 1980s, you have pointed to the Western European way of relating body to mind and how that contrasted with the attitude in the Lebanon, where there is no straightforward split between mind and body.

Hatoum  **The first thing I noticed when I came here was how divorced people were from their bodies, although recently the art world has become far more preoccupied with the body. I am convinced that this is a direct result of the AIDS epidemic which has forced everyone to become aware of the body's vulnerability. Since my early performances, the body has been central to my work. Even before that I was making small works on paper using bodily fluids and body rejects as materials. I have always been dissatisfied with work that just appeals to your intellect and does not actually involve you in a physical way. For me, the embodiment of an artwork is within the physical realm; the body is the axis of our perceptions, so how can art afford not take that as a starting point? We relate to the world through our senses. You first experience an artwork physically. I like the work to operate on both sensual and intellectual levels. Meanings, connotations and associations come after the initial physical experience as your imagination, intellect, psyche are fired off by what you've seen.**

**Archer**  Did you very quickly recognize the relevance of performance to the way you were thinking at college?

Hatoum  **Coming to performance was quite a gradual process which resulted from a number of coincidences. When I was at the Slade, after the Byam Shaw, the experimentation I was doing was quite dangerous. I was using 240 volts of electricity passing through a 'circuit' of metal household objects; or an electric current going through water to connect electrodes that intermittently lit up a light bulb. I could not put up these works without getting permission from security and fire officers, and very quickly got tired of all the bureaucracy. As a way out, I would put something up for a very short time – half an hour, an hour – to an invited audience. These works became like a kind of performance or demonstration. This also coincided with my new political awareness at the time. The Slade politicized me. I got involved with feminist groups, I became aware of class issues, I started examining power structures and trying to understand why I felt so 'out of place'.**

Archer  This sense of displacement was something you had to deal with?

Hatoum  **I had both to understand it intellectually and integrate it emotionally into my life. It was a time of tremendous personal struggle, turmoil and confusion. Performance was very attractive to me because I saw it as a revolutionary medium, setting itself apart from the gallery system and the art establishment. It fitted exactly the kind of issue-based work I was beginning to make.**

Archer  Were there examples that you followed: Stuart Brisley, say, who was teaching at the Slade then, or others such as Marina Abramovic or the Viennese Actionists?

Hatoum  **Of course Stuart Brisley and others, but mostly I was hanging around with a group of students who were involved in performance. In fact my first performance at the Slade was a collaboration with two other students whom I had overheard talking about an idea for a work. They were planning to perform two independent actions in the same space without prior knowledge of what the other would do. I started suggesting other things to them, like somehow intervening in the audience's space. They invited me to participate with them, and this was when I used a live video camera for the first time, to scan and annoy members of the audience while they were trying to watch the performance.**

*opposite*, **Marina Abramovic and Ulay**
Imponderabilia
1977
Performance, Galleria d'Arte Moderna, Bologna

*above*, **Hermann Nitsch**
48th Action
1975
Performance, Paris

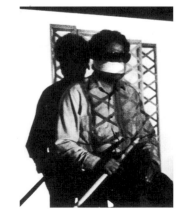

*right*, **Rasheed Araeen**
Paki Bastard: Portrait of the Artist as a Black Person
1977
Performance, from 'The Artists for Democracy'

Archer  You talk about becoming politicized in terms of class and gender, which were issues dealt with in a lot of people's work in this country at the time. What about the politicizing of your sense of cultural difference, something that would later become an important aspect of your work? In the late 1970s I would think someone like Rasheed Araeen was an important example. He had made the performance *Paki Bastard*, and published the first issue of his journal *Black Phoenix*, which later became *Third Text*.

Hatoum  **I wasn't aware of all that until much later. When I met Rasheed Araeen in the mid 1980s, it was a revelation. He was someone who had rationalized and theorized issues of Otherness. But long before that, for several years after leaving art college, I was involved with activist groups outside the art world which I saw as a separate activity from my work as an**

artist. While I was at the Byam Shaw I saw art school as a sort of haven from social and political upheaval. It was a time of formal experimentation for me, and I enjoyed every minute of it. I had a very long relationship with Minimalism at the time before starting to make work that was more conceptual. The Byam Shaw was a small and friendly place, like a big family with lots of foreign students, so I did not feel like the odd one out. The Slade was my first encounter with a large institution, and the impersonal, bureaucratic machinery that constitutes the 'institution' was totally foreign to me. I was so much at odds with that environment that I started to examine the reasons why. Getting involved, however briefly, with feminist groups started me on my enquiry about power structures. Before then, I had this very naive idea that as an artist you are part of a community of people with shared interests which somehow cut across social differences.

**Archer**  Your dealing with the body, with the personal both as theoretically enlarged through feminism and in the physical sense you described, is evident in your work right from the beginning, even as far back as the 1981 performance, *Look No Body!*, which you made while still a student at the Slade.

**Hatoum**  With *Look No Body!* I was considering the body in terms of its orifices, and how some of the orifices and the activities associated with them are considered socially acceptable and some not. I was trying to unite the activity of, say, drinking and pissing. I should have called it *United Orifices* or something like that; it was quite humourous. I had a video monitor in the space which was connected to a live camera in the toilet. I drank cups of water and offered every other cup to the audience, hoping to incite them to use the toilet. I used it myself two or three times. Throughout the performance you could hear my voice on a soundtrack reading out a detailed scientific account of the act of pissing, or 'micturition', to use the scientific term. It was like looking inside the body while keeping the 'correct' distance from it. My accent was much more pronounced then, so trying to read all these scientific words made the whole thing quite funny.

**Archer**  That performance also asks fundamental questions about identity. The scientific viewpoint of the soundtrack offers a certain perception of the world; one that conflicts with a very physical understanding of what, where and who one is. This concern with identity is a thread that runs through your work. In *Don't Smile, You're on Camera* (1980) you trained a video camera on your audience, relaying the image to a monitor which they could see. Out of their sight, however, you had someone mix into the signal other images of unclad body parts, both male and female. It appeared that you were seeing through their clothing and shifting their gender.

**Hatoum**  Yes, I was doing some gender bending there, but there was also a desire to look behind the surface or beyond social constructs. In both these performances, I was also interested in the issue of surveillance and the penetrating gaze. Around the same period I made a proposal for the 'New Contemporaries' exhibition at the Institute of Contemporary Arts in London. In those days the toilets were on either side of the bookshop. I wanted to place a small monitor above each door and connect it to a live video camera trained on a cubicle in each of the two toilets. I wanted to look into the taboos

**Don't Smile, You're on Camera**
1980
40-min. performance with two
live video cameras, three
monitors, one dissolve unit, X-ray
images, technical assistant, two
live models
Battersea Arts Centre, London

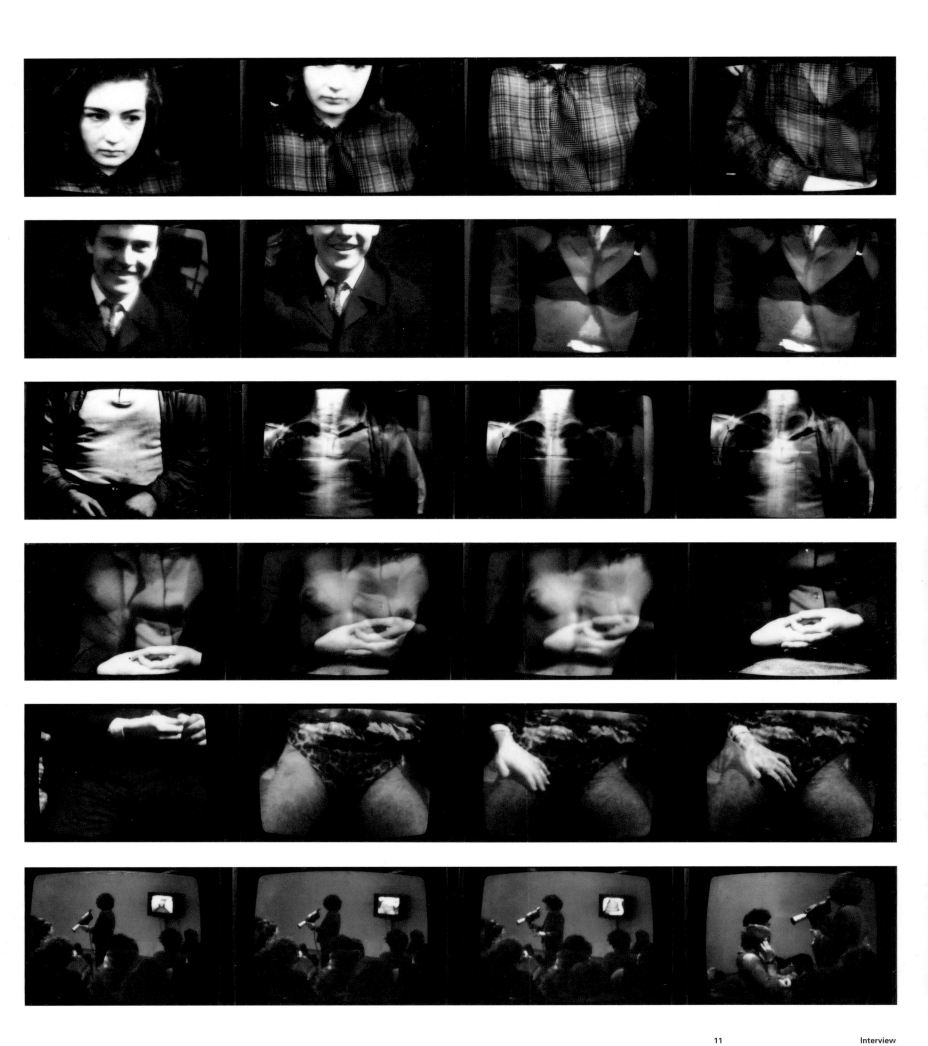

around certain bodily functions, and how the body's orifices have been organized in a hierarchical structure.

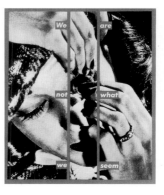

**Archer** Did you find that there was a certain critical resistance to some of the things that you were doing, in so far as they could be construed as objectifying the body in a very negative way? In the end, for instance, your ICA proposal was rejected.

Hatoum **The ICA wouldn't allow me to put it on although it had been selected by the 'New Contemporaries' committee. I was told that the toilets are in a public space, where people have not made a conscious decision to be con-fronted by art – can you imagine this kind of response now? I then tried to do the same work for my postgraduate show at the Slade, but it was turned down again. So I put up a statement in my space documenting the history of the piece and how it had been censored. Because I was not allowed to use the toilets, I constructed a male and a female toilet in the main studio space, but of course there it became something else. In** *Don't Smile, You're on Camera,* **where I focused my live video camera on members of the audience, I was crit-icized for being aggressive and invasive. I was trying to make people aware of the fact that we are constantly subjected to some mechanism of surveillance – the invasive look. It was making people aware by showing an exaggerated form of surveillance. Of course, I** *was* **invading people's boundaries.**

**Archer** If you do something by example you're involved in the whole process yourself: you are as gazed upon as anybody else. You are complicit and not in a position of power. Was it, however, seen as manipulative rather than as having to do with shared responsibility?

Hatoum **People got up and walked out of that performance, asking me why I was doing this to them. I remember a review that described one of my works as 'another macho performance by Mona Hatoum'. At the time people were talking about the gaze being a male thing and I was insisting that it was not necessarily so. I suppose I was trying to challenge prescribed male/female roles. I have always resisted those stereotypes, and I was criticised, even by feminists at one point. I collaborated with my friend Brenda Martin in a performance which was basically about competition between women. We were both quite critical of this blanket concept of 'sisterhood', and wanted to question whether competition is an inherently male trait. We were accused by women of being publically critical of feminism.**

**Archer** These issues and preoccupations are still in a lot of what you do. I don't see a split between your early performance period and a subsequent phase in which you went on to do other things. A sense of the body, the way in which you see relationships of power, questions of gender, considerations of cultural background and placement – those things are persistently there.

Hatoum **Very much so, but now I'm not using a clear narrative. I'm not pointing a finger directly at one issue or another. Things are implied and not directly stated.**

**Archer** How much do you think that was just to do with the times? There was a

lot of work like that in the late 1970s and early 1980s; it was the fashion.

**Hatoum  Yes of course. In the 1980s it was possible to make didactic political statements. I think we have gone beyond obvious statements into something perhaps a bit more sophisticated and subtle. Some work of artists I admired in the 1980s – for instance, Barbara Kruger – can look quite dated now. I don't think art is the best place to be didactic; I don't think the language of visual art is the most suitable for presenting clear arguments, let alone for trying to convince, convert or teach.**

**Archer**  Visual art's not didactic.

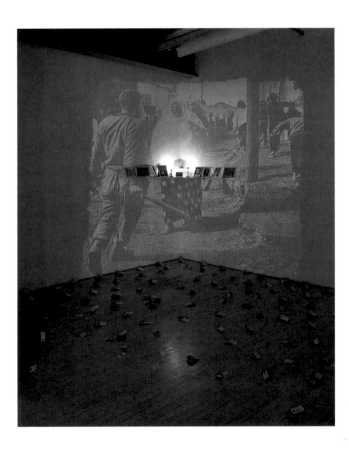

**Hatoum  In 1988 I was invited to do an installation for an exhibition called 'Nationalisms: Women and the State' in Toronto. It was one of those times I felt I had been given an assignment because I was known as a political artist. At the time the Intifada was happening in the West Bank and Gaza, which was the biggest spontaneous demonstration of social protest or resistance that had ever taken place in that part of the world. The work had to have something to do with women and it had to deal with stone-throwing. That's what the Intifada was about: kids throwing stones at the army and getting bullets back in return, hundreds of bullets. The title was something like _A Thousand Bullets for a Stone_. I found a newspaper image of a woman confronting a soldier holding a big gun, and in the background there were these kids throwing stones at the soldier. It was perfect. I projected the image quite large on two walls and had stones scattered all over the floor. Each stone was labelled and numbered, like weapons when they are seized and displayed by the police. At least there was a bit of humour in the work, but overall I felt really unconvinced by it because the Intifada was such a strong expression of dissent or protest, and had manifested itself in so many different ways . I felt almost opportunistic using that material. For me that was really the beginning of the end of working in an overtly political way. When you present someone with a statement in an artwork, once they get it, they either agree with you or dismiss your argument and move on to the next thing – no need to look again. It was the same with black issues.**

**Archer**  Even when there was much more of a sense of narrative to what you were doing, you rarely did work that was specifically directed at where you came from. You did the performance _Under Siege_, which referred to the Lebanon, and later you did the video piece _Measures of Distance_, which was about conversations and correspondence with your mother.

**Hatoum  _Under Siege_ happened a week before the Israeli invasion and the siege of Beirut; it was almost like a premonition. But in general in my work at that time, I was trying to remind people that wars were still raging in many parts of the world. I say 'still' because at that time most people's energy was going into the the anti-nuclear movement and 'keeping the peace'. They were saying, 'We've had peace for forty years and we want to keep it that way'. But that only concerned Europe. I was trying to remind people of conventional wars happening outside the West. For instance the billboard work _Over My Dead Body_ touched on that, though there was also a humourous reversal of power relationships. _Measures of Distance_ was really the only work where I**

Doormat
1996
Stainless steel pins, nickel-plated
pins, glue, canvas
3 × 71 × 40.5 cm

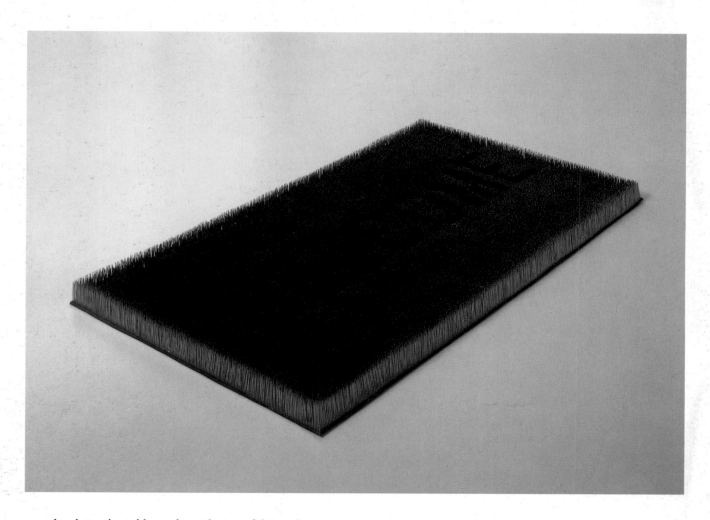

**consciously used autobiography as the text of the work.**

**Archer**  You mentioned black issues just now. How useful and how restrictive
was it to think about a lot of these issues of cultural difference in terms of
blackness? There has been a totalizing use of that word, which can erase all
kinds of differences within its scope.

Hatoum  **At the beginning it was important to think about the black struggle
as a total political struggle. There are common political forces and attitudes
that discriminate against people. In the same way as feminism started off
with this totalizing concept of 'sisterhood', and then we ended up with many
feminisms, if you like. The black struggle became more diversified once the
basic issues were established. And blackness here is not to do with the colour
of your skin but a political stance. In the early 1980s I don't think I saw my
practice as part of the black struggle, I was doing my own thing. I have always
worked in an intuitive way and couldn't see my work as serving any group,
political or otherwise. I was basically trying to deal with an environment that
I had experienced as hostile and intolerant and eventually those feelings
began to pervade the work – and still do. For instance, they are evident in a
piece I've just made for the current exhibition at De Appel: a little doormat
made of pins with the word 'Welcome' in it. It's related to a series of works I
made last year which had to do with carpets. Visually I find it quite beautiful,
because the word 'Welcome' is made with shorter pins, so it's like a little
recess within the surface of the mat. From a distance you see the word clearly,
but when you get close and you look down at it, the word almost disappears.**

The Light at the End
1989
Angle iron frame, six electric
heating elements
166 × 162.5 × 5 cm
Installation, the Showroom,
London
Collection, Arts Council of Great
Britain, London

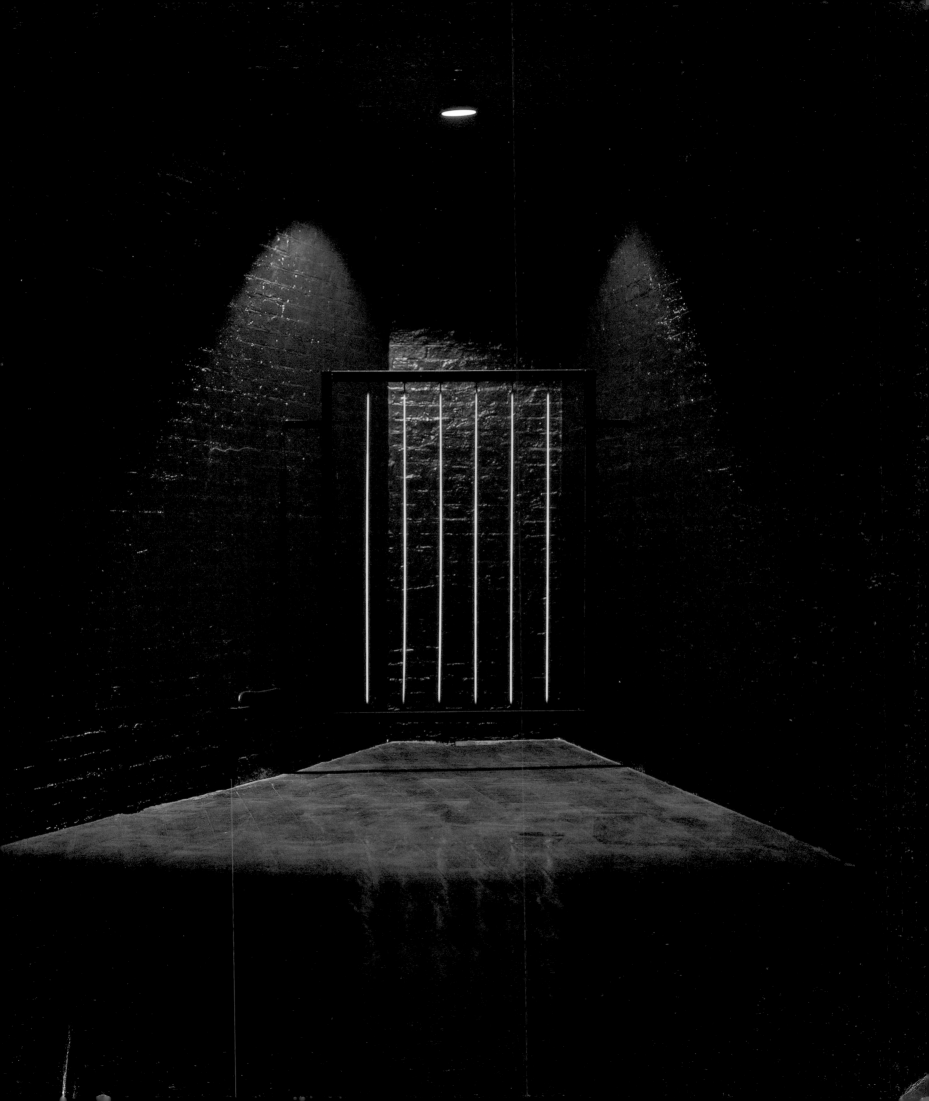

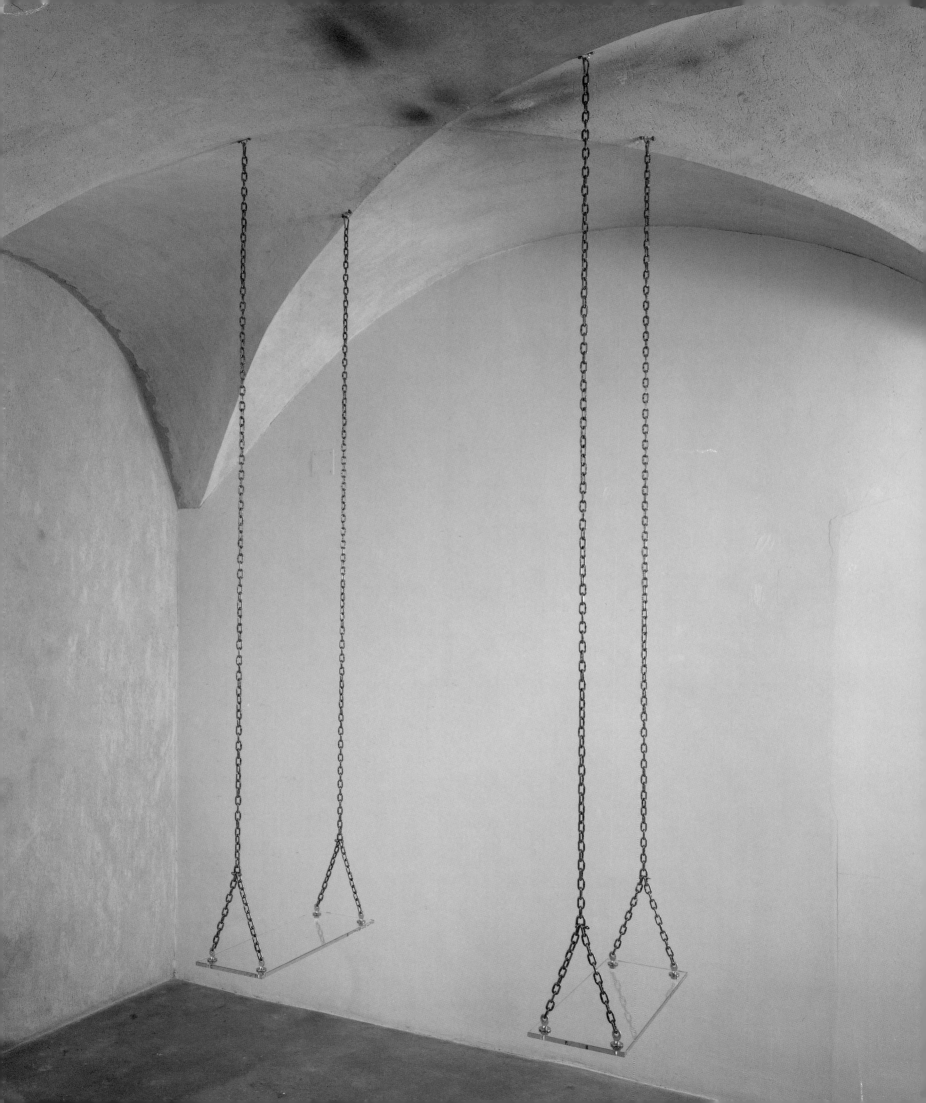

**Archer** The first work with that dual characteristic of being both welcoming and potentially harmful was *The Light at the End*, the installation you did at the Showroom in London in 1989. The glow from vertical electric elements at the rear of an otherwise darkened space drew you towards them, until you were hit by the intense heat they gave off and realized the immense danger of the situation. Is it also true that the title – 'the light at the end' (of the tunnel) – was important for you? Was there something revelatory about doing that piece?

Hatoum **The Light at the End was the beginning of a whole new way of working. In a sense with this work I was going back to a minimal aesthetic and working with certain material properties which amplify the concept. The associations with imprisonment, torture and pain were suggested by the physical aspect of the work and the phenomenology of the materials used. It was not so much a representation of something else but the real thing in itself. I felt satisfied for the first time that the balance between the issues, the materials and the space was just right for me. It also had this paradoxical aspect of being both attractive and repulsive. It was obscene. The space at the back of the Showroom is this strange funnel shape which made me think of a trompe l'oeil perspective of a tunnel. The expression 'the light at the end of the tunnel' came to mind and I used it in the title to set up the expectation of something positive which is then disrupted when you realize that the light was actually red hot bars that could burn you to the bone.**

**Archer** I'm interested that you mention Minimalism, because it also seems to me that your more recent work clearly pulls that back in. I'm thinking, to mention a few, of the very spare white installation at the South London Art Gallery in 1993, with the glass swings hung very close together; or the form of a piece like *Socle du Monde* (1992-93); or the mats you just mentioned; or the glass bead floor piece.

Hatoum **I like to explore the sensuousness of materials and use them to create an emotional charge, if you like. In A Couple (of Swings) I feel that the elegance and coolness of the swings makes the tension of an impending disaster – they could swing towards each other and smash to pieces – even greater. Socle du Monde is a very good example because it was specifically a reference to the archetypal form favoured by Minimalism, the cube. But instead of it having a machined, clean surface, untouched by human hands, I wanted to turn this upside down and make it very organic. The strange furry texture on the surface gives you a moment of anxiety because when you first see it you don't immediately recognize the material.**

**Archer** The turning upside down, which refers to Manzoni's gesture in his original 1961 *Socle du Monde*, is allied to turning inside out. In your *Socle*, the way in which the iron filings cluster on the cube's magnetic surface make it look visceral: like intestines, or the brain.

Hatoum **I was commissioned to do that piece for an exhibition in Montréal called 'Pour la Suite du Monde'. First I thought, 'Here we go again, they want me to make a political statement about the state of the world'. I was resisting doing something very obviously political, but in fact they seemed to have a very open-minded attitude about what constitutes a political statement.**

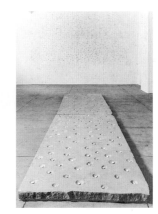

**Hans Haacke**
Eagle and Prey
1992
Installation, 'Pour la Suite du
Monde', Musée d'art
contemporain de Montréal

**Adrian Piper**
Self-Portrait Exaggerating My
Negroid Features
1981
Pencil on paper
25.5 × 20 cm

**Giuseppe Penone**
*background,* Unghiate
1989
Torn paper, plaster
71 × 100 cm each
*foreground,* Untitled
1989
Paving stone, plaster
10 × 610 × 250 cm

*opposite, above,* **Pier Paolo
Calzolari**
Un Flauto dolce per farmi suonare
(A Sweet Flute to Make Me Play)
1968
Copper, lead, motor, cooling
device
10 × 250 × 140 cm

They had invited artists like Hans Haacke, Alfredo Jaar and Adrian Piper, but also less political artists like Giuseppe Penone, for example. So I decided to make this piece which referred to the world put on a pedestal, but a pedestal that might have been eroded by some kind of disease and so had lost its stability. At the same time it was an excuse to play with this intriguing and beautiful material. When I made *Socle du Monde* and saw those meandering shapes that looked like intestines, I decided to make a carpet with the same pattern of 'entrails', which I called *Entrails Carpet*. I thought it would look quite repulsive and I wanted to contradict that by using a seductive material. While researching another piece a year or so later, I had a lot of rubber samples sent to me. One was this translucent, almost opalescent silicone rubber, and I knew that would do it.

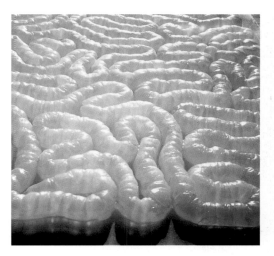

**Archer**  Does it sometimes happen that you light upon material and say simply, 'I'd like to work with this stuff'?

Hatoum  **Yes. But it is more that I recognize certain properties in a material I come across, that I feel would work for certain ideas I've had in the back of my mind for a while. Sometimes it is the space that triggers certain associations, or sometimes the possibility of using certain local materials and crafts inspires the work.**

**Archer**  Like those glass beads you used in the installation in Rome?

Hatoum  **Oh yes. I was in Rome trying to work out ideas for a piece, and I kept coming across marble everywhere. It made me wonder whether the marbles kids play with were called that because they were originally made of marble. Also, the gallery space at the British School at Rome had a very busy herringbone-patterned floor, which I did not like very much. I started thinking of covering the entire floor with marbles made out of Carrera marble, like a carpet, but that turned out to be very expensive. A few weeks later, I came across these transparent ones which had the additional quality of reflecting the light beautifully. So they looked very seductive but at the same time they created an unstable surface on which you could slip and fall.**

**Archer**  You have been collecting your hair for a long time.

Hatoum  **A very long time. Sometimes an idea develops over a long period of time before it finds a 'home', so to speak. The hair balls that ended up in**

**Entrails Carpet**
1995
Silicone rubber
4.5 × 198 × 297 cm
Created in collaboration with the
Fabric Workshop and Museum,
Philadelphia
Collection, Fabric Workshop and
Museum, Philadelphia

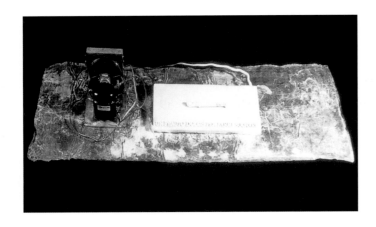

*Recollection* were collected over a period of six years. I made one accidentally when I was staying at a friend's place in Cardiff in 1989. I had just started my job there. It was the hair that came off my head in the bath. I didn't want to leave it behind, so I picked it up and was playing with it absentmindedly, rolling it in my hands. It was a perfect ball, very cocoon-like. It was beautiful. I decided to collect them without any specific idea of what I would do with them. I made a hair ball every time I washed my hair and they ended up in shoe boxes under my bed. When I saw the space in Kortrijk I felt that this was the time to use the hair balls, partly because the space had been occupied by women. I visualized the hair balls as dust balls that gather in the corners of rooms. Similarly, I had been looking for an excuse to use heat for about three or four years before I made *The Light at the End*. I had seen the work by Calzolari which used ice in 'The Knot', a fantastic Arte Povera exhibition at P.S.1 in New York in 1985. I still think that is the most brilliant exhibition I have ever seen. It was a major experience for me. When I saw that work, I thought,

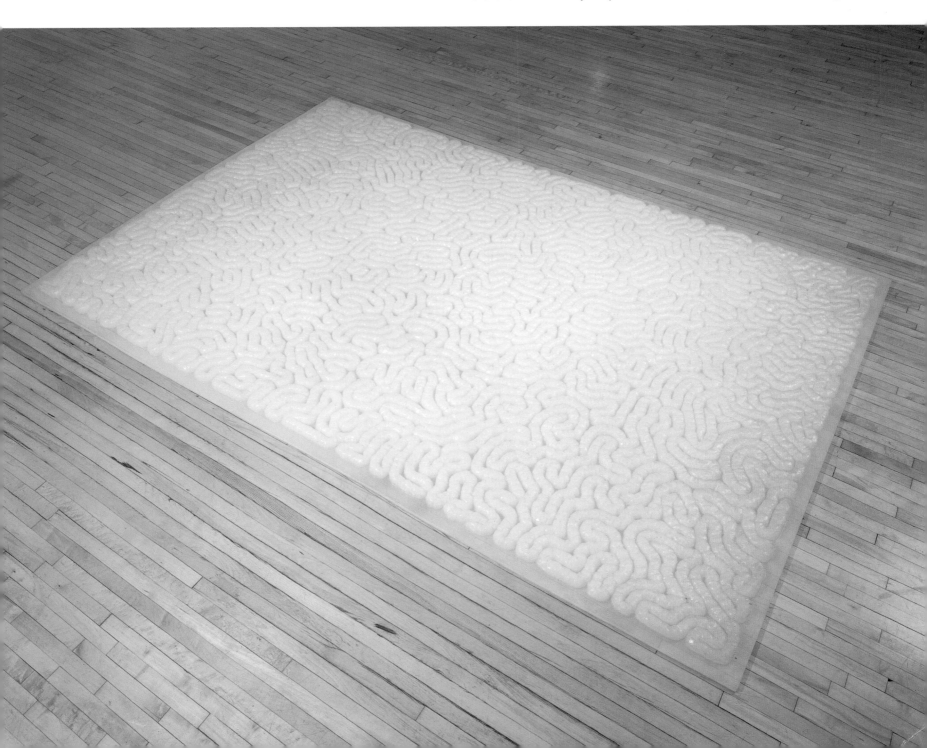

it would be nice to make a work using heat. I find it difficult to build pieces for no specific reason. You know this little idea for the doormat? I had this idea before I made the big pin carpet or the prayer mat, but I had no specific reason for making it until I saw the space at De Appel. They have a room that looks like a living room with a narrow doorway, and I thought it would look good just inside that doorway. That was the incentive to make it.

**Archer**  Visual welcoming and the contrasting physical danger recur in your work, like in your installation at Mario Flecha Gallery in London in 1992. The wires strung tautly across the space guided the viewer in a very helpful way, yet if you strayed slightly off the path you would cut your ankles, groin or neck. This sense of danger comes up again in the visually provocative baby cot, *Incommunicado*, where the mattress base is made from cheese-slicer wire.

**Hatoum  The Mario Flecha installation was an instance where I felt that the balance between beauty and danger was taken to an extreme. It looked like an effortless drawing in space, almost ethereal but also quite lethal. Every aspect of life is full of contradictions: some people think that aesthetics and politics don't mix, but that's ridiculous. When I moved into the studio in Cardiff I had this vast space with nothing in it. The first thing I did was to stretch these wires across the space. The Mario Flecha Gallery gave me the perfect opportunity to use this idea two or three years later. I see furniture as being very much about the body. It is usually about giving it support and comfort. I made a series of furniture pieces which are more hostile than comforting. *Incommunicado* is almost like an imprisoning structure, with its cold metal bars. I replaced the solid platform that would have supported the mattress with taut cheese wires.**

**Archer**  There was also a chair, *Alive and Well*, which used electric elements.

**Hatoum  Don't remind me of that! For a couple of years after I made *The Light at the End* no one wanted to show anything else. It was made as a site specific piece for the space at the Showroom and I never, ever thought of it**

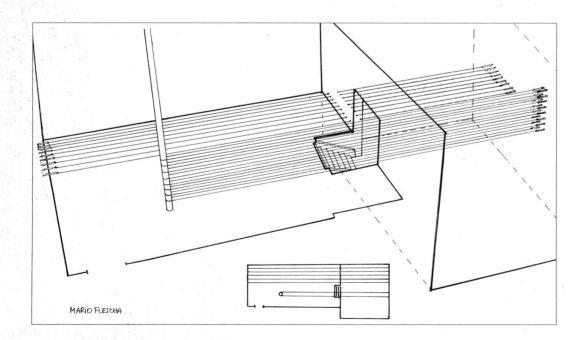

Proposal for 'Untitled', Mario
Flecha Gallery, London
1992
Ink on paper
21 × 36 cm

*opposite*, **Untitled**
1992
Stainless steel wire
Upper space, 9 × 4 m; lower space,
5 × 5 m
Installation, Mario Flecha Gallery,
London

MARIO FLECHA.

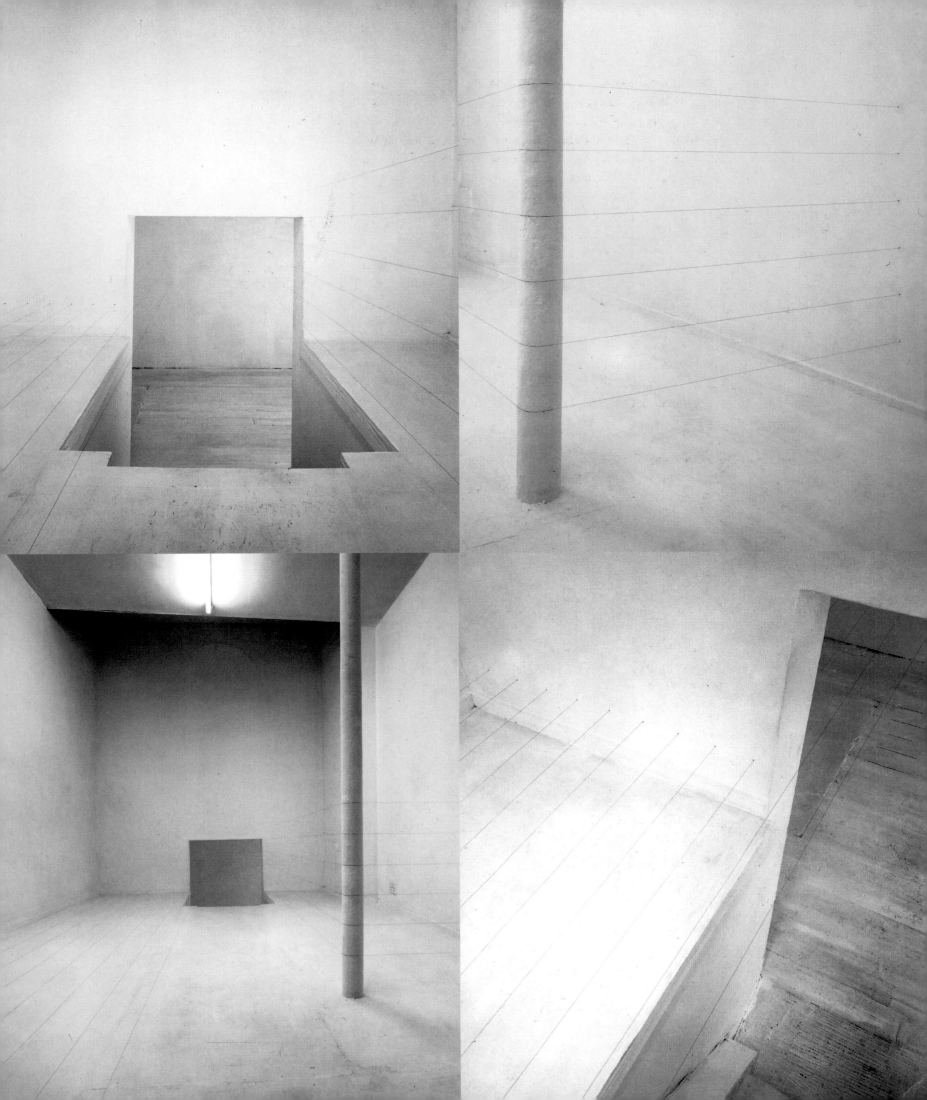

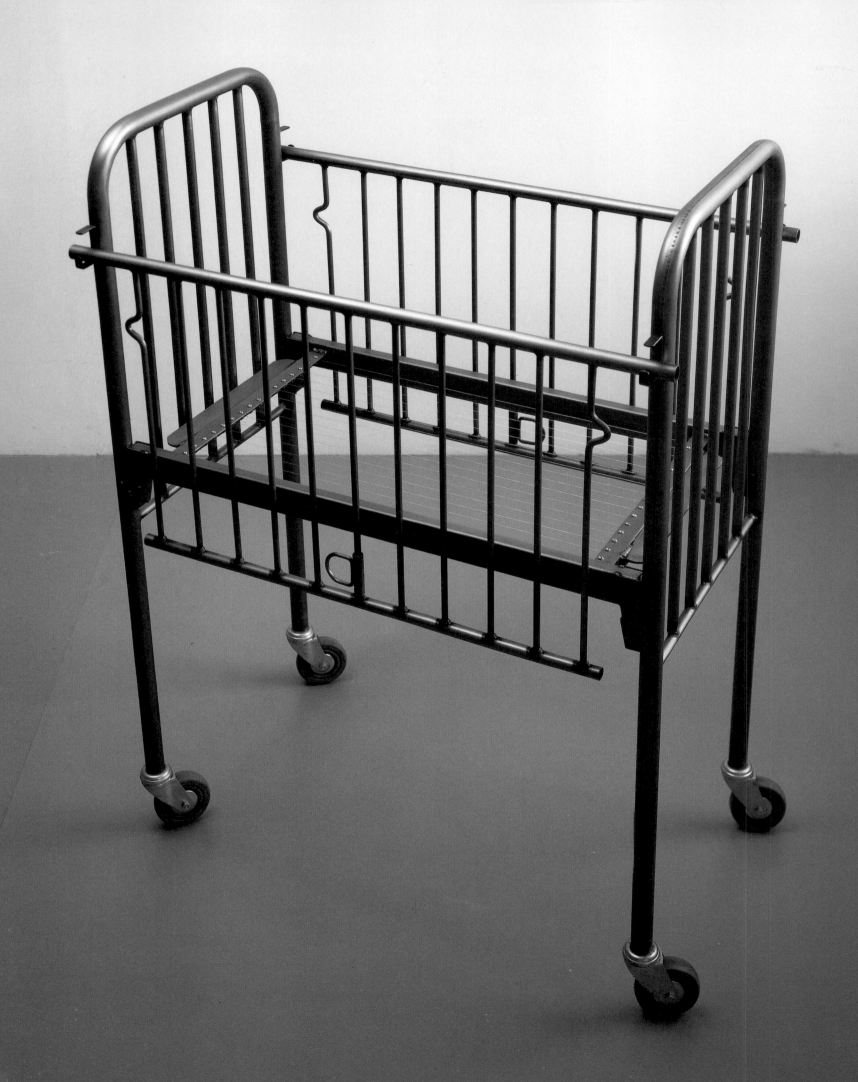

opposite, **Incommunicado**
1993
Mild steel and wire
127 × 49.5 × 95.5 cm
Collection, Tate Gallery, London

**Marrow**
1996
Rubber
Dimensions variable

going anywhere else. The curators of 'The British Art Show' insisted that I
reproduce it for the tour rather than make new work. But then it became
something else, because putting it into the museum it had to have all the
security devices to make it childproof, foolproof, everything proof. I was
working on elements of *Light Sentence* and *Short Space* in my studio in
Cardiff, but no one was interested. I made *Alive and Well* as a sequel to *The
Light at the End*, but I didn't think it worked. I think it was a bit too obvious.

**Archer** The piece with the two chairs is intriguing, the big chair with the little
chair butted up against it. Why is it untitled?

Hatoum  I didn't give it a title because I wanted to keep it open. That was
actually one of my first furniture pieces. I had made the two very large
installation works, *Light Sentence* and *Short Space*, for an exhibition at
Chapter in Cardiff. I saw the large-scale pieces as referring to some kind of
institutional violence. I wanted to place another piece in the space between
them which dealt with the same ideas but on a more personal, domestic
level. It was referred to as *Mother and Child*. The two chairs have an unequal
but inescapable relationship. They are very angular, cold and cage-like, but at
the same time there's a symbiotic relationship between them because they
are so similar.

**Archer** *Light Sentence* seems to be a grand refusal of any possibility of fixing a
particular meaning, of saying 'This is about this'. The whole thing is so utterly
mobile: the scale changes, the relationship between the viewer and the
elements of the work – the light source and the walls of cages between which

**Untitled**
1992
Two steel wire mesh chairs
98 × 44 × 71 cm

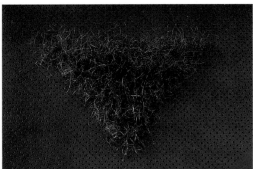

one can stand – constantly shifts. The manner in which the shadows of these cages are thrown onto the walls by the slowly moving light bulb makes them both hugely threatening and insubstantial. The work goes through all the things we have talked about so far and beyond.

Hatoum  **I'm happy to hear you say this, because most people look for a very specific meaning, mostly wanting to explain it specifically in relation to my background. I find it more exciting when a work reverberates with several meanings and paradoxes and contradictions. Explaining it as meaning this or that inevitably turns it into something fixed rather than something in a state of flux. A work of art has two aspects: the natural, physical aspect, which I think of as the conscious aspect that the artist can manipulate and shape; and then there is the very complex cultural and unconscious aspect of the art work. This is rich and full of meanings and associations, and it is as impossible to explain fully or comprehend as an individual or the social subconscious. Years after making this work, I still discover interesting associations, sometimes pointed out to me by viewers.**

**Archer**  Following *Short Space* and *Light Sentence* at Chapter, and *Socle du Monde* in Montréal, you did *Corps étranger* for the Centre Pompidou in Paris. This endoscopic exploration of the body brought forward concerns explored in the performances we talked about at the beginning. *Look No Body!* included the sound of the heartbeat and the noises of the body; the gaze of *Don't Smile, You're on Camera* is here sharpened so that it can penetrate not only clothes but also skin and flesh. Was the Pompidou show an opportunity to realize an idea that you actually had had that far back?

Hatoum  **Yes, it was exactly that: a piece that I had shelved because nobody would take me seriously. As a student at the Slade, I thought I was entitled to hassle the doctors at the University College Hospital across the road. They wouldn't do the endoscopy on me, but I managed to get a sound-recording of my heartbeat and stomach rumbles, which I used in *Look No Body!* and eventually in *Corps étranger*. It only became possible to make this work when the Centre Pompidou commissioned me to produce it. Without their influence and financial support I would never have been able to make it. So *Corps étranger* was a very old idea, but there are a lot of old ideas that keep coming up in different ways. There are different strands in my work that develop over a long period of time and keep coming in and out of focus. For example, I've recently made a piece related to *Light Sentence*, because that work is 'still there' in my mind. Certain works I made as a student were about the dispersal of the body, and this is now coming up in works like *Recollection*. I used to collect all my nail parings, pubic hair, bits of skin and mix them with pulp and bodily fluids to make paper: a kind of recollecting of the body's dispersals, if you like. Pubic hair I had collected all these years ago ended up in a much later work, *Jardin Public*. There is a triangle of pubic hair that looks like it is growing out of the holes in the seat. Incidentally, this work was the result of discovering that the words 'public' and 'pubic' come from the same etymological source. Some of my current work represents the maturing of ideas from many years ago; ones that I could not articulate at that time without relating them directly to their sources – a news item, or even a childhood memory – like a kind of illustration.**

**Archer**  Tell me about working in Jerusalem.

**Hatoum**  **Going to Jerusalem was a very significant journey for me, because I had never been there. My parents are Palestinian. They come from Haifa, but have never been able to go back since they left in 1948. Jack Persekian, who has this little gallery in East Jerusalem, and I had been discussing the possibility of doing the exhibition there for over two years. I kept postponing it because emotionally it's a very heavy thing, and I wanted to be able to spend a whole month out there, producing the work.**

**Archer**  What work did you do when you were there?

**Hatoum**  **I ended up making about ten works. I made three installations and a number of photographic works and small objects. The ideas I had proposed beforehand seemed to be about turning the gallery into a hostile environment, but the environment outside was so hostile that people hardly needed reminding. On my first day in Jerusalem I came across a map divided into a lot of little areas circled in red, like little islands with no continuity or connection between them. It was the map showing the territorial divisions arrived at under the Oslo Agreement, and it represented the first phase of**

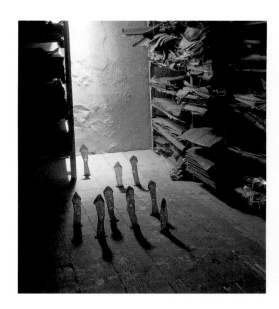

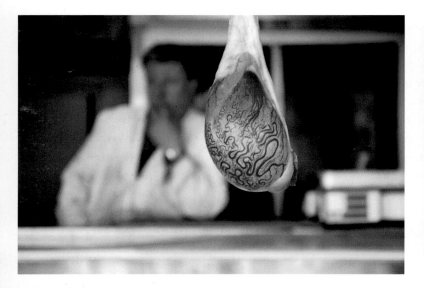

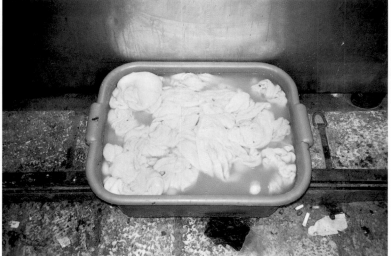

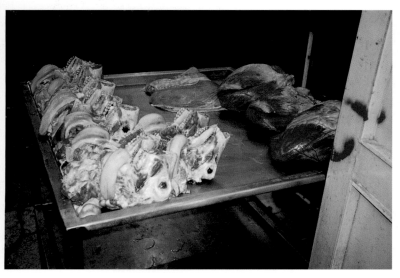

*opposite*, **Let Your Feet Do the Talking**
1996
Nylon stockings, nylon thread
Installation, Anadiel Gallery,
Jerusalem

*right, above*, **Present Tense**
(in progress)
1996

*right, below*, **Nablus Soap**
1996
Soap and pins
7.5 × 8.5 × 8.5 cm each

*left,* **Baid Ghanam (Sheep's Testicle)**
1996
Colour photograph
17 × 26 cm

*left below*, **Rous Ghanam (Sheep Heads)**
1996
Colour photograph
17 × 26 cm

*right*, **Kroush (Tripe)**
1996
Colour photograph
17 × 26 cm

*right below*, **Sissan (Chicks)**
1996
Colour photograph
17 × 26 cm

**Present Tense** (detail)
1996
Soap and glass beads
4.5 × 299 × 241 cm
Installation, Anadiel Gallery,
Jerusalem

returning land to the Palestinian authorities. But really it was a map about dividing and controlling the area. At the first sign of trouble Israel practices the policy of 'closure'; they close all the passages between the areas so the Arabs are completely isolated and paralyzed.

When I first came across it, I had no intention of using it, but a week later I decided that I would like to do something with this local soap made from pure olive oil, and the work came together. Originally I was going to draw the outline of the map by pushing nails into the soap, but it looked quite aggressive and sad. I ended up using little glass beads which I pressed into the soap. The piece is called *Present Tense*; it's about the situation as it was then. Now, with the change in government, some of those areas are not being returned to the Arabs. The Palestinians who came to the gallery recognized the smell and the material immediately. I saw that particular soap as a symbol of resistance. It is one of those traditional Palestinian productions that have carried on despite drastic changes in the area. If you go to one of the factories in Nablus, the city north of Jerusalem which specializes in its production, you feel you have stepped into the last century. Every part of the process is still done by hand, from mixing the solution in a large stone vat, to pouring it on the floor, to cutting and packing it. I also used it because of its transient nature. In fact, one visitor asked, 'Did you draw the map on soap because when it dissolves we won't have any of these stupid borders'?

When the exhibition opened and Israeli people came from Tel Aviv, they started reading a reference in the soap to concentration camps. This couldn't have been further from my thoughts. Those two readings of the work give you an idea of the very different backgrounds and histories of the two cultures trying to co-exist.

For another piece I brought into the gallery a metal bed which I'd found in the street. I attached castors to the legs and then proceeded to immobilize it by tying it down to the floor with fishing wire. The wires were invisible, you almost tripped on them before you saw them. I called it *Lili (Stay) Put*. I was

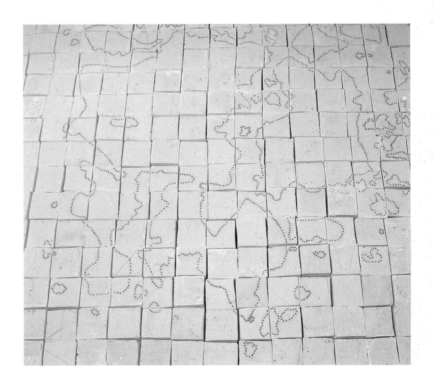

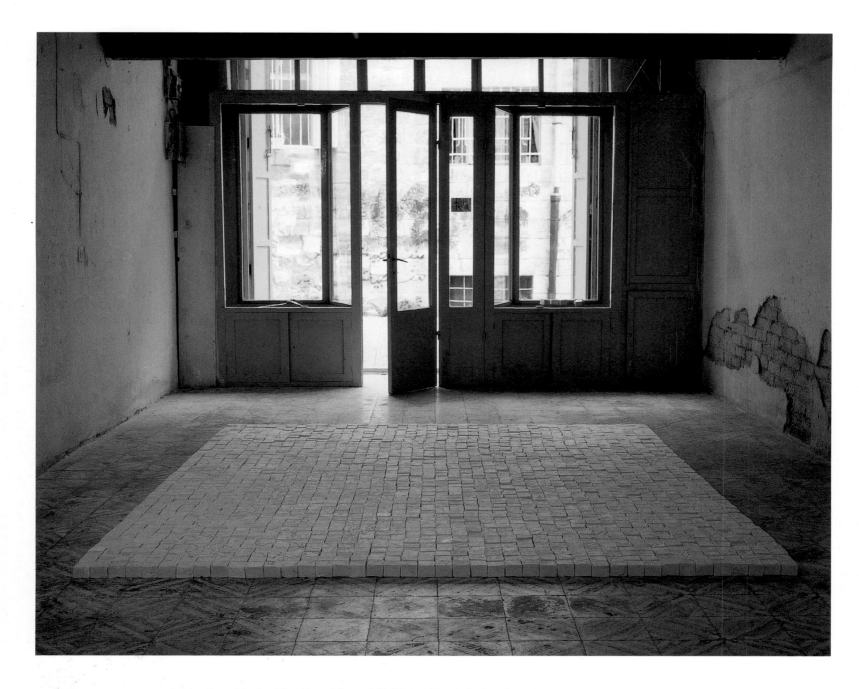

**having fun with the titles. One visitor said it felt just like their situation, that everything is trying to push them out but invisible threads tie them down. I was impressed that he'd made the connection between an inanimate object and his situation.**

**Archer**  So someone who knows nothing about Conceptualism or Minimalism won't necessarily see some of the formal resources you are employing. You've said similar things about the performance you did in Brixton, where you walked around with Doc Martens boots tied to your feet. There was a directness of perception amongst the passers-by which suggested that people knew exactly what was happening.

**Hatoum  Yes, because that was another instance where I was performing for an uninitiated audience – passers-by – and addressing issues that they experienced in their everyday life: police presence and surveillance.**
**Anyway, the saddest thing in Jerusalem was the policy of 'closure' that**

restricted movement for the Arabs. I gave a piece the title *No Way* as a response to that. It was a large spoon I'd found full of holes, and I decided to block all of them with nuts and bolts. At the same time it became an uncanny and threatening object, like a weapon. I have since made another version of it.

**Archer** The colander.

**Hatoum** Yes, *No Way II*. I did another residency this year which was extremely inspiring. I spent a month at a Shaker community in Maine, the last remaining Shaker community. It is a small community of only eight members. There was this wonderful, settled feeling of warm domesticity in the place, so household objects became my focus. I did some rubbings of colanders which the community had made by hand in the 1830s. I had fun knitting and weaving with spaghetti and pasta and making miniature baskets. I like turning up at a place and letting myself be inspired by the situation. After being with the Shakers and making very discrete little objects, I then went to San Francisco for another residency at the Capp Street Project, where I had to deal with a very large space that required a bold statement – not quite what I felt like doing at that time.

**Archer** Big things?

**Hatoum** Yes. These days I feel drawn towards making works like *Recollection* with the hair, or even those little objects I made at the Shaker community. I feel it is more appropriate for our times. People have become more aware of the body's fragility, and the work has become more humble in a sense.

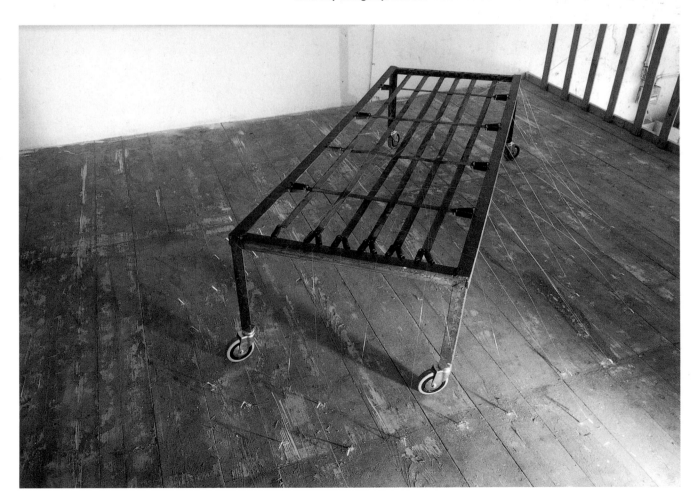

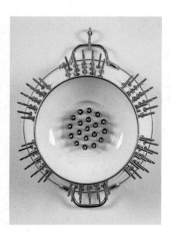 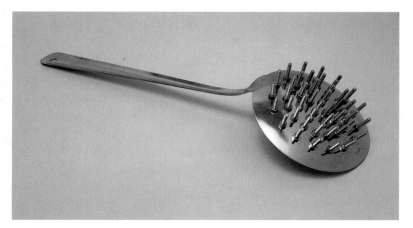

No Way II
1996
Stainless steel, enamel
27 × 22 × 13 cm

No Way
1996
Stainless steel
6 × 41 × 13 cm

*opposite*, Silence
1994
Glass infant's cot
127 × 93 × 59 cm
Collection, Museum of Modern Art,
New York; Louisiana Museum of
Modern Art, Humlebaek, Denmark

**Archer**  They occupy space by giving a sense of the activities of people living in and using it, rather than by physically imposing themselves.

> Hatoum  **The redeeming factor in the Capp Street installation was its simplicity. In a sense it is similar to *Light Sentence*, which is quite spectacular but very simple. Neither of these works are about the glorification of power structures, but rather a critique of those dehumanizing institutions and their effect on our existence.**

**Archer**  It's a square enclosure of wooden 'cages' which is empty in the middle.

> Hatoum  **There were four very imposing wooden columns interrupting the space. I had somehow to integrate them into the work, so I constructed an enclosure of wooden cages between them. Every cage had a light bulb lying at the bottom, and I used a computerized device which dimmed the light bulbs on and off in a quick, random sequence. I amplified the buzzing sound of the sixty-cycle current going through the light bulbs. There was something unsettling about it because there was such chaotic and mad activity within the regimented structure of the cages. It felt as though it was about to self-destruct. It's called *Current Disturbance*.**

**Archer**  Do you think the humbleness you speak of is something particular to you or do you sense that it's more widespread?

> Hatoum  **It is a feeling I have been picking up for a while.**

**Archer**  Do you want to say anything else?

> Hatoum  **It is refreshing to be interviewed without once being asked to explain my work in relation to where I come from. Most people who interview me seem to have this journalistic attitude that wants to explain or validate my work specifically in relation to my background.**

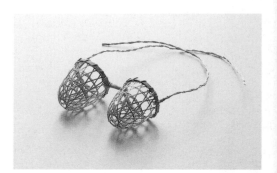

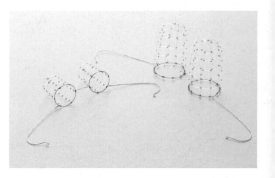

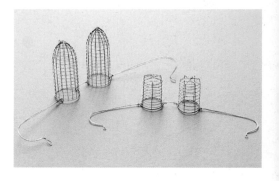

Eyecatchers
1997
*above, top to bottom*, bamboo,
straw, 7 × 16 × 27 cm; fishing wire,
steel wire, large 9 × 7 × 34.5 cm;
small 5 × 6 × 28 cm; stainless
steel, large 9 × 7.5 × 33 cm;
small 5 × 6 × 28 cm

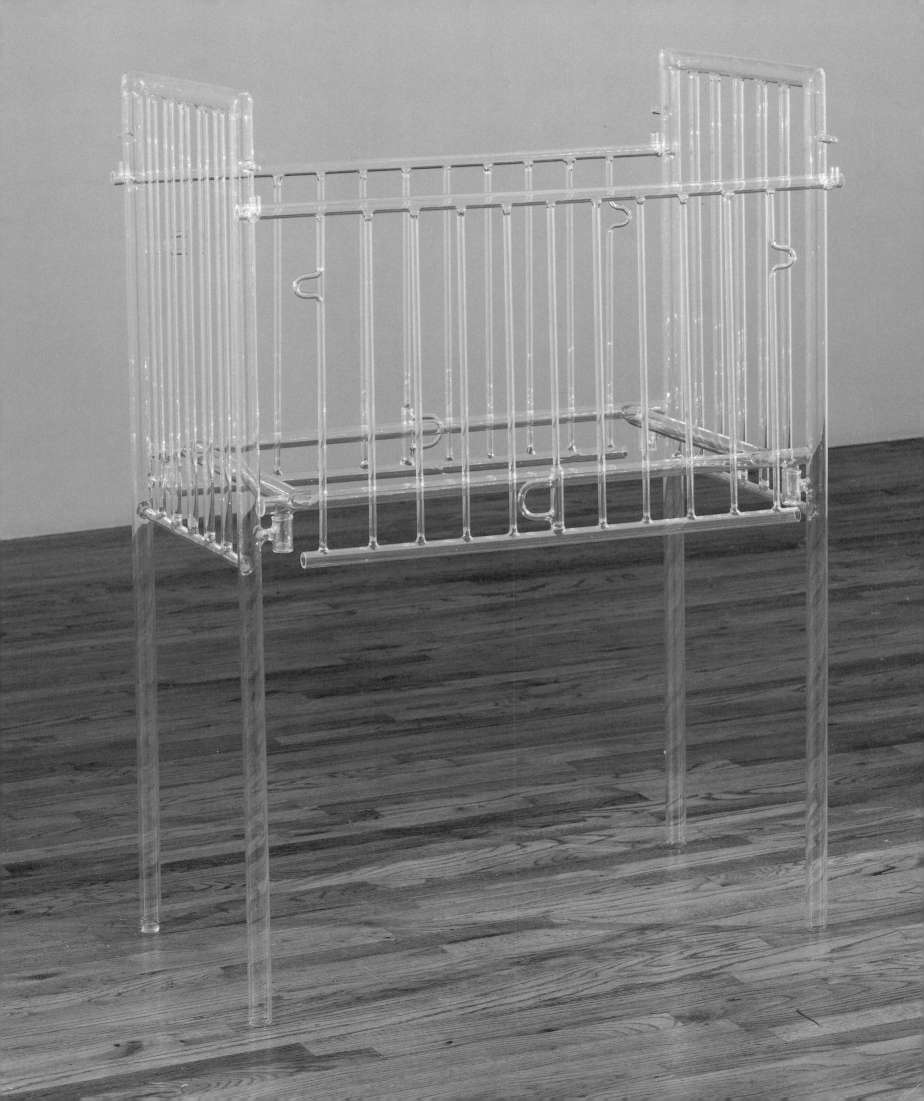

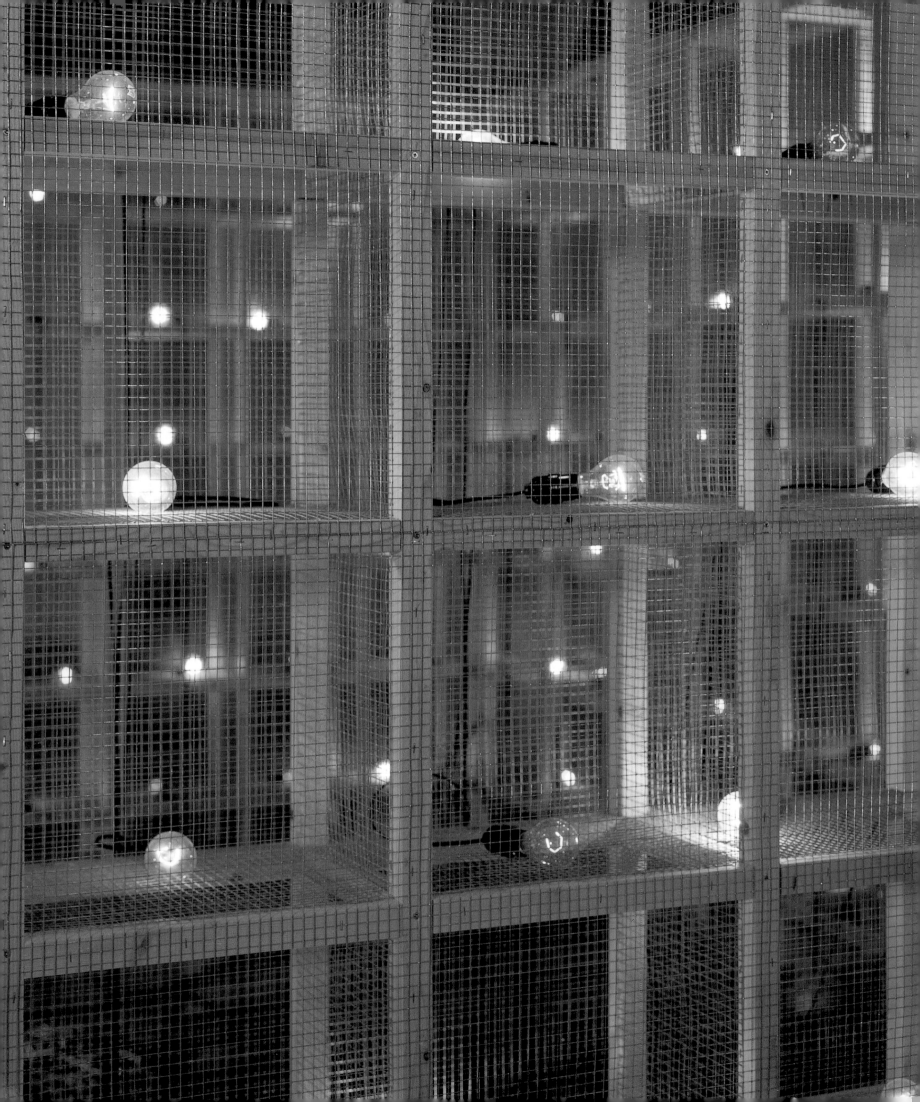

What words should we use about experiences that are very physical, very material? Experiences which affect us in ambiguous ways, powerfully, before words can order and contain them? We have to use words but hope they will take us back to that materiality and that ambiguity which were basically questions, potentialities, with any number of dimensions and answers. Visual art is a kind of knowledge which is not transmitted in words. We hope the words we use will link it to the issues which matter, but will also continue to convey that we cannot really say what it means.

Fluid meanings, fertile paradox and a subtle dialectical movement run throughout the powerful body of work Mona Hatoum has produced in the last fifteen years. Her work is an outstanding example of the interweaving of ethical, political and aesthetic issues. Its beauty lies in the wit, economy, risk-taking and even mischief-making combined with an artistic practice in which her own imagination – the artist's 'will to form' – engages in an extremely fine process of interaction with the spectator. In this meeting, bombast on either side becomes almost impossible because the space created is one of sensitization, of mutual questioning, not of dictation or final statements. In Hatoum's deceptively simple works, defiance cannot easily be separated from vulnerability, order from chaos, beauty from revulsion, the brain from the body, the self from the other, affirmation from negation, form from content, light from dark.

**The Metaphor of Place**
One way of 'formatting' this rich field, one way of tracking a relationship between art work and reality, would be through the metaphor of 'place'. Place can be taken as a metaphor because it can operate simultaneously in several different registers, in both life and art. In each one it is always accompanied by its opposite: displacement. Mona Hatoum's place of origin, place of birth, was already a displacement. In 1948 her Palestinian family were forced to flee from their home in Haifa as a result of Isreali intimidation. They moved to Beirut, where Hatoum was born and grew up. Her father spent all his working life as a civil servant for the British administration, first in Palestine and later at the British Embassy in Beirut. This entitled him to hold a British passport (the only identity papers possessed by the family after Palestinian nationality documents became invalid). In Beirut their Palestinian accents marked them as foreigners, and Hatoum remembers from her childhood the ambiguous feeling of being home and not home simultaneously.

In 1975 she came to London on a visit and found she could not return because of the outbreak of the civil war in Lebanon. She decided to enroll at art school and remained to work as an artist. She thus entered another experience of place, again only understandable as a mass of contradictions. On the one hand, art school offered a place of refuge and freedom after the turmoil of war in the Middle East; on the other, she began to feel her difference as a 'Third World' person. She realized that the comfort and confidence of the students around her came from a feeling of rootedness, so different from the dislocations and restlessness she had known. London was a complex mixture of positive and

negative. One had the freedom to pursue an avant-garde existence and not be answerable to anyone, unlike family- and community-oriented Lebanon where everyone knew what everyone was doing. Yet the atmosphere at the Slade school, where Hatoum studied from 1979 to 1981, was quite restrictive and she could only experiment in the ways she wanted by searching for alternative contexts outside the institution. This became the origin of some of her first public works. She gravitated towards performance and video, which represented a small, marginalized but vital area where artists' experimentation in media and language coincided with their awareness of social issues.

A second notion of place, intricately related to the first, concerns the artistic work itself and the 'place' where it is seen or emerges. In a sense, the history of art could be understood as a dialectic of placement/displacement which the nature, even the notion of art itself, has changed. The broadening of the concept of art in the twentieth century, and the proliferation of new genres, has been a continuous attempt by artists to escape the embalming process carried on by art's own institutions, in order to regain a 'life' context. Art has been displaced from the gallery or museum to the street (or other everyday medium of circulation), from expensive commodity to freely-accessible proposal, and so on. But to present this process as a linear progression would be naive and simplistic, since the site displaced from the institution itself becomes institutionalized. The 'gallery' and the 'street', for example, are governed by different customs, codes and taboos to which the artist may be highly sensitive. But as categories

they are not absolutes. Neither is pure. The gallery is a set-aside space of contemplation, but it is not only artificial; it is also real, beginning with its architecture. Similarly, the street is not only real but also fictional. One partakes of the other. The way they do so varies in minute particulars in each national and cultural context. In the face of these complexities, the most interesting artistic responses have been fluid and non-formulaic, practising what the Brazilian artist Hélio Oiticica liked to call 'a critical ambivalence'.

Mona Hatoum has shown a most subtle understanding of these fluctuations, as will emerge from a chronological consideration of her work. For the moment, one telling indication of the relationship between the 'art' place and the 'real' world could be cited by pointing to a change which has taken place in her work over the past ten years. In the mid 1980s, for example, she was giving as stark an expression as possible to her experience as 'witness' of the embattled conditions of peoples in the Third World by almost literally building a 'shanty town' inside the art gallery (*Position Suspended*, 1986; *Hidden from Prying Eyes*, 1987). By 1989, with a work like *The Light at the End*, she had developed her strategy and was deliberately using the reality of the calm, clean art space as a given from which to induce a physiological change in the immediate experience of the spectator. The concerns remained the same but the means of introducing them became more subtle and mature. In other words, rather than referring to another reality somewhere else, the work grasped reality 'here and now', thereby allowing the spectator to become conscious, perhaps in a deeper, more

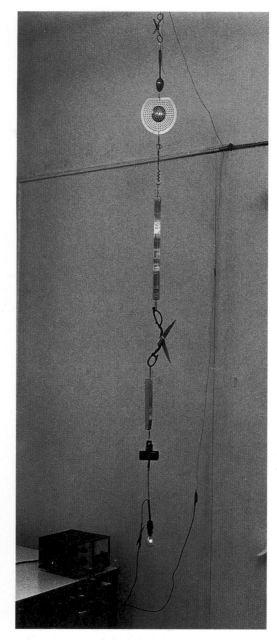

**Untitled**
1979
Scissors, wire, car light bulb,
paper clips, metal ruler, drainer,
comb, corkscrew, bull-dog clip,
teaspoon, transformer
h. 172.5 cm

internal way, of the experience of others. Fruitful contradictions between the real and imaginary become the very means of insight the artist uses.

Conceptual displacements between the space set aside for art and the space of everyday flux, and between artist and spectator, always take place in specific circumstances. With the growing mobility of the artist in the late twentieth century this has taken on its own complexities and contradictions. Huge historical injustices like those of imperialism lie behind these encounters between artist and place, to which the artists themselves may be sensitive or blind. Mona Hatoum's itinerary gives one illuminating example of the translation of local, contingent origins into the practice of a 'global artist' who travels frequently, working in and adapting to different contexts. To these she brings an attitude, formed by lived experience, of responding to rather than colonizing space.

Place of origin, place of work, place of exhibition; each is tied to a fourth notion of place, less material but no less real: the artist's placement in the discourse of contemporary art. The fact that this locus departs from the material into a vapourous realm of market forces and media hype, delusion, vaunted egos and name-dropping, does not alter the fact that it remains a battleground between the forces of change and conservatism. The way insights are 'in the air' on a global scale at any given moment, the exchange of ideas, the subtle structures of collaboration – all these are real connections much more complex and enriching than those confined to the 'art circuit'. The nature of contemporary art has been gradually changing as a result of struggles by women artists, by non-Western artists and others, to be seen as 'primary makers of meaning'[1] and not relegated to the margins or to special categories outside the mainstream. But the ways of this vapourous realm remain very tricky. A fashion can flare up and die without changing the basic structures, obscuring the aspirations the favoured artists have in common with those others, still consigned to invisibility, for transforming the relationship between art and life. Are artists to adjust to the established institutions, or can the institutions genuinely respond to the changes they propose?

Again, there is hardly a final answer: only intelligent and imaginative strategies by different artists stemming from an attitude of pluralism and a distrust of the final and absolute. Some have characterized this as an 'in-between' space, operating as a metaphor on many levels. Hatoum herself has spoken of 'the feeling of in-betweenness that comes from not being able to identify totally with my own culture or the one in which I am living', and of 'the inability to identify with a specific solid reality'[2] (two sentences which clearly link her life and her art work). This could be a negative way of describing the positive qualities which unite the different metaphors of placement/displacement as a motive force for the works whose evolution I would now like to consider.

**Danger, Dialectics**
Mona Hatoum's work to date falls conveniently into three periods: first, an early period marked by free experiment; then the years of 'issue-based'

works, roughly 1982-88, which mainly take the form of performance and video; and third, a period beginning in 1989 with *The Light at the End* and drawing on many ideas first proposed in her student days.

Because several student experiments inspired or prefigured later works, I will describe them when I reach that later stage in the narrative. The fact that this happened is interesting in itself. Hatoum was quickly drawn away from traditional fine art practice to projects which involved an element of provocation and danger, which hovered on a borderline between artistic and technological experiment, with a mischievous influx of everyday life. One of these hybrid productions was a long, hanging 'string' of metal household objects – scissors, comb, corkscrew, colander – which conducted electricity to a light-bulb (a later version of this proposal, in the form of 'do-it-yourself' instructions published in a newspaper in Iceland during an exhibition there in 1996, was considered so provocative it caused a national incident and was censored).[3] Another apparatus made an early link with the body. Drops of water fell into a suspended tumbler from a glass laboratory dripper hung in the air by string. The rising water completed an electric circuit, lighting a bulb which intensified gradually, tremblingly, 'like an orgasm', in Hatoum's words. Some experiments disconcerted even the artist herself. A chair she made out of mirrors produced such a sense of an abyss when one looked down at the seat, that when she attempted to photograph it she became anxious and discovered she could not. 'I was afraid of it', she recalls, 'I was trying to

make something which would merge with its surroundings, something beautiful and ethereal which would be both there and not there. But it became frightening. Now I realize that these kind of paradoxes were just what I was looking for'.[4] Later, pursuing her interest in the body, she made graphic works incorporating her own hair, shreds of skin and nail-parings. This interest also brought her to video and performance.

The Slade school looked in alarm at the kind of work Mona Hatoum wanted to do. Her electrical pieces were considered too dangerous and she was restricted to showing them in a controlled environment to an invited audience (forcing her, in effect, into a form of proto-performance). Student performances then became the subject of special conditions at the school, demanding that plans be submitted in advance for approval, and that a staff member be present throughout. The history of Hatoum's attempts to stage her early live video work, *Waterworks*, in public gives an indication of attitudes at the time.

The work was selected for the 'New Contemporaries' exhibition in February 1981, to be held at the ICA in London. The artist proposed using both the public foyer space and nearby men's and women's toilets. Video cameras were to be set up in one cubicle in the toilets, relaying their interiors live to the foyer. People watching the monitors in the foyer would see and hear men and women using the bathroom (a note placed on each toilet door gave people the option of using another lavatory if they did not wish to be observed). Despite its selection by the jury, the ICA management refused to allow the piece, giving

Frithstool, or Freedstool, literally 'the seat of peace.' A seat or chair placed near the altar in some churches, the last and most sacred refuge for those who claimed the privilege of sanctuary within them, and for the violation of which the severest punishment was decreed. They were frequently, if not always, of stone: according to Spelman that at Beverley had this inscription: "Hæc sedes lapidea *freedstoll* dicitur i.e. pacis cathedra, ad quam reus fugiendo perveniens omnimodam habet securitatem." Frithstools still exist in the church at Hexham, and Beverley Minster, both in the north aisle of the chancel: the former of these has the seat hollowed out in a semicircular form, and is slightly ornamented with patterns of Norman character; that at Beverley is very rude and plain.

Beverley Minster.

**Frithstool chair**
from John Henry Parker, *A Concise Glossary of Architectural Terms*, 1896

the curious reason that the toilet was a public space where people 'had not made a conscious decision to be confronted by art'. In March of the same year, Hatoum integrated the basic idea into a performance and renamed it *Look, No Body!*, which she staged at the Basement in Newcastle. The artist entered the gallery dragging a hose. Her action consisted of repeatedly filling a cup from the hose, drinking it, retiring to the toilet, pissing, flushing and returning. The performance lasted twenty minutes. A sound track combined sounds of the artist's heart-beat and stomach rumbles with a scientific text describing the process of micturition, and the artist's personal and social reasons for making the work. An attempt to create the original installation at her finals show at the Slade in June again met with censorship. Hatoum posted up a notice in her empty space at the Slade which said, among other things:

*'The work presented here was intended as an investigation into the nature of the taboo surrounding the eliminatory process and its direct*

*relation to sexual taboos and our general negative attitudes to the body and its natural processes, which socialization teaches us to keep under control in order to maintain a formal social distance ...'*
She was finally able to stage a version of *Waterworks* in London at the Filmmakers Co-op in July 1981.

A third strand of Hatoum's student work consisted of 'conceptual', minimalist objects embodying philosophical and perceptual paradoxes. One was a kinetic object she called *Self-Erasing Drawing* (1979). A motor-driven arm, rotating at five rpm on a central pivot, draws circular lines in a bed of sand with one end while the other end of the arm immediately erases them. *A reductio ad absurdum* of a closed system, a paradigm of the inseparable but ambiguous relationship of opposites, an ironic automation of the artist's volitional act of marking and rubbing out, 'a sense of existence accentuated by the fear of disappearance'[5]: however one sees it, the little object turned out to have a prophetic relation to the structure of many of Hatoum's later works.

### An Act of Separation
In the meantime, material and conceptual experimentation came to seem increasingly untenable. Interaction with the audience (embryonic in *Look, No Body!*, more developed in *Don't Smile, You're on Camera*, discussed below) came to an abrupt end, and even turned into its opposite. Under the impact of events in Lebanon – as the destruction worsened, her parents lived under virtual seige in their Beirut apartment – Hatoum not only felt separated from them, but

**Self-Erasing Drawing**
1979
Wood, sand, metal, electric motor
9.5 × 28 × 28 cm

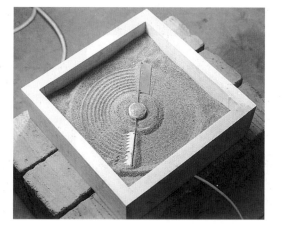

*opposite and following pages,*
**+ and -**
1994
Sand, wood, stainless steel, motor
32 × ø 400 cm
Installation, Museum City Tenjin, Fukuoka, Japan

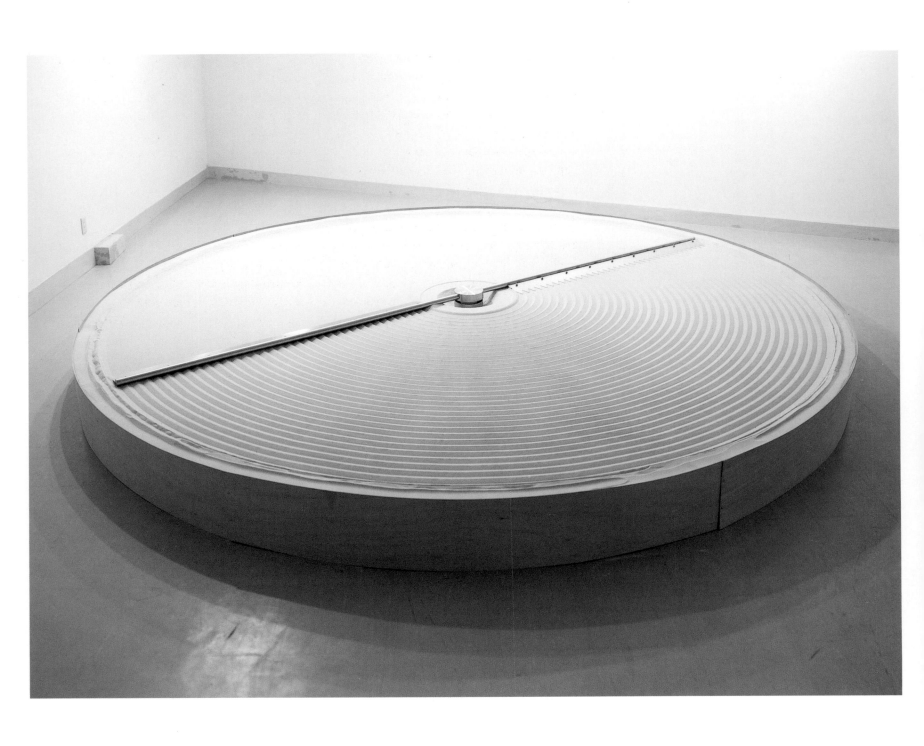

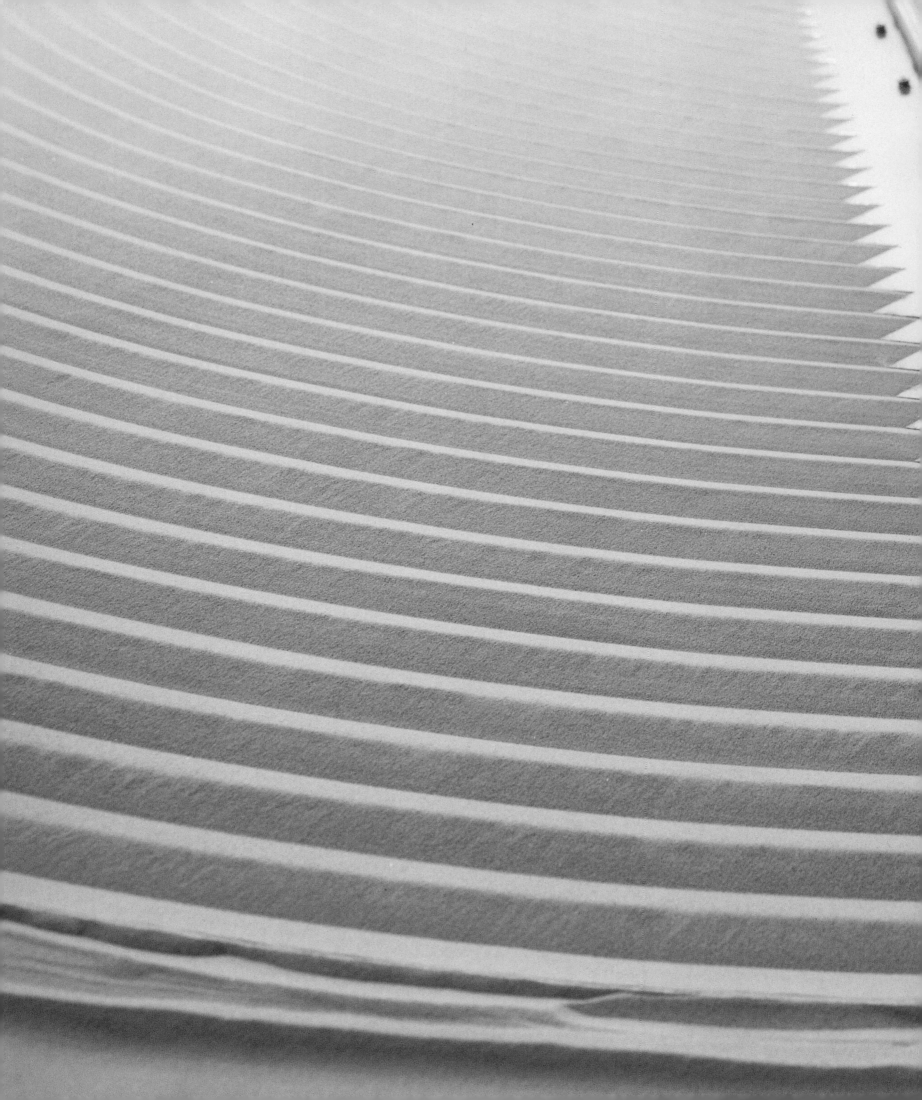

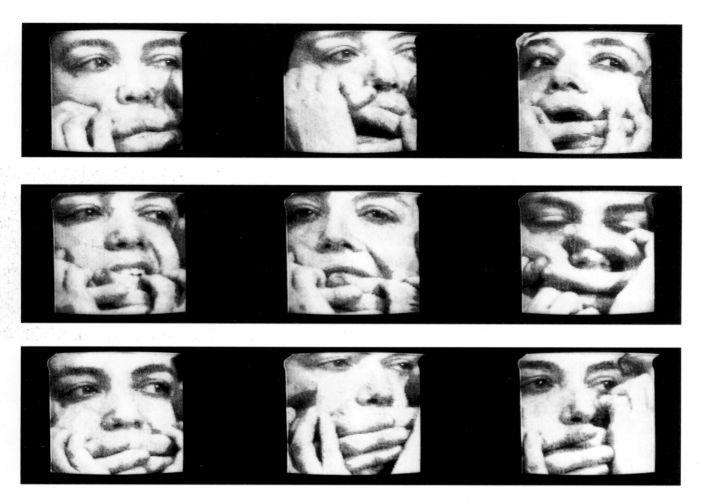

**So Much I Want To Say**
1983
5-min. video
A Western Front Video Production,
Vancouver
Collection, Art Gallery of Ontario,
Toronto; Musée national d'art
moderne, Paris; Museum of
Contemporary Art, Chicago

also felt dislocated in her position in England as 'witness' of a turmoil unknown to the society around her. A turning point was the heinous, organized massacre of Palestinian refugees in the camps of Sabra and Chatilla outside Beirut, which took place in September 1982, and which the artist described as 'the most shattering experience of my life'.[6] She was shocked into a politicization which could only, in her circumstances in England, take a subjective form and cast her in the role of witness. This was another factor which drew her to performance. The genre was still very much an open area, without binding conventions and rules, offering a stark presentation of the self and confrontation with the audience. In practical terms too, performance was an inexpensive form for a young artist with no studio and few

resources. These aspects came to seem inwardly linked. In performance art, 'the artist is being herself, making her own statement, and not pretending to be someone else, somewhere else'.[7]

Hatoum's early live works focus with great intensity on herself, her body, often divided from the audience by some form of barrier, plastic membrane, cage, cell, wall, hood or veil. One early video, *So Much I Want to Say* (1983), takes the form of a pair of male hands that gag and partially obscure the artist's face in close-up, while her voice on the sound track repeats over and over the words of the title. This 'barrier of communication' registers clearly in photographs of one of her earliest live events, *Under Siege* (1982), in which people stand around watching the artist struggle, naked, to stand in a transparent, clay-filled

Position: Suspended
1986
5-hour performance, Laing Art
Gallery, Newcastle-upon-Tyne

unemployment and wasted creative energies were combined with the considerable physical dignity with which the artist occupied this marginal and debased corner of the city museum.

The sense of experiencing a barrier while actually being in close proximity reached surreal and illogical lengths with *Matters of Gravity* (1987). At Riverside Studios, the artist constructed another cell, or perhaps bomb-shelter, by barring off an alcove near the restaurant with pieces of corrugated iron. The occupant, the artist, could only be seen through a spy-hole and a lens which appeared to turn her upside down, as if defying gravity. The disorienting play on gravity was further complicated by the artist's striving to lie on the bed or sit on the chair with the appearance of normality, when, bed, chair, table and everything else in the room, down to cigarette-butts, were stuck to the wall.

Obviously, much connects Mona Hatoum's performances with other artists' live work of the time, or even earlier. If a model is required for the artist's use of the physical ordeal, with its real and not pretended exhaustion, for the bandaged or blood-soaked body, it could be found in work like that of Stuart Brisley or Alastair MacLennan in

Matters of Gravity
1987
Performance in several sessions
of two hours
Kettle's Yard, Cambridge

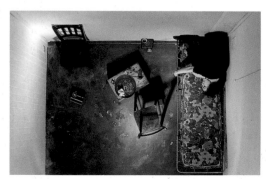

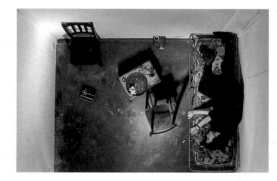

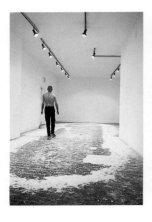

*above left*, **Alastair MacLennan**
Days and Nights
1981
Paint, ice block, flour
Performance, Acme Gallery,
London

*above right*, **Carlos Leppe**
Cuerpo Correccional (Punishable
Body)
1981
Video performance and
installation

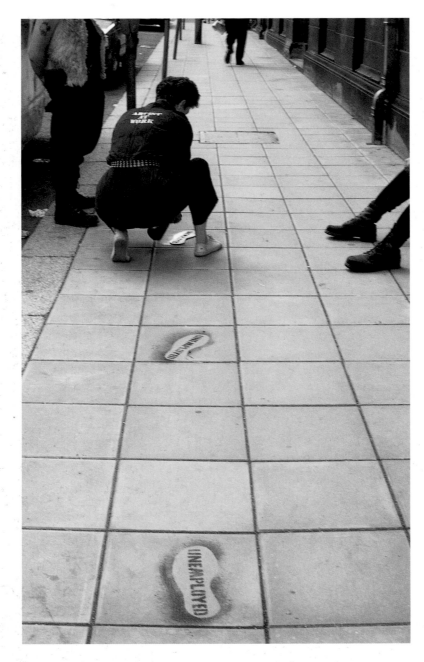

Britain, or the Vienna Actionists. In closer parallel to Hatoum's experience were actions like those of Diamela Eltit or Carlos Leppe in Chile, roughly contemporary, exposing the vulnerability of the body at the height of the Pinochet military dictatorship.[8] The agonized testimony to suffering struck spectators in Canada forcefully when Hatoum toured there in 1984. One reviewer wrote of a 'condition of profound alienation, paranoia and pain'.[9] However, in retrospect one is equally struck by certain formal qualities in Hatoum's performances, especially the abstract structure of paradox. This changes the one-sided presentation of the sufferings of a 'victim' into a dialectical movement, where oppression is interwoven with resistance, and weakness with strength. A strong conceptual element informs Hatoum's performances, traceable back to objects she made while a student, and it is this economy and conceptual clarity, as much as the emotional content, which made her best performances so memorable.

The dialectical interpenetration of opposites appeared in two beautiful and ephemeral actions Hatoum carried out in the streets of Brixton in 1985. These were part of an event called 'Roadworks', proposing a dynamic relationship between the work of selected artists and the locality, a predominantly black and working-class area of London. It was organized by another artist, Stefan Szczelkun, who himself appeared with Hatoum in one of these performances. Two figures appeared, barefoot, dressed in overalls, with taped mouths. One figure pulled the other to the pavement and drew a forensic chalk line around the body. But this figure was in turn pulled to the ground by the one who had been lying prone, and so the process continued in a chain, one figure's fall becoming the other's rise and vice versa, with traces of the fallen bodies forming a trail on the pavement. In another action that lends itself very well to reproduction as an image, Hatoum walked through the streets with a pair of heavy Doc

**Unemployed**
1986
Lino stencil, spray paint
Performance, from 'Streets Alive',
Sheffield

**Untitled**, with Stefan Szczelkun
1985
Performance for 'Roadworks',
Brixton, London

*following pages*, **Roadworks**
1985
Performance, Brixton, London

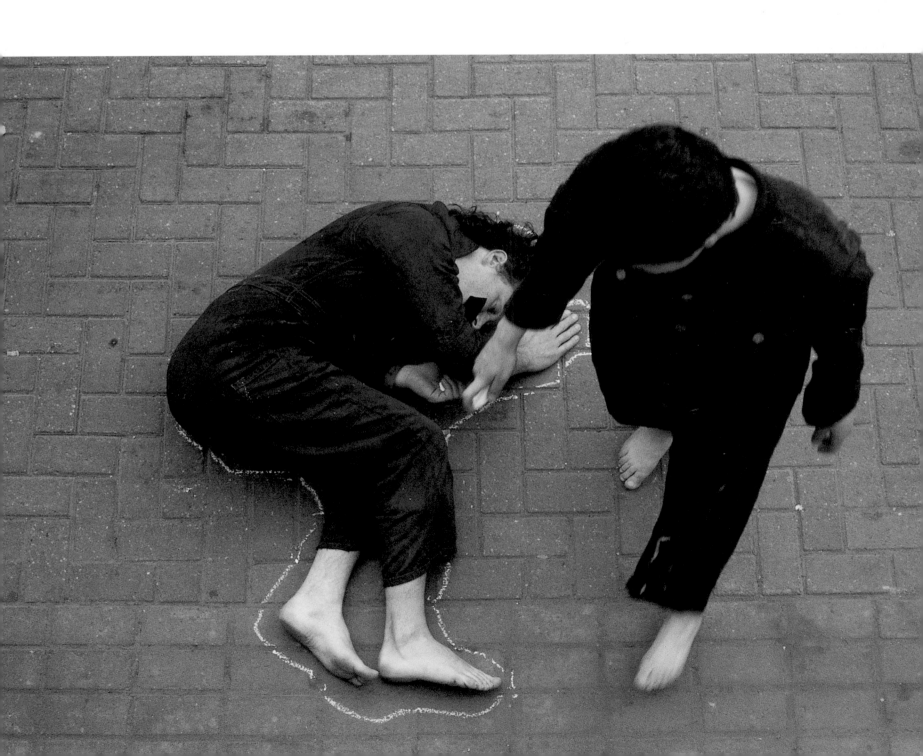

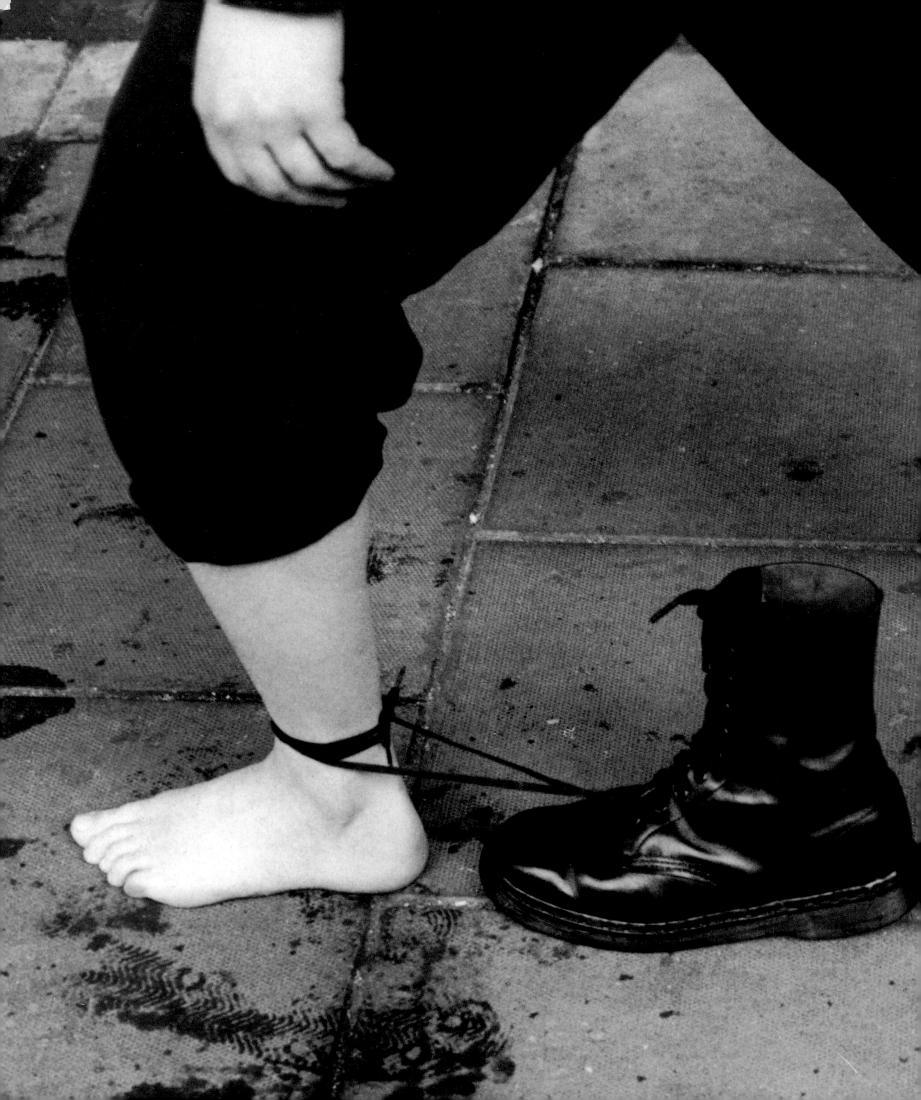

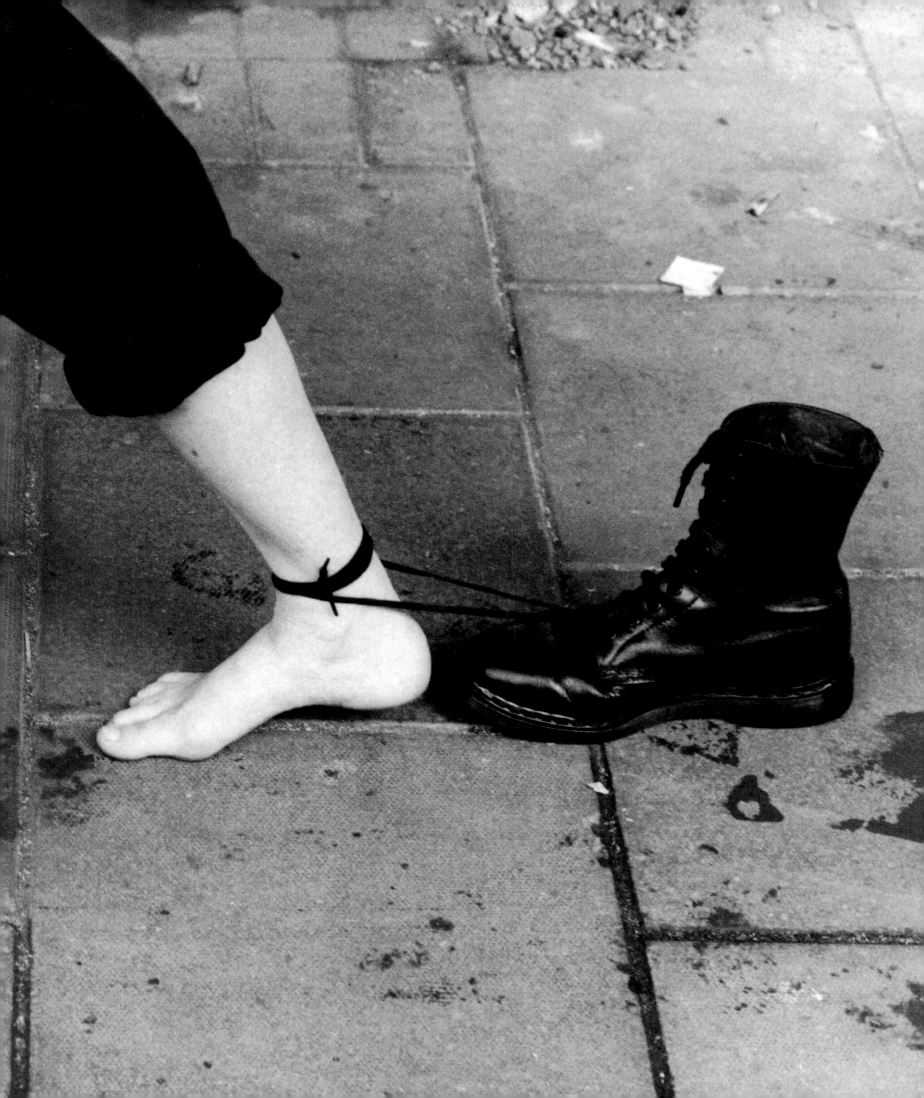

**Changing Parts**
1984
24-min. video
A Western Front Video Production,
Vancouver
Collection, Art Gallery of Ontario,
Toronto; Musée national d'art
moderne, Paris; Museum of
Contemporary Art, Chicago

Martens boots attached by their laces to her bare feet. Here again there were paradoxical role reversals, with liberating intent. The feet were naked and vulnerable, yet they had the strength and dragged along the massive military, police or 'skinhead' boots like lifeless puppets.

Many elements of Hatoum's live works crossed over into her videos, which gradually began to supercede performance. As well as its ability to reproduce and reach a wider audience, video allowed a more structured and layered approach. Fragments of super-8 footage which she

had made a couple of years before during her *Under Siege* event turned up again in her video *Changing Parts* (1984). In this work, grainy, freeze-frame close-ups of her face and hands attempting to bite and tear her way out of the plastic membrane were used, along with a cacophonous 'interference' of street noises and half-audible news reports, to disrupt a mood of tranquility and order which had been established by a slow montage (accompanied by the music of a Bach cello suite) of an intimate, familiar place: the tiled bathroom in the family apartment in Beirut.

The second sequence breaks violently into the first by a series of grating, incoherent interruptions. Apparently the harsh reality outside invades the secure interior space. But, as Desa Philippi has perceptively written, to read the work primarily in terms of this dichotomy would be to 'pass over the techniques and formal procedures which indicate the fragility of these categories themselves'.[10] A fruitful space of uncertainty is opened up. The bathroom's tranquility is reassuring but also somehow cold and static, while the second, chaotic, disordered part communicates a sensuous vitality; its violence is not seen only as the experience of a victim, but as if from inside a struggle to emerge from the lower depths, or perhaps from the womb.

If events in the Middle East had initiated Mona Hatoum's sequence of overtly political works, they also in a sense ended them. Commissioned in 1988 to produce a piece for an exhibition in Canada entitled 'Nationalisms: Women and the State', she decided on an installation inspired by the Intifada uprising of the Palestinian population against the Isreali occupation, which had begun late the previous year. Her work was an effective montage. It incorporated a projected newspaper photograph, a small lighted shelf with portraits as a shrine to the resistance fighters and a floor littered with rocks and stones, the main weapon of the insurgents, each one tagged with a number and date. But Hatoum was not satisfied. She felt she had reached the limits of this kind of representation, which seemed woefully inadequate to the reality of this great popular explosion. On the viewer's side it could be no more than an illustration of events, far removed, appealing only to the intellect; and on the artist's side it was something contrived, made to order, not an idea arising organically from within. All these realizations were in different ways responses to the sense of a divide with which she had been preoccupied, and the conclusions she came to had both short-term and long-term results. Her immediate reaction was to re-interpret the whole matter of ties and separations in terms of the personal.

The resulting video *Measures of Distance* (1988) is a complex and poignant work which is difficult to describe in a brief fashion. Its three principal elements are letters written by Mona Hatoum's mother in Beirut to her daughter in London; still photos which the artist, on a visit to Lebanon, had taken of her mother in the shower; and taped conversations between mother and daughter which ensued from the daughter's unusual demand. All are superimposed and mediated. The mother's letters are read aloud in English in a sad voice by the daughter in London, while part of their Arabic script appears on the screen over the mother's image, rather like a cage of wire or a veil. The letters also refer tangentially to matters discussed in Arabic in the conversation, between bursts of laughter. The transference of 'lived experience' to various forms of recorded and transmitted discourse may perhaps be most vividly conjured up by contrast with a moment in *Mind the Gap*, an earlier live performance which broached the themes of *Measures of Distance*. At this moment, Hatoum placed her hands on her mother's image projected onto a plastic sheet (like

*following pages*,
**Measures of Distance**
1988
15-min. video
A Western Front Video Production,
Vancouver
Collection, Art Gallery of Ontario,
Toronto; Musée national d'art
moderne, Paris; Museum of
Contemporary Art, Chicago;
Museum of Modern Art, Toyama;
National Gallery of Canada,
Ottawa

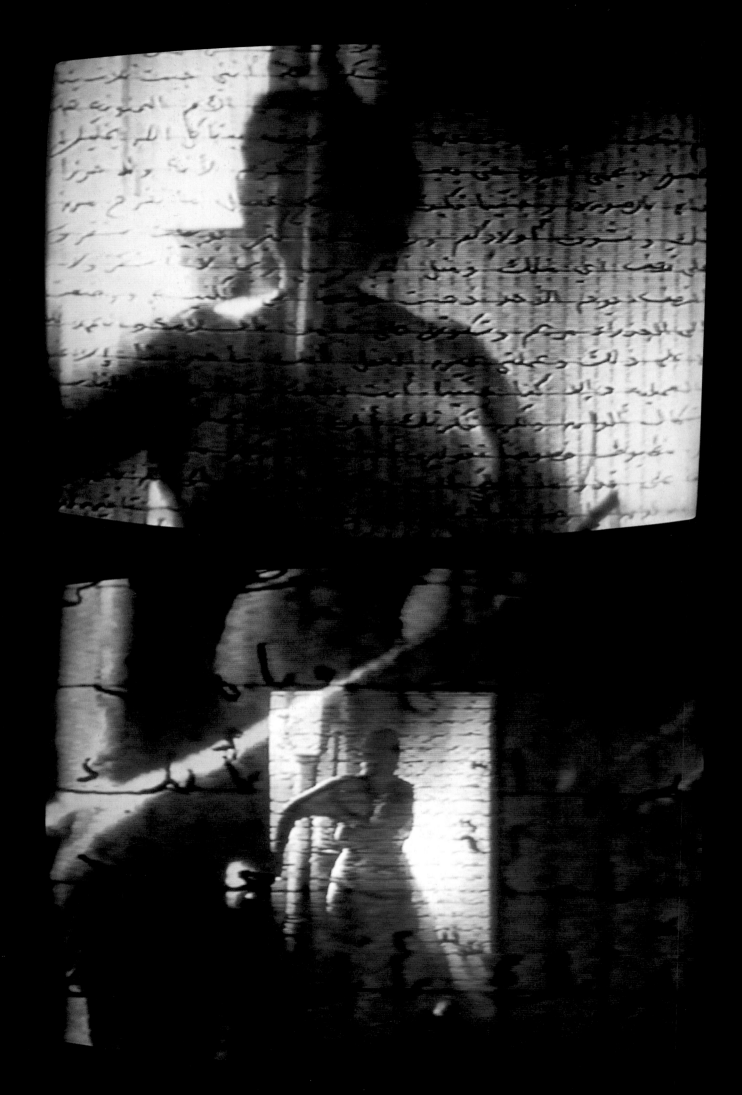

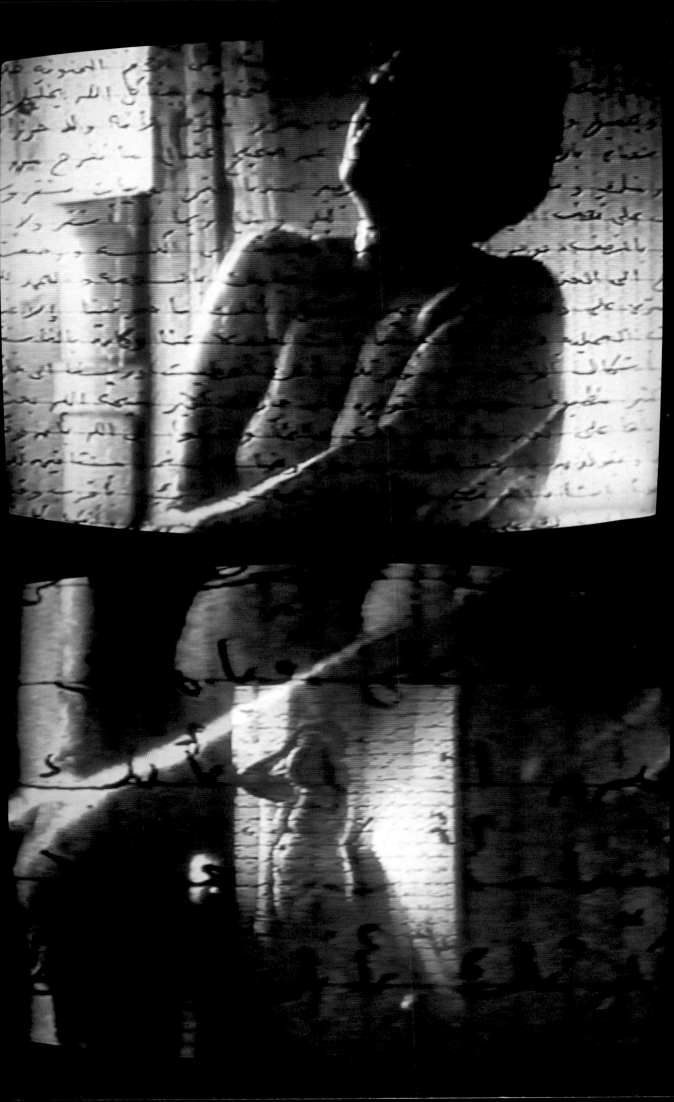

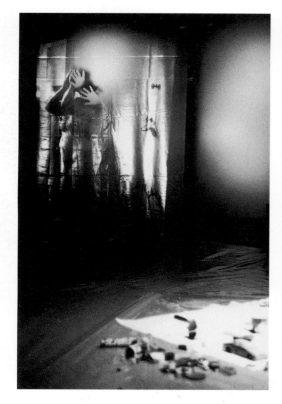

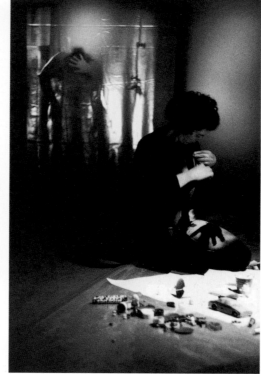

**Mind the Gap**
1986
40-min. performance, Collins
Gallery, Glasgow

a shower curtain) and sprayed paint around them to create a crowd of hand-prints which remained there, as if trying physically to hold onto the shifting image.

The artist gave as one of her reasons for adopting an autobiographical form the Western media's stereotypical portrayal of Arabs 'as a mass or herd without individual identity'.[11] She wanted to go against the image of the Arab woman as passive, as mother, as a non-sexual being. As she says in an interview reprinted elsewhere in this book, every image in the video that speaks of literal closeness – the emotional relationship between mother and daughter, the close-ups of her mother under the shower, and their conversation in which her mother speaks openly of her feelings and sexuality – also implies a gulf of separation.

The interplay of closeness and distance does not end with the personal content. As Desa Philippi has written in her searching analysis of

this work, 'the political circumstances as a set of specific causes for loss and the psycho-sexual determinations of loss in the mother-daughter relationship ... are constantly interwoven and inseparable'.[12] Western viewers too may become implicated in the fluctuations and discontinuities, being at one moment drawn in by the narrative of the letters, which the daughter reads in English, and at another distanced by a conversation in a language they cannot understand. The work is not less moving for this partial estrangement. Indeed, the work as a whole is structured around a refusal to be defeated by all forms of 'divide and rule'. The mother-daughter link is presented as creative and transformative, since it is through the daughter's 'project' (making the video) that the mother is able to present herself in a form of freedom and plenitude, so cementing a bond of identity across generations which is independent of all colonial and patriarchal dictates.

**Body and Eye**
A remarkable change takes place after the completion of *Measures of Distance*. Mona Hatoum reached a turning-point in her work at this time, a sense of crisis perhaps, which she was able to resolve with great intelligence, releasing her to continue with a burst of new and creative works. This 'crisis' had several strands, involving both content and form. In other words, her dissatisfaction with the possibilities of 'representing' political and social reality, which came to a head with the work inspired by the Intifada, became inseparable from a questioning of the act of seeing, the exchange between artist

and viewer, that takes place when a work of art is exhibited.

One of these strands was the paradox engendered by her performance works, in which she had been physically close to the audience but separated by a barrier. This gulf emphasized the nature of the event as a spectacle in relation to which the viewer remained detached, passive and secure. (This was structurally true, even though the composition of any actual audience might

range from those with a merely voyeuristic curiosity to those who identified strongly with the artist.) One analogy for the spectator's role would be that of surveillance, of having power and control over what is viewed while remaining physically uninvolved.

A resistance to this process began to emerge within the scenario of her live works. For example in one of her 'single image' performances, *Eyes Skinned*, at the ICA, London, in 1985, she took a

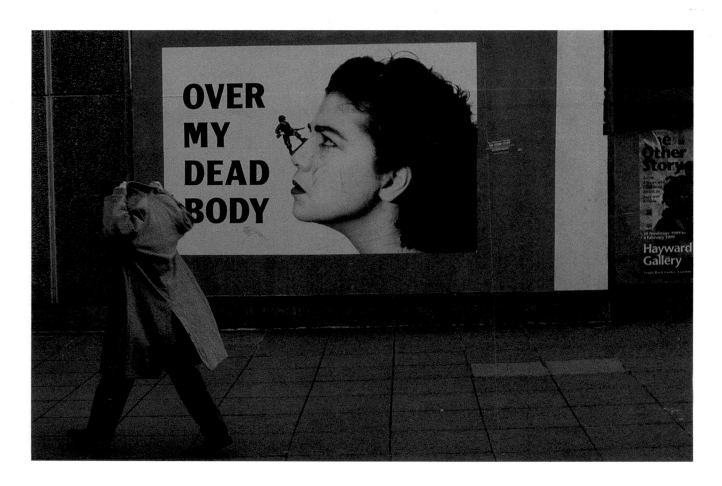

**Over My Dead Body**
1988
Black and white billboard
182 × 304 cm

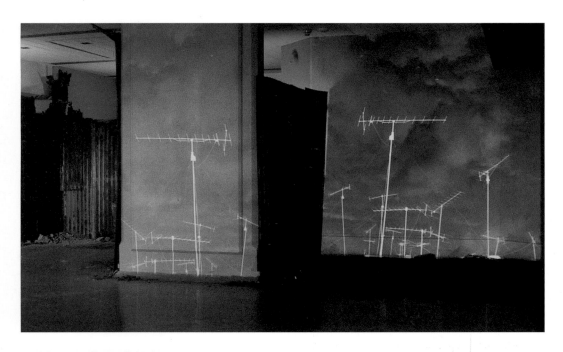

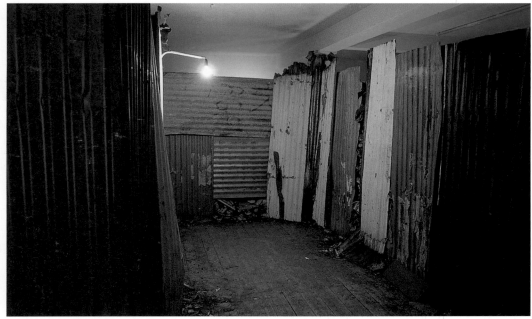

sharp knife and cut away eye-holes in the dark hood which covered her head, fiercely returning the look which had been directed at her anonymous form. *Over My Dead Body* (1988), a giant photographic poster contributed to an urban billboard project, performed the same reversal, 'staring down' the forces of the state in the form of a toy soldier, and directly implicated the body in the defiance. Another work, which becomes intriguing in retrospect as witness to this moment of transition, is *Hidden from Prying Eyes*, an installation made at the Air Gallery in London in 1987. On the one hand it was one of Hatoum's most literal efforts to build a shanty town within the metropolitan art space. She collected a large number of waste corrugated iron sheets from derelict sites and constructed a labyrinth of high screens along one side of the gallery. Behind them the sounds of busy street life and the lights of flickering TVs suggested that unseen people were present. Although the work implies a critique of Western media invasion of the Third World, it becomes a more complex metaphor of surveillance, of journalistic or anthropological intrusion, since, as spectators, *we* are excluded. The structure baffles our stare as if guarding from our sight some interior life.

Obviously, however, Hatoum was looking for more than a simple reversal or blocking of the power-filled gaze. The eye is part of the body. In withdrawing her own body as the object of the spectator's gaze, none of the physical intensity of her performance pieces was lost; nor, indeed, was the sense of an experience unfolding in time. It was transferred, instead, to the spectator's self-

**Hidden from Prying Eyes**
1987
Corrugated iron, rubble, five
monitors, slide projector, sound,
electric bulb
Installation, *top,* Leeds City Art
Gallery; *bottom,* Air Gallery,
London

awareness. Instead of passively looking at the representation of another's experience, Hatoum brought the spectator to feel that the act of seeing is inseparable from the body: our entire physical being, which we have responsibility for, which we commit in the actions we take, in which we suffer the circumstances of life. This was done by means of 'installations' – which really means a room where every aspect of space and light, material and sound, is put to use and acts as a sensitizing agent. Each of Hatoum's installations has been different and has allowed external themes, or associative references, to be brought in many subtle ways into relationship with the spectator in the 'here and now'.

The new work which came out of these changes, beginning with *The Light at the End* and leading to such major pieces as *Light Sentence* (1992), can be related to broader cultural developments. The innovations and insights of artists are paralleled by historical studies, critically examining the inheritance of a culture from both inside and outside its boundaries. Studies of 'visuality' are one subdivision which weave into the overall picture. In the writings of Michel Foucault and others, the 'rationalization of sight' represented by the European Renaissance invention (or rediscovery) of perspective, is noted not only for its liberating effects but also for its repressive implications when appropriated by the structures of power. In their analysis, the sight-lines of infinity are also the bars of our prison. One of Foucault's favourite examples was the eighteenth-century philosopher Jeremy Bentham's ideal prison, the Panopticon, a radial structure of

cells whose inmates could be monitored from one all-seeing central point. The 'eye of power' is a phrase which has passed into common usage as a result of these studies. The severance of this eye from the body as a whole was the subject of Jonathan Crary's fascinating book, *Techniques of Observation: On Vision and Modernity in the Nineteenth Century*. Crary took the camera obscura, the sixteenth-century drawing aid which projects the visible world by 'natural perspective' onto a flat screen in a darkened room, as the source and paradigm of this severance. The camera obscura posits an observer 'cut off from a public exterior world'; its effect was to 'sunder the act of seeing from the physical body of the observer, to de-corporealize vision'.[13] In his book Crary traced connections between the camera obscura and Descartes' philosophical separation of mind from body, and followed the implications up to the modern period of television and computers.

The mind/body split was something that struck Mona Hatoum forcefully on her first move from the Middle East to northern Europe. She recalls the experience in her *Kunst-Bulletin* interview of 1996. After recognizing a heightened awareness of the body in recent Western culture, and suggesting that it came as a result of the AIDS epidemic which had made us all reflect on our own vulnerability and mortality, she goes on to explain the insistence on the presence of the body in her work. She traces this to her upbringing in a culture which does not make a great separation between body and mind: 'When I first came to England it became immediately apparent to me that people were quite divorced from their bodies and very

Camera Obscura
1646

**Piet Mondrian**
Composition with Red, Yellow,
Blue and Black
1921
Oil on canvas
59.5 × 59.5 cm

**Kasimir Malevich**
Suprematism
c. 1921-27
Oil on canvas
84 × 69.5 cm

caught up in their heads, like disembodied intellects. So I was always insisting on the physical in my work ... I wanted it to be a complete experience that involves your body, your senses, your mind, your emotions, everything'.[14]

In one sense, the geometrization of art in twentieth-century abstraction represents an advanced point of the rationalization and decorporealization of vision expressed in perspective. For Moholy-Nagy for example, writing in 1945, abstraction was exciting because it cleared away 'the welter of traditional symbolism', and 'all loosely trailing connotative associations' – his very words 'welter' and 'loosely trailing' betraying the unwanted visceral body.[15] Some later developments of abstraction, such as American Minimalism, have been linked with an impersonal, industrial aesthetic and a 'rhetoric of power'.[16] On the other hand, however, it is not geometry which is really operative in the work of the great abstract artists – Mondrian or Malevich for example – but the clearing of a space for imaginative projection and reverie. The whole matter is paradoxical. Hatoum, it seems to me, has been able to work through and escape the restriction of mutually-annihilating terms. She has woven together an examination of the relationship between graphic structures and coercive power, the integration of the eye in the body, the associativeness of forms and materials, and the potential of the abstract and undefined for multiple meanings.

As she embarked on a new series of works, Hatoum was able to look in two directions. One was to look back at her early work, before the performances which created a divide between artist and audience. The other way was to look forward by translating exactly that ambiguous relationship between entrapment and freedom she had expressed through her performances to the spectator's lived experience. Appropriately, the new direction was inaugurated with a brilliant installation which played precisely on the idea of a barrier. *The Light at the End* (1989) was made originally for the Showroom, an alternative gallery in East London, an odd triangular space which narrows progressively towards its end. What was first seen visually as a delicate group of six red lines etched in the blackness (the space was really dark, much more so than appears in photographs of the work), became, as you approached, a source of uncomfortable heat, forming a barrier across the neck of the room. The lines were actually red-hot bars (heating elements). The moment of transition from optical to bodily sensation was an unforgettable experience, a kind of Zen *satori*. Light changed to heat and the visual sense was perturbed and enlarged by the sense of the body as a whole, arousing a disturbing complex of feelings. Attraction to the warmth was mixed with fear. The barrier appeared to be permeable but associated with great risk and danger. At that moment the habitual connection of the eye with detachment and distance was challenged. It became almost physically impossible simply to 'look on' in a state of neutrality, and you felt yourself responsible for your actions.

Hatoum was encouraged to look both backward and forward, too, by changes in her circumstances. In 1989 she was appointed Senior Fellow at Cardiff Institute of Higher Education,

giving her a studio for the first time, and the resources to experiment in a co-ordinated way with space and materials. Growing support also enabled her to realize ideas which had remained in notebooks since her student days. Hence the diversity of ways she approached, in the next few years, the themes we have outlined.

Several of the large-scale installations Hatoum has made since 1989 have drawn subtly on the perspectival/geometric tradition. They define and dissect space to produce an anthropomorphized, or as she has termed it 'anatomized' space. All have a striking graphic quality: the six vertical red lines in *The Light at the End*; the extremely thin wire in *Untitled* (Mario Flecha Gallery installation, 1992); the bed-springs in *Short Space* (1992); the projection of the shadows of wire-mesh lockers in *Light Sentence* (1992); the bed metaphor drawn to a limit of rationalized uniformity, an infinite structure of bars, in *Quarters* (1996). The spatial structures affect us optically and corporeally, often in contradiction and interacting with their associative meaning to make us waver constantly between a sense of beauty and anxiety.

In *Short Space*, a number of bed-springs

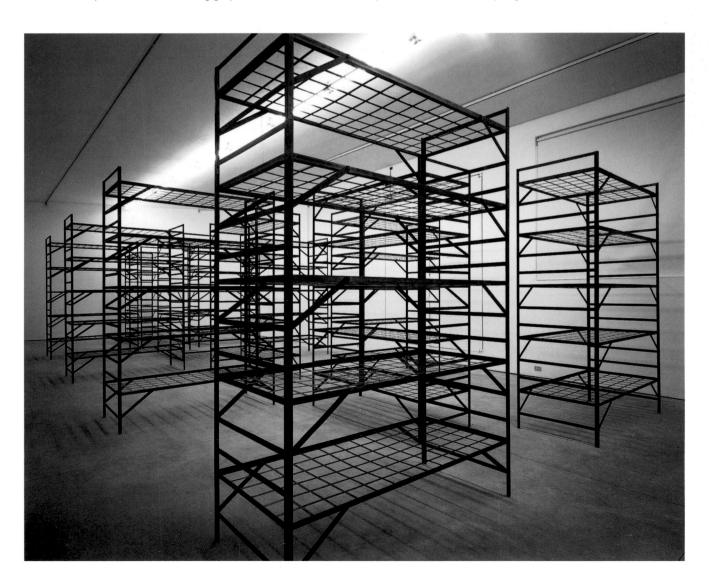

*left and following pages,*
**Quarters**
1996
Mild steel
2.75 × 517 × 12.96 m
Installation, Viafarini, Milan

**Short Space** (detail, in progress)
1992
Metal bed springs
Installation, artist's studio,
Cardiff

*opposite,* **Short Space**
1992
Metal bed springs, pulley system,
three motors, fluorescent light
180 × 362 × 215 cm
Installation, Galerie Chantal
Crousel, Paris
Collection, Musée d'art
contemporain de Montréal

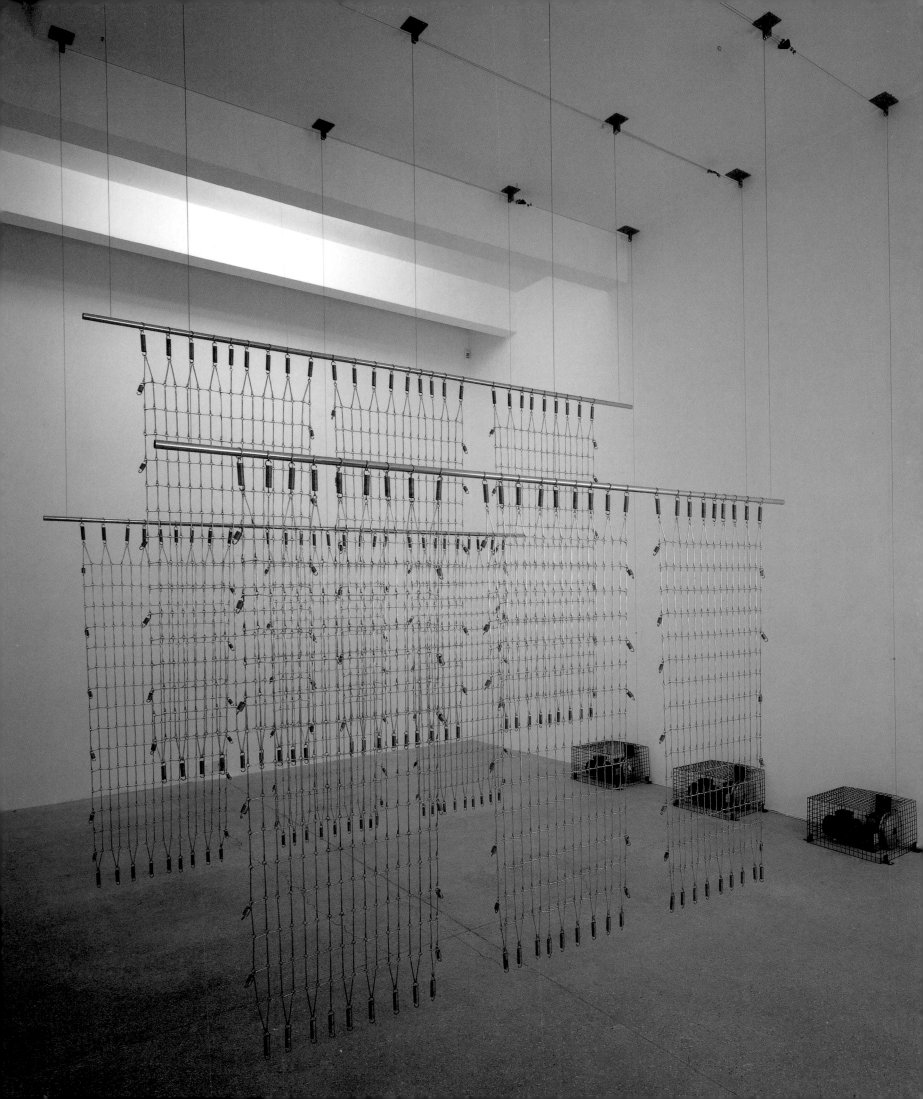

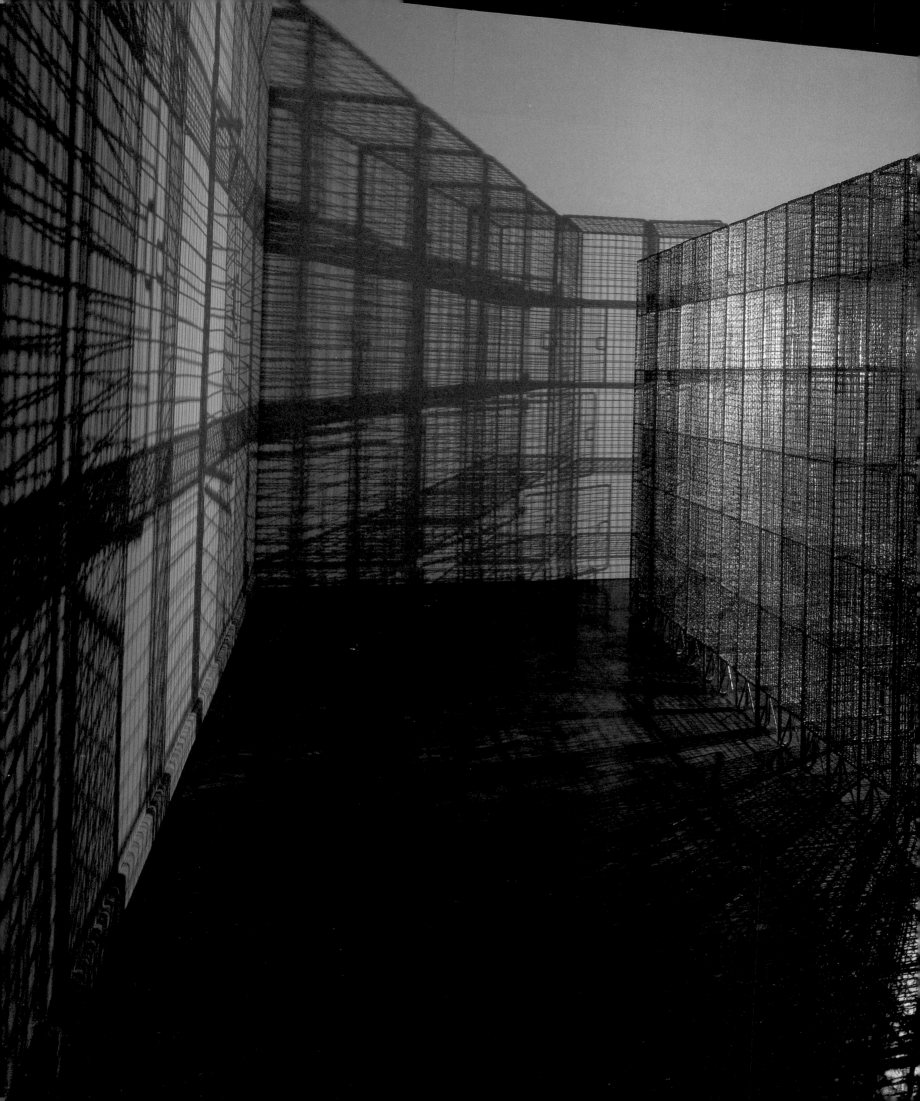

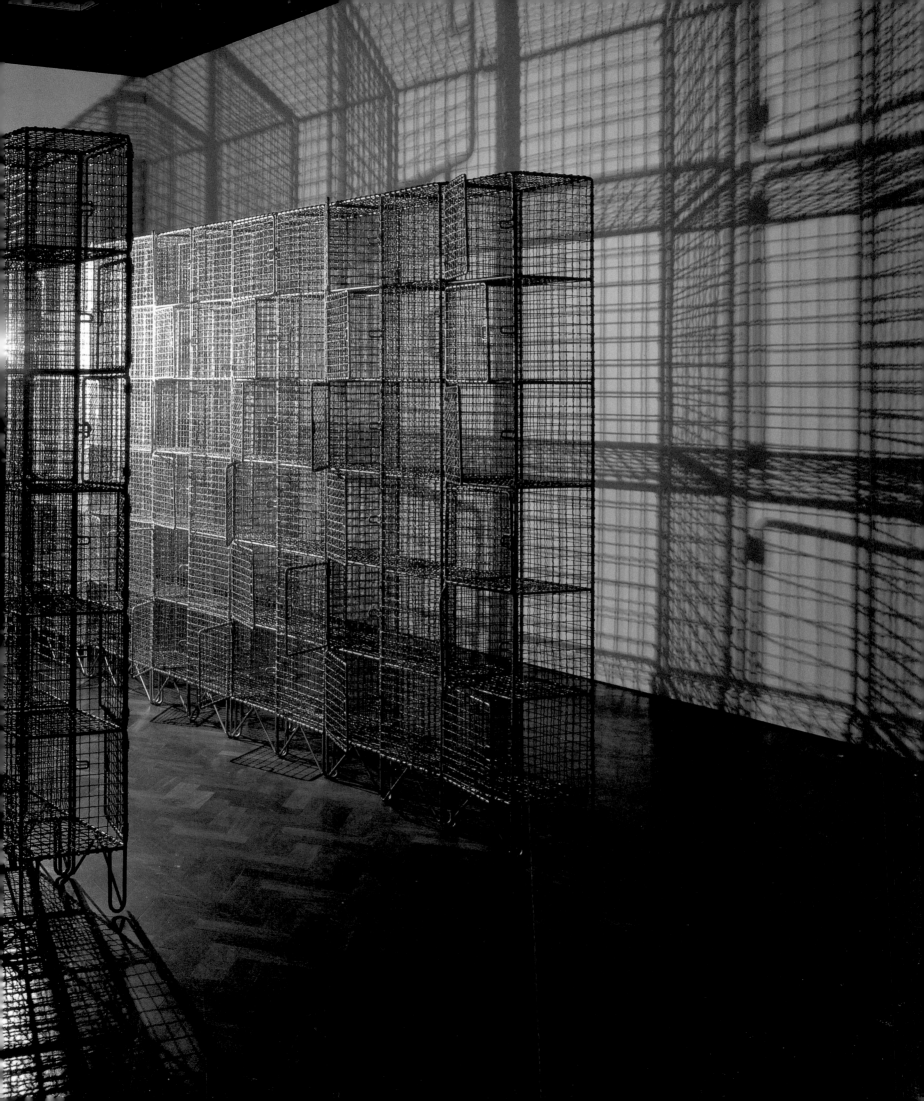

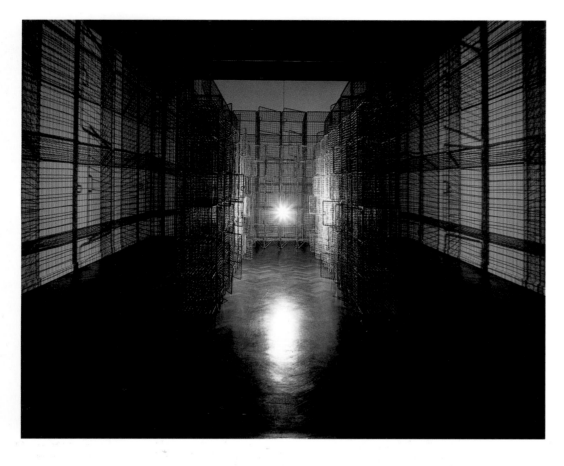

suspended from long horizontal rods move very slowly upwards and downwards. The tensioning frame has been removed from the bed, making the structures hang limply or tenderly like a body, or like a flayed skin. Banal and repulsive electrified beds used as torture-instruments, rows of beds or bodies in prison, hospital, morgue or other depersonalizing institution, rows of carcasses in butchers shops such associations come to mind by the simplest, and one must say witty, recycling of a mundane and familiar object. (Part of the wit, too, is Hatoum's neat demonstration of how she would 'anatomize' the grid structure beloved of the Minimalists.) At the same time, the bed-springs here take on a linear beauty often unnoticed in their everyday existence. In *Light Sentence*, the 'space-frame' – a feature of all these works – is made of standardized wire-mesh lockers ordered from a catalogue, and running in two parallel rows

down the centre of a large room. The single naked bulb, in all its associations of a dingy place of deprivation, moves slowly up and down by motor, throwing on the surrounding walls a liquid, rippling, cage-like tracery of extraordinary beauty.

The essence of the spectator's dilemma is confusion between the beneficent and malevolent aspects of one and the same thing: a confusion the artist could not, or did not wish to, resolve. The structure is both abstract and associative enough to work instantly on several scales, making one think of bureaucratic filing-cabinets, the cages of animal experiments, drab mass housing, the fences of internment camps, the lockers of itinerant workers. These are analogies of an oppressive kind, but there is also the opposite: a sense of psycho-physical expansion. As the light descends towards the floor, the shadows seem to carry us upwards, as if we slowly ascended a superb modern building towards the sky.

On the abstract side, the room becomes an astonishing weave of varying densities, both materially and optically. Lines are abstracted to such a degree that they become the basic co-ordinates orientating our body in space, the means of our balance, our sense of enclosure or release – a kind of summing-up, if you like, of the Foucault insight into the positive and negative aspects of the organization of space. It is a finely balanced situation where a material core becomes a huge mobile drawing, where the centre of the room is a sculptural space and the walls a screen, where we are both optically and bodily affected, all by the simplest means. In the ambiguity between the luminous associations of rational order and a dark,

chaotic flux, the artist refrains from giving fixed, immutable values to either, since each is continually being rediscovered inside the other. The capacity of the single lightbulb to work such a transformation is quite magical.

The dilemma was posed with equal elegance, though perhaps in starker terms, in the installation *Untitled* (1992). This was a response to the curious, two-level space of the small Mario Flecha Gallery (made by the conversion of the ground floor and basement of a London terraced house). The installation was so specific it could not be translated anywhere else. Steel wires, thin enough to be almost invisible, taut enough to feel dangerous, ran in parallel lines across the space, leaving visitors a small passage to negotiate their way through the rooms and up and down the stairs. Wires which ran at ankle-height and groin-height in the upper room passed through the walls and emerged at neck level in the lower, windowless basement. *Untitled* enhanced the empty white space with great refinement, at the same time dissecting it into areas where one dare not tread. In a sense, *Untitled* could not be contemplated as an art object, only lived as a double-edged experience.

Two further works of this period approach

*above*, **Proposal for '+ or -',**
**Arnolfini, Bristol**
1993
Ink on paper
21 × 29.5 cm

*left*, **+ or -**
1993
Glass, steel, magnets, iron filings
2.44 × 12.07 × 9.05 m
Installation, Arnolfini Gallery,
Bristol

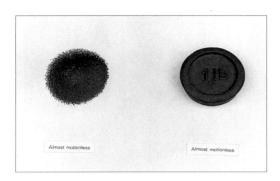

**Almost Motionless**
1979
Iron filings, magnet, cast metal
weight, turntable
Dimensions variable

the same problematic in completely different ways: *Socle du Monde* (1991) and *Corps étranger* (1994). *Socle du Monde* ('World Pedestal') was conceived as a homage to Piero Manzoni's eponymous work made in 1961, an upside-down pedestal supporting the world, and an extension of Manzoni's ironic proposition that anything placed on a pedestal becomes an art work. It also looked back to another 'machine' of Hatoum's early days as an artist, a flat surface on which a circle of iron filings in continuous motion, activated by a magnet mounted underneath on a 33 rpm turntable, was placed next to a cast-iron, one-pound weight. The legend 'Almost Motionless' was placed under both, a paradoxical demonstration of the dynamism of matter. The entire surface of the cube of *Socle du Monde* was covered in iron filings adhering to hidden magnets in dark, entrail-like contortions. Hatoum partly intended a reference

to the dangerous spread of obscurantist ideas throughout the world. Yet this vast cube of dust can also be read as a 'corporealization' of the modernist tradition, putting the body back into the immaculate minimalist cube. To take a longer and perhaps more fanciful view, it might also be seen as a subversion of the ideal 'column of the world', the centre of converging lines in some Renaissance perspectival drawings, to become the more ancient 'navel of the world' represented by certain pre-Christian carved stones.

The 'debasement' implied continues in *Corps étranger* ('Foreign Body'), whose whole scenario brings the spectators to stare down, down, into a tunnel of churning viscera unfolding at their feet and threatening to swallow them. Hatoum had had the idea for this work fourteen years earlier, but then it was technically and financially impossible to realize. At that time she had been making video

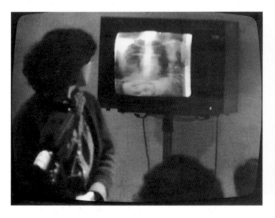
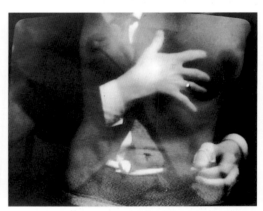
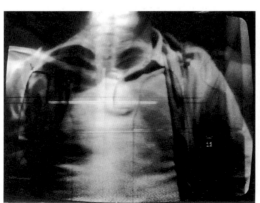
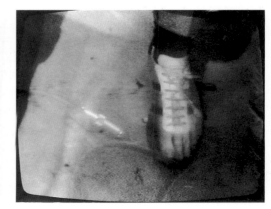

following pages, **Corps étranger**
1994
Video installation with
cylindrical wooden structure,
video projector, video player,
amplifier, four speakers
350 × 300 × 300 cm
Collection, Musée national d'art
moderne, Centre Georges
Pompidou, Paris

experiments exploring the relationship of eye and body, either using her own body, or in an interactive format with the audience. For example, *Don't Smile, You're on Camera*, carried out at Battersea Arts Centre, London, in 1980, involved the audience sitting in rows facing a large monitor. The artist moved about the rows closely scanning the people, and at the end, herself, with a live video camera. Her images of their bodies were mixed with images taken by another camera out of sight, in which two people scanned one another's naked bodies. Members of the audience would see their clothed body give way to a naked breast, foot or crotch (or even an X-rayed chest that was being filmed behind the scenes from a photograph). This piece played on a range of responses from the entertaining to the unsettling, from showing a naked foot within a shoe, for example, to mixing male and female bodies together, conflating genders. There was an underlying eerie feeling in the way the camera was able to materialize a fantasy of seeing through the body.

Her early project to base a work on a filmic exploration of the interior of her own body now became a possibility with the invitation to exhibit at the Centre Pompidou in Paris in 1994, and the work was made for that event. With the help of medical staff, two recording systems were used: endoscopy/coloscopy for visually exploring both the outer surface of her body and penetrating into each orifice in turn, and echography for the sound of breathing and heartbeat. A crucial decision was to orientate the projection on the floor, giving the inner passages of the body a strong analogy with the earth, like the shafts of wells which plunge

into the depths.

The metaphoric title works in many directions: 'foreign body' could be the invasive camera like a virus; it could be an allusion to the medical establishment's depersonalization of the patient; to male exploitation of the female body; to the inside of the body as foreign to all of us, and so on. Hatoum herself commented on the 'wonderful paradox between woman portrayed as victim and woman as devouring vagina'.[17] With all these readings, however, the body is presented at such close quarters that it becomes genderless and classless – anybody. The experience of this work seems to mix the emotively subjective and the objectively documentary in an almost hallucinatory way for each spectator, as the French writer Yves Abrioux keenly observed:

*'As images, allusions and references tumble into consciousness, I come to realize that the foreign body to which the title of the work refers is ultimately my own – its impulses and pleasures more stringently and surprisingly programmed by the mechanisms of civilization than even the putative lucidity of this post-Freudian era had led me to believe.'*[18]

### The 'Exstasy of Communication'[19]
The subtle dialectic with which Mona Hatoum was now able to interconnect the eye, the body, place, the notion of the real and her physical presence in dialogue with that of the passer-by or spectator, is strikingly apparent in two works from 1995. Both involve her hair, but they are as different as they are similar in their poetry and wit.

*Pull* was set up in Munich as a three-day

**Don't Smile, You're on Camera**
1980
40-min. performance with two
live video cameras, three
monitors, one dissolve unit, X-ray
images, technical assistant, two
live models
Battersea Arts Centre, London

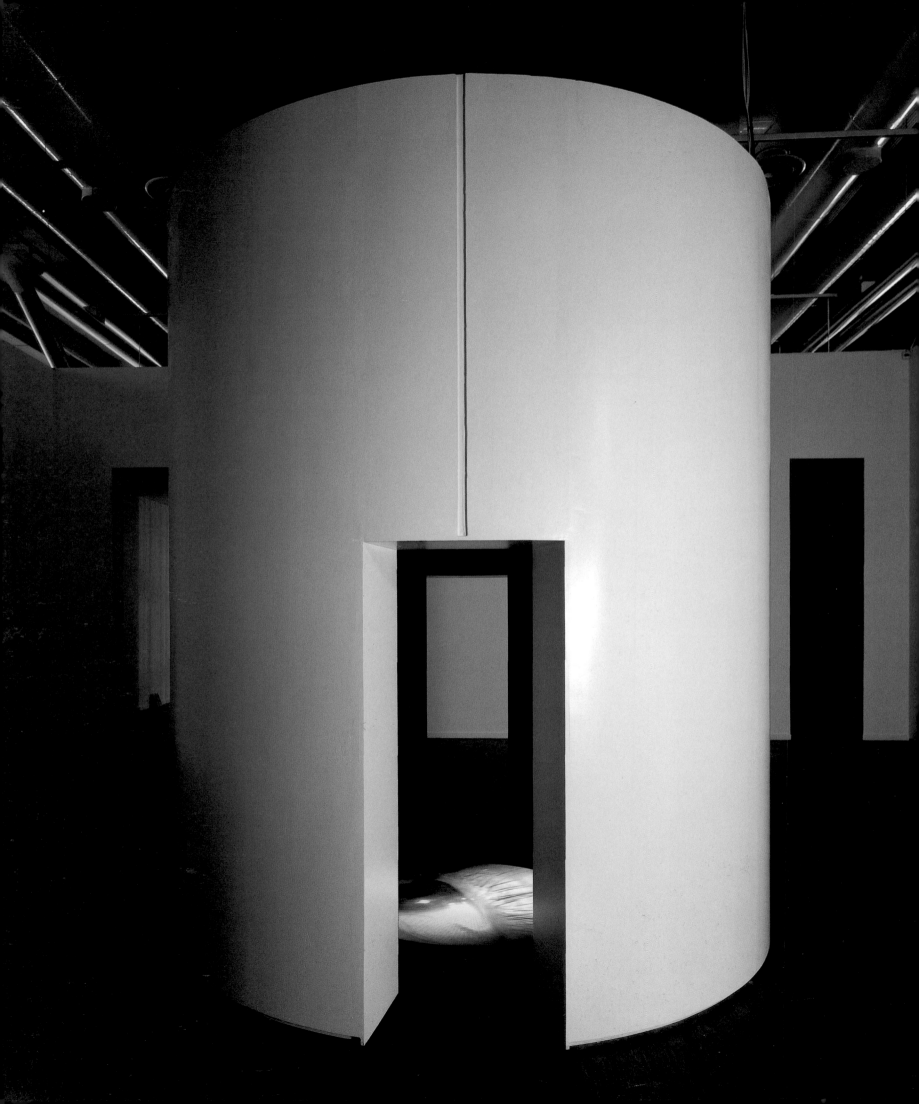

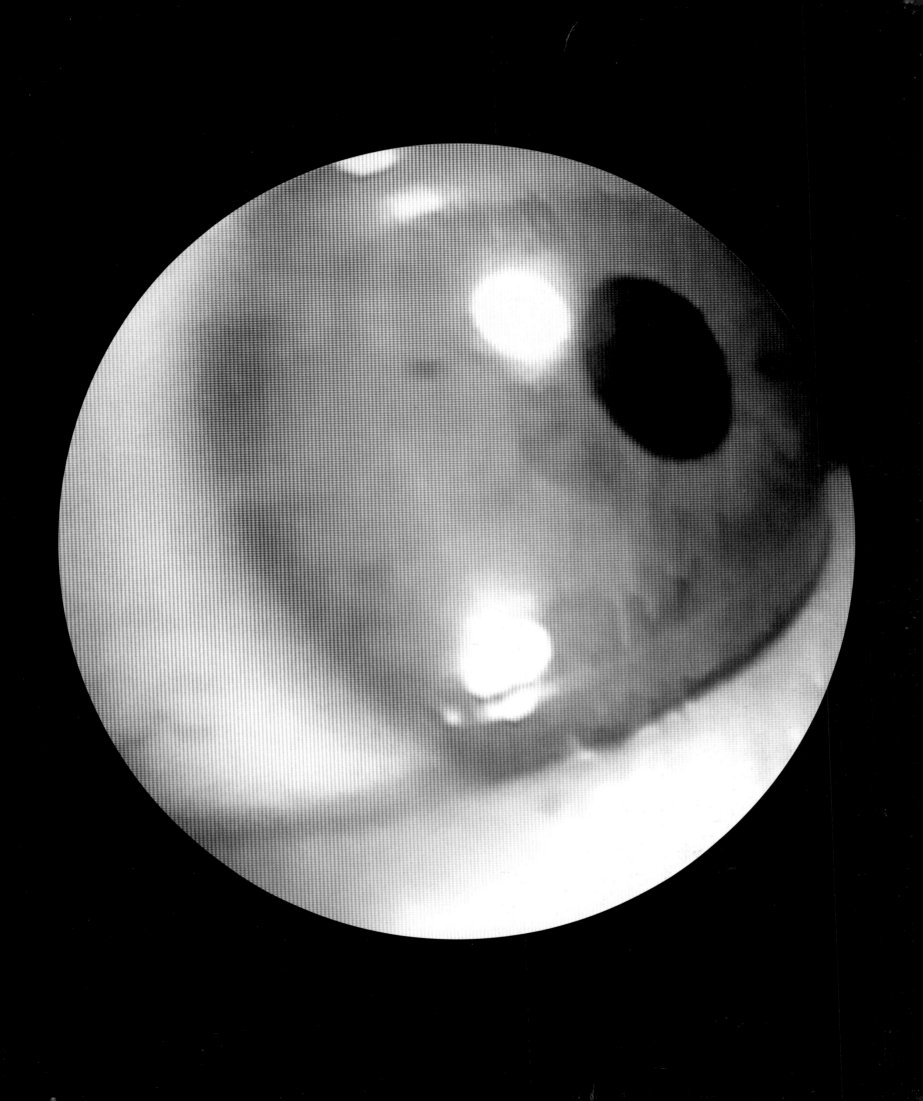

Hair Necklace
1995
Hairballs on mannequin
27 × 21 × 16 cm
Installation, Cartier shop,
Bordeaux

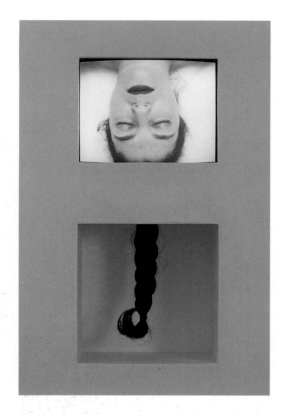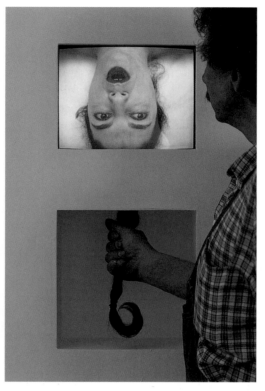

Pull
1995
2-hour video performance,
Künstlerwerkstatt, Munich

event. The spectator was invited to pull a hank of hair hanging down in a specially constructed niche below a TV monitor. The artist's face on the screen registered a feeling of pain or discomfort. When I saw slides of this work I thought the image on the screen was a pre-recorded tape. I had no idea Hatoum was physically present behind the wall, that it was her actual hair hanging down (with an extra length platted in), and a real sensation registering on her face. So conditioned was I to the distance of the TV image, the media image, its lack of a direct connection with *me*, that my reaction seemed involuntary. The presumed

process of this work would be the spectator's gradual realization that there is a direct connection between his or her action, and the person whose electronic version appears before them. At a certain moment the spectacle suddenly ceases to be a spectacle. Him or her! The response calls forth one's intimate psychology and Hatoum noticed that, on the whole, men yanked the hair without compunction, whereas women were more gentle, and even reluctant, presumably through self-identification.

The event was brilliantly contrived to respect the art gallery scenario – the cool, neutral space without the distraction of the external world, where the public encounters the work of the artist according to certain protocols and conventions – and yet to introduce there a crucial contemporary dilemma: our confusion between the real and the representation. Comfortable notions of distance and privileged observation are suddenly upset. In almost laboratory conditions, the passive encounters the active in an intimate denouement.

*Recollection*, the second work I want to consider, exchanges a neutral space for one rich in associations. This installation was the result of a commission by the Belgian Kanaal Foundation, and took place in the main meeting hall of the Beguinage, a women's community dating from the Middle Ages, in the centre of Kortrijk. If you go there, you enter a town within a town, passing from the modern city into another space, cobbled, gardened, very quiet and still. By the time you have climbed the stone steps into the upper meeting hall your mind is already full of the

presence of the past: a state of *recollection*. But the title also refers to the material defining this installation, the artist's hair, collected by her over a six-year period from combs, brushes and bath plugs. At first the room looks just empty, apart from a small table at the far end. After a while you notice that tiny hair balls are scattered over the floor. As you walk around they stir. As you move around your face is very lightly brushed by single strands of hair hanging from the beams.

There is something fascinating about the origins of this work: keeping strands of one's fallen hair over a period of six years, rolled into balls and stored in shoe-boxes without any particular purpose. Then there is the marrying the material, at a certain point, in certain circumstances, with a space. It would be hard to imagine a more fragile manifestation of a human presence in a space, or a more startling contrast to the often bombastic colonization of space by artists' installations; or an occasion where eyesight was more delicately – and disturbingly – interfered with by the sense of touch, triggered by the awareness in space of another, absent, person

represented, perversely, by the presence of what would normally be got rid of in disgust, precisely in order to maintain the body's usual presentability. These were some of the contradictory sensations.

I wondered why Mona Hatoum had kept this particular, superfluous part of her body. Besides the rich symbolism of hair, there could be a further reason, and this is the graphic or linear quality of hair. The invitation announcing the Beguinage exhibition was illustrated with a single pubic hair. In the middle of the white card it looked almost funny, refusing to lie straight, containing its own energy and tensility. It is also of course a ready-made graphic line. In the installation the hair appeared in three linear forms: in small and delicate balls, in hanging threads (these could only be made long enough by tying individual hairs together) and as a piece of weaving. In a peripheral relation to all the rest, since it was clipped on the edge of the old table – the only other object in the room – was a small, roughly made wooden loom on which strands of the artist's hair had been woven to form a kind of fabric.

I didn't give the loom much importance at first, but then came back to reconsider it. As Desa Philippi has said, this room creates a tension – or rather she calls it a 'material continuity' – between the opposites of chaos and order, nature and culture.[20] This is epitomized in the little loom where the cloud of wild and unruly hair is drawn into the extreme ordered construct of the woven fabric. Weaving, at the basis of human culture, is a powerful figure for the contradiction between order and chaos: it embodies the meeting of two threads, or lines, at right angles, like the figure of

**Van Gogh's Back**
1995
Colour photograph
50 × 38 cm
Collection, Tate Gallery, London

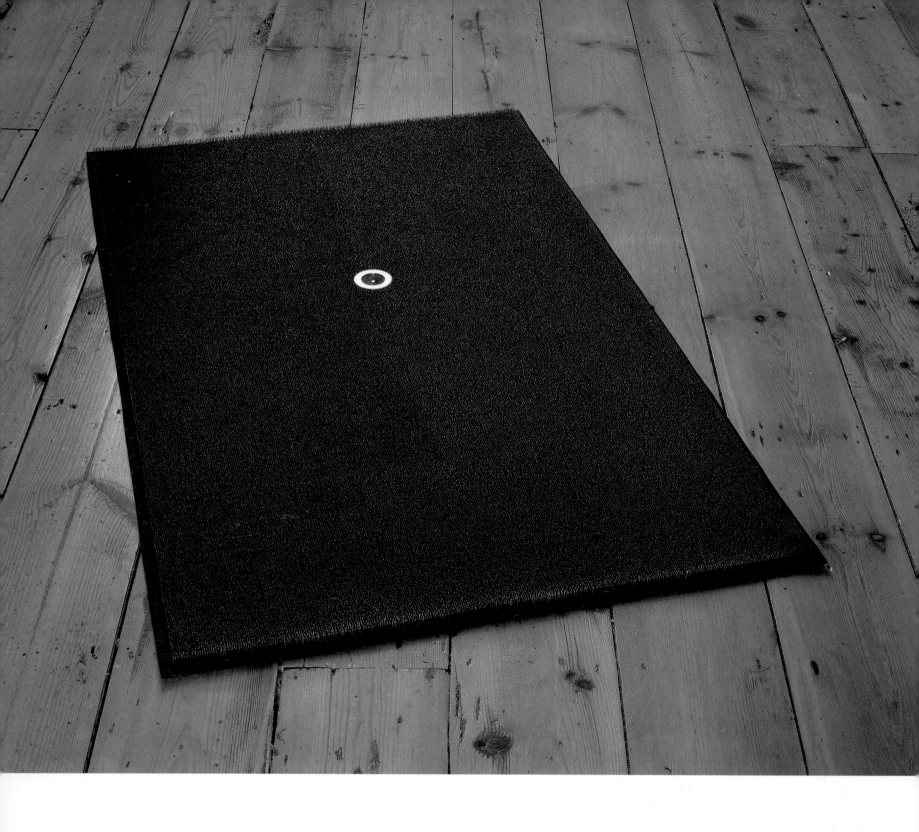

the cross and the intersecting of opposed forces. One can trace this linear weave structure, or grid structure, back into many of Mona Hatoum's works – to *Short Space* for example, and *Light Sentence*, where it becomes the ambiguous agent of both oppression and freedom, of both rigidity and fluidity, of aggression and peace. It conflates references to furniture – beds, chairs, cots, baskets, mats – with evocations of architectural space, further multiplying meanings. It is interesting to note that in Muslim cultures the 'absolute' quality of a woven pattern was actually avoided as too perfect, and weavers deliberately entered mistakes in their carpets so as not to compete with God.

The same year that she exhibited the home-made loom as part of *Recollection*, Hatoum came to devise three 'carpets' of her own. They were not woven, and probably owe as much to her ironic, anti-heroic retake on the ground-hugging sculpture of such artists as Carl Andre and Richard Long as they do to her cultural background;

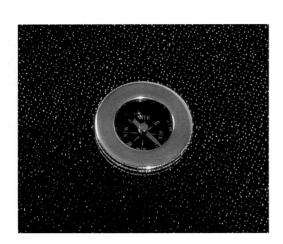

nevertheless one was conceived in typically provocative and ambiguous fashion for an international art event located in a specific cultural context, the 1995 Istanbul Biennial. *Prayer Mat* (1995) consists of thousands of nickel-plated brass pins standing upright on a canvas base. Near the centre there is a compass, like a certain brand of kitschy prayer mat available in Muslim shops in Brick Lane in East London, which help orientate the worshipper towards Mecca. We might take this simply as a satire on religiosity, expressed as an attracting/repelling object, were it not also a poetic, imagination-stretching invention that re-circles on itself to evoke the cosmic wonder of a starry sky.

More ethereal still, as if a creation of the light falling on it, is *Marbles Carpet* (1995). A vast expanse of clear glass marbles covers the entire floor of the gallery, leaving only a narrow band of space around the edges for spectators. What the series of carpets has in common, as Michael Archer noted, is that 'they make uncertain the ground on which they lie. The floor, or, more fundamentally, the earth upon which the spectator stands, that basis, above all others, upon which not only bodily presence, but also attitudes and beliefs rest, is made uncertain'.[21]

### Works in Progress

Works from 1996 – an incredibly active year for Hatoum – have shown the artist reacting with great flexibility to different contexts, audiences and commissions. None were pre-planned and each response evolved first and foremost through material form.

**Marbles Carpet** (in progress)
1995

**Marbles Carpet**
1995
Glass marbles
1.5 × 340 × 1100 cm
Installation, The British School
at Rome

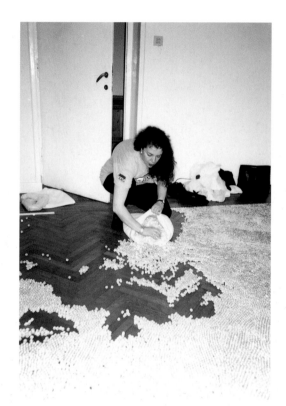

For example, invited in April 1996 to exhibit in a small gallery in the largely Arab part of East Jerusalem, she at first considered an aggressive, body-menacing installation of walls of nails. But this seemed wrong: why remind people of restrictions and threats they experience every day? Her return to the Middle East had been in part an immensely pleasurable re-immersion in a familiar sensory universe (so many sights, sounds and smells remembered from childhood). Something softer, arising from specific and shared memories, eventually became the basis for the works she made and exhibited.

*Present Tense* (1996), the piece that occupied the central part of the floor of the old, somewhat dilapidated abandoned shop that formed the gallery, consisted of a grid formation of blocks of white soap. Palestinian families traditionally made this soap, derived from olive oil, themselves; Hatoum obtained hers from a small factory in Nablus still using the old methods which are based on a form of manual mass production. The entire surface of the square of soap was covered in a complex pattern made by pricking little holes with a nail and filling each with a red bead. What seemed like an abstract drawing turned out to be the map of the Oslo Peace Agreement of 1993, the first phase of a process by which Israel would give back to Palestinian Sovereignty certain separated and scattered areas of the country. The beauty of the countless amoeba-like islands belied the outrage represented by the map, a process of divide and rule taken to lunatic lengths.

Smaller objects were shown at the same time in the gallery windows. Individual blocks of Nablus soap with pins stuck in them like tiny explosive mines, repelled the natural desire to touch or smell. A large perforated serving spoon from the kitchen called *No Way*, its holes blocked up by screws and bolts; an object, again, half-way between a metaphor of helpless immobility and an active weapon. A Palestinian passer-by delighted Hatoum by reacting immediately and positively to *Present Tense*, affectionately smelling the soap and saying he could imagine the dissolving of the soap would be the dissolving of all borders and barriers ...

'Every force evolves a form' – strangely

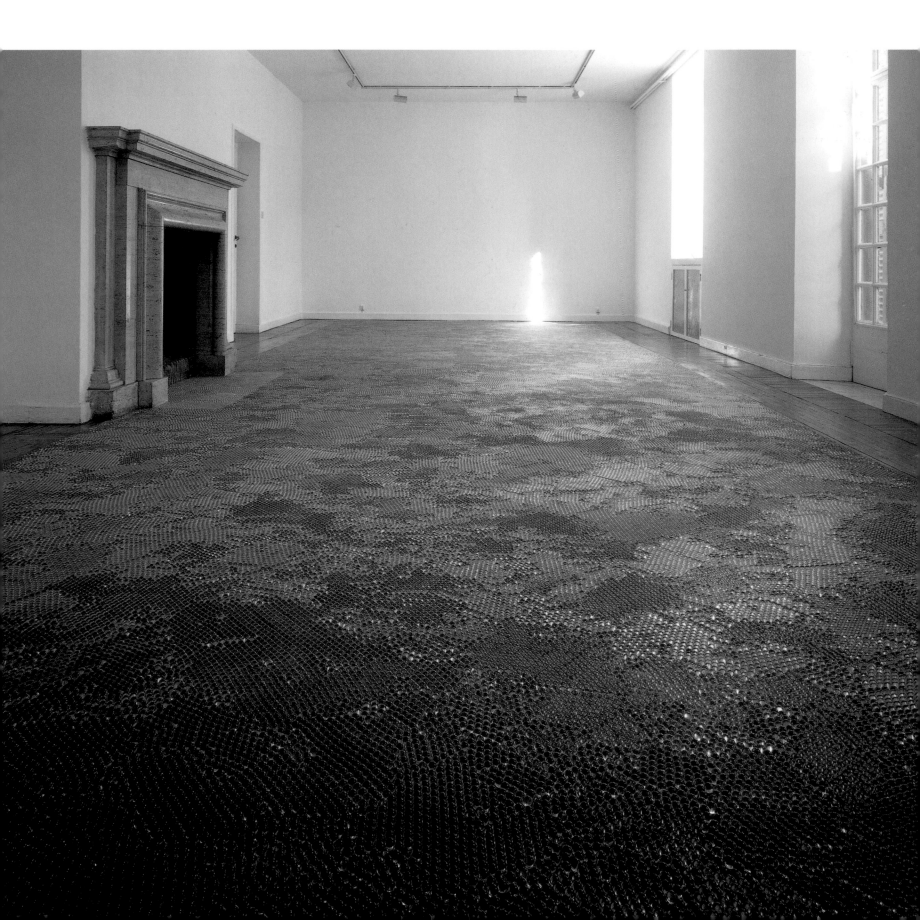

**First Step**
1996
Wooden cot, steel mesh, icing
sugar
94.5 × 106 × 60 cm

enough these words do not come from Hatoum herself, nor from a theoretician of aesthetics, but from Mother Ann Lee (1736–84), the founder of the Shaker sect in America. Hatoum spent the month of July, 1996, as one of several artists in residence at the Shaker community of Sabbathday Lake, Maine. This settlement is now reduced to only eight members. She had long admired the mixture of formal simplicity and technical inventiveness of Shaker furniture and utensils. The Shakers constructed their own peaceful way of life in which an appropriate tool was intended to give ease and dignity to each activity. She also felt drawn to communities set aside from the social mainstream (the Beguinage in Belgium had aroused similar feelings). It was enough to absorb

the atmosphere and share the activities. Interestingly, in several of the objects she made she used a method of imprintation: a cot, with an impression of its springs dusted on the floor with icing sugar *First Step* (1996), and a number of graphic works made by pressing a form of waxed paper into colanders, which was then flattened out to reveal every hole, crease and stress. Pasta from the kitchen was used to make small tokens of weaving or knitting.

After leaving Sabbathday Lake she went immediately to San Francisco, where a two-month residency at the Capp Street Project demanded a completely different response. From a small rural community, using many of the same implements for two hundred years, based on the spirituality of

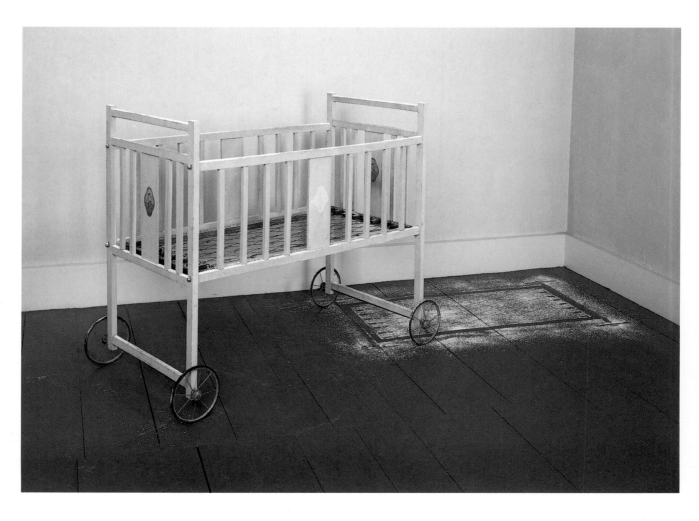

**Work from the Shaker Residency**
1996
*l. to r.,* pasta, glass plate, ø 24 cm;
pasta, l. 13 cm; pasta, plastic
knitting needles, l. 18 cm

**Grater**
1996
Japanese wax paper
27 × 40 cm
Collection, Museum of Modern
Art, New York

**Large Shaker Colander**
1996
Japanese waxpaper
54.5 × 71.5 cm
Collection, Philadelphia Museum
of Art

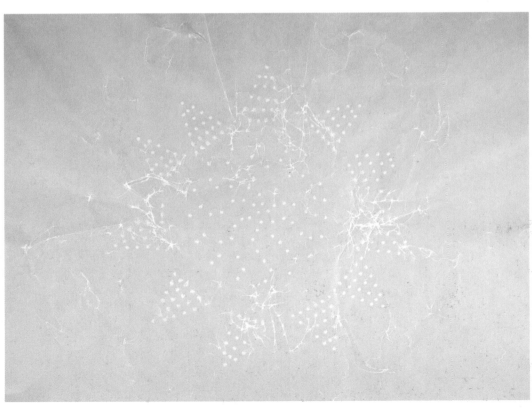

**Work from the Shaker
Residency**
1996
Petroleum jelly on window
ø 21 cm
Sabbathday Lake Shaker
Community, Maine

domesticity, she moved to a large urban warehouse integrated into the international art circuit. The space was dominated by four massive wooden columns, and Hatoum decided to use them to create a monumental, imposing work. The overall framework would be rigid and regimented; a human element, a sense of tenderness rebellion would be discovered inside. *Current Disturbance* (1996) began in the attempt to see if a sound could be made from the waxing and waning current in a lightbulb. Early experiments at the Slade using incongruous objects to conduct electricity to a lightbulb also come to mind. Eventually she created a cubic structure of 228 cages, each with a single bulb lying in it, controlled by a computer which fed the fluctuating current, and its accompanying amplified sound, to run erratically through the system.

'In what appears to be a random fashion, the lightbulbs fade on and off starting with just the glow of the filament, sometimes getting very bright before shutting off, sometimes holding some level of intensity. The sound of the current flowing into the lightbulbs is at times a crackling, sizzling sound, at times a humming. An image that comes to mind is one of a malfunctioning nerve centre where some of the synapses are misfiring. Hatoum has literally disturbed the current, and it is that disturbance that generates the sight and sound.'[22]

In perpetual conflict between being a monolith projecting its own power, and a network in whose interstices the unexpected and spontaneous can happen, *Current Disturbance* again offers contradiction as its sensitizing and illuminating method.

Something that Michael Archer wrote of Hatoum's earlier and more modest *Untitled* installation (Mario Flecha Gallery) could apply equally well to many other works of hers, including this latest one.

'The enormous aggressive potential of [the] installation was constrained by its extraordinary visual delicacy ... With the simplest means, Hatoum symbolically threatened the symbols of oppressive power through an exposure of individual fragility.'[23]

Archer's description evokes the same paradoxical relationship of opposites I have traced throughout Mona Hatoum's work over the past

**Work from the Shaker Residency**
1996
Japanese wax paper
ø 4 x 5.5 cm

*following pages,*
**Current Disturbance**
1996
Wood, wire mesh, light bulbs,
computerized dimmer switch,
amplifier, four speakers
279 × 550.5 × 504 cm
Installation, Capp Street Project,
San Francisco

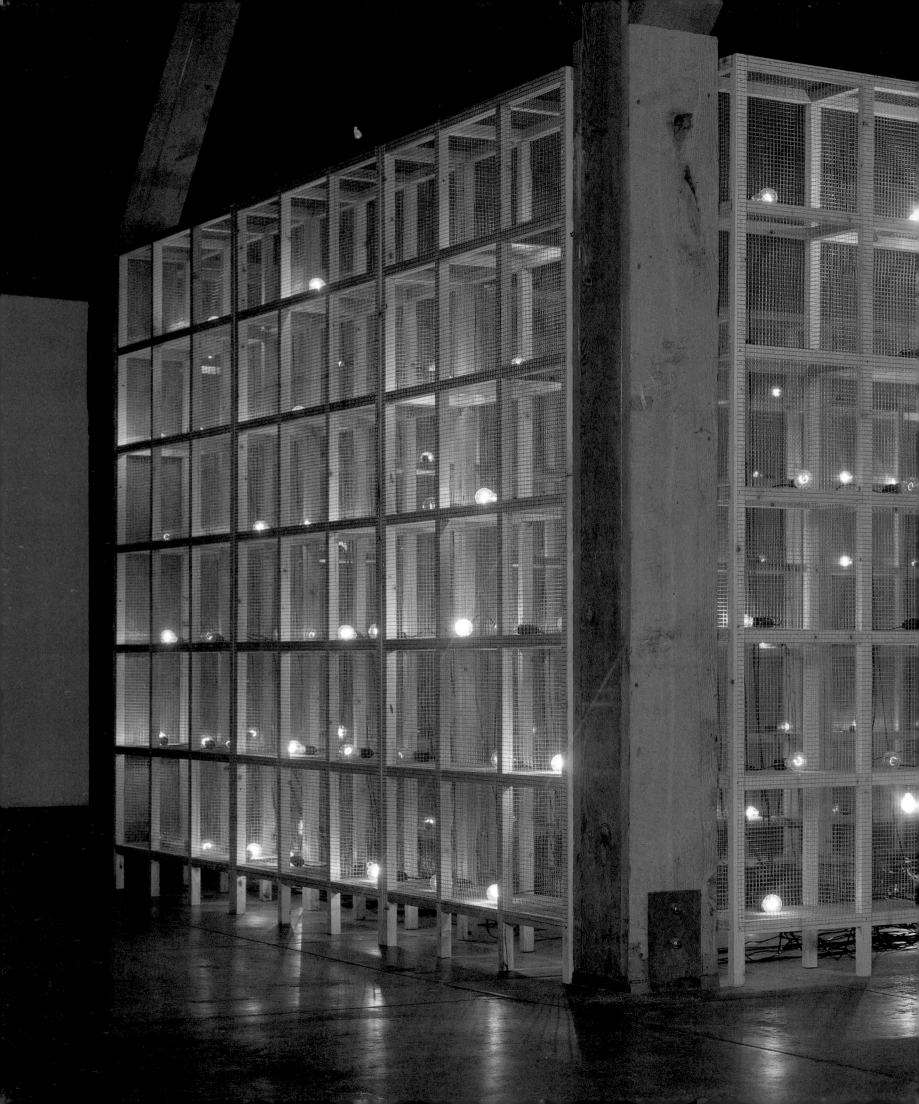

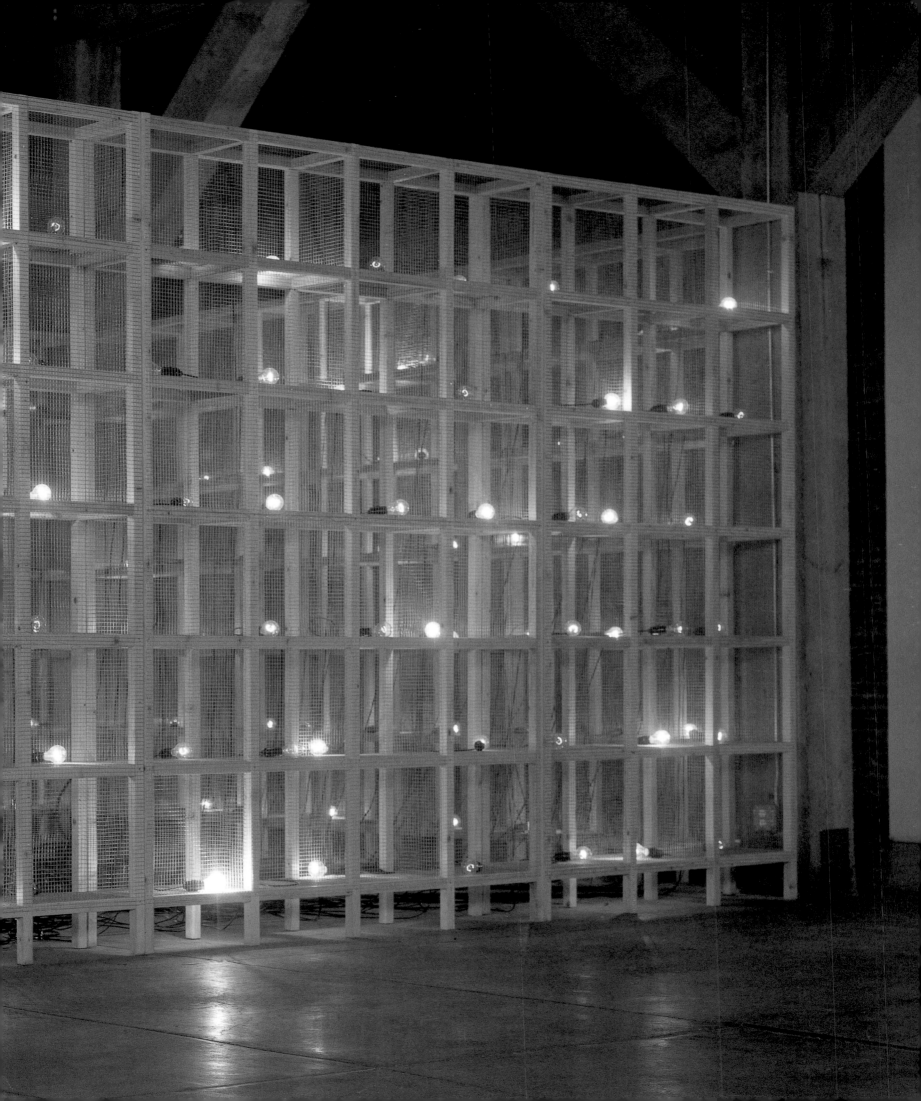

fifteen years, and to which she has herself frequently referred. This seems the best criterion for placing her work in the context of contemporary art as a whole: truer and more reliable than groupings based on packageable style ('neo-Minimalism', for example), on media or technique (video, installation) and least of all on nationality. I think, rather, that Mona Hatoum is part of a group – a 'virtual' rather than an actual group – of artists and thinkers, multinational, multicultural, who question the barriers which keep us divided and enclosed, whether those barriers are described as physical, mental, ethnic, cultural, sexual, religious or economic. Instead, she proposes plural entities, reciprocal relations, multiple selves. We can no longer exist by trying to annihilate the 'other'.

The field of art has its own particular versions of the interpenetration of opposites. One concerns the barrier between artist and spectator – a binary relationship in the past where a unique, expressive artist is set against a passive, merely receptive spectator. Another is the contradiction between art's engagement with urgent and topical social issues, and its material ambiguity, its wordlessness, its space of reverie and not-yet-defined meanings. Hatoum has worked across both barriers. Beyond simply pointing out the contradictory nature of experience, this is the great value of her work's ambivalence. It can be both critical and affirmative at the same time, a way of keeping a liberating and hopeful perspective alive, after realizing that utopian proposals of the past have always foundered by trying to exclude part of experience.

**You Are Still Here**
1994
Etched mirrored glass, metal
fixtures
0.5 × 38 × 29 cm

1   The phrase is Susan Hiller's, 'Interview with Paul Buck', *Centerfold*, Toronto, November, 1979

2   Mona Hatoum, quoted in Laurel Berger, 'In Between, Outside and in the Margins', *Art NEWS*, New York, September, 1994, p.149

3   Hatoum's proposal, ironically written as if an extract from a book called *Surviving in the 90s*, was a contribution to 'Do It', an anthology exhibition organized by Hans-Ulrich Obrist. (Republished in this volume, p. 121.) Out of the art context, the proposal was taken seriously and the Icelandic Electricity Inspection Manager issued a strongly worded warning. As a result, the exhibition catalogue was withdrawn and re-printed without Hatoum's page. The Director of the Reykjavik Municipal Art Museum, Gunnar B. Kvaran, whose institution sponsored the event, together with the *Morgunbladid* newspaper and *Dagsljós* TV magazine, published an apology. Mr. Kvaran, to whom I am grateful for this information, pointed out to me that electrical installation and equipment is surrounded by very strict surveillance in Iceland, and it was never possible to discuss the matter in artistic terms.

4   Mona Hatoum in conversation with the author, November, 1996

5   Yuko Hasegawa, *De-Genderism détruire dit-elle/il*, Setagaya Art Museum, Tokyo, 1997

6   Sara Diamond, 'An Interview with Mona Hatoum', *Fuse*, Toronto, April, 1987, p.49. Republished in this volume, pp. 124-33.

7   Ibid, p.50

8   See Nelly Richard, 'Margins and Institutions: Art in Chile since 1973', *Art & Text*, Melbourne, Australia, May-July, 1986

9   Geoff Pavere, 'Collision in the Capital', *Fuse*, Toronto, Summer, 1985; p.49

10  Desa Philippi, 'Mona Hatoum: The Witness Beside Herself', *Parachute*, Montreal, no 58, April, 1990, p.12

11  Claudia Spinelli, 'Interview with Mona Hatoum', *Kunst-Bulletin*, Zurich, September. Republished in this volume pp. 134-43.

12  Desa Philippi, op. cit., p.14

13  Jonathan Crary, *Techniques of Observation: On Vision and Modernity in the Nineteenth Century*, MIT Press, London, 1990, p. 39

14  Claudia Spinelli, op. cit.

15  Lazlo Moholy-Nagy, 'In Defense of Abstract Art', 1945, *Moholy-Nagy* ed. Richard Kostelanetz, Allen Lane, Penguin Press, London, 1971, p. 44

16  Anna C. Chave, 'Minimalism and the Rhetoric of Power', *Arts Magazine*, New York, January 1990, p. 44-63

17  Mona Hatoum, quoted in Laurel Berger, op.cit., p. 148

18  Yves Abrioux, 'Mona Hatoum at the Pompidou', *Untitled*, London, 1994, p. 5

19  Jean Baudrillard, 'Exstasy of Communication', *Postmodern Culture*, ed. Hal Foster, Pluto Press, London, 1986

20  Desa Philippi, 'Mona Hatoum: Some Any No Every Body', *Inside the Visible*, ed. M. Catherine de Zegher, MIT Press, London, 1996, p.369

21  Michael Archer, *Mona Hatoum*, The British School at Rome, 1996

22  Mary Ceruti, *Mona Hatoum: Current Disturbance*, Capp Street Project, San Francisco, 1996

23  Michael Archer, 'Mona Hatoum: Mario Flecha', *Artforum*, New York, December 1992, p. 107-08

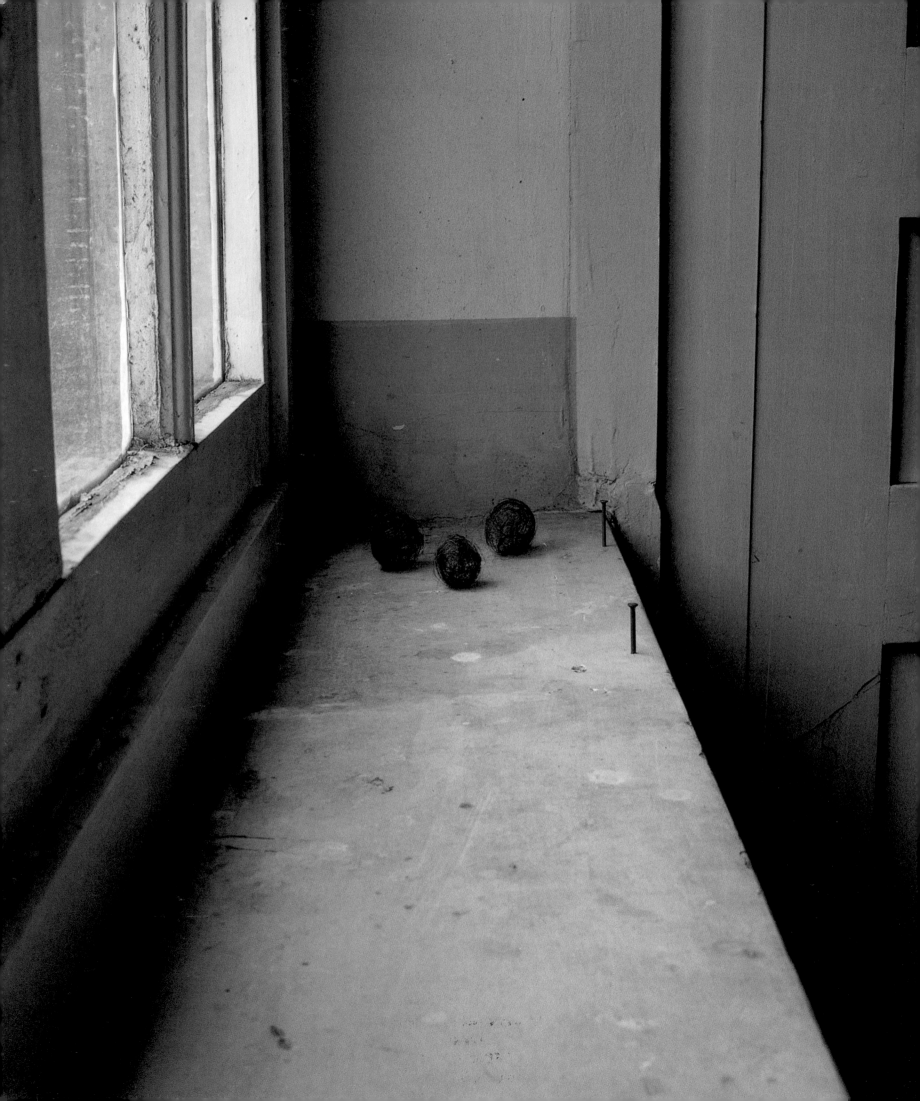

# Contents

*When traced back to their source, displacements of feeling reveal themselves as based on early childhood events when the loser was himself 'lost', that is, felt deserted, rejected, alone, and experienced in full force as his own all the painful emotions which he later ascribes to the objects lost by him.*

Anna Freud [1]

**Recollection**
1995
Hair balls, strands of hair hung
from the ceiling, wooden loom
with woven hair, table
Dimensions variable
Installation, Beguinage St.
Elizabeth, Kortrijk, Belgium
Collection, De Vleeshal,
Middelburg, the Netherlands

**Recollection** (in progress)
1995

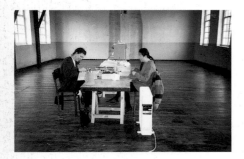

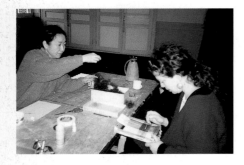

'I'm sure I cleaned this space just a while ago, and now, in no time at all, it's full of cobwebs!?' wondered the woman taking care of the large room. The room can be found at the top of a steep flight of wooden stairs, on the second floor of an eighteenth-century building; it is the temporary exhibition space of the Kanaal Art Foundation at the Beguinage Saint-Elizabeth in Kortrijk, Belgium.[2] The woman is the first person to enter the space where Mona Hatoum has worked steadily for a full week, and did not know what the artist would install. To realize her work Hatoum has used the most fragile of materials: her own hair, collected from bathtub drains, combs and brushes over a six-year period. Armed with patience, she has delicately knotted single hairs into long strands and hung them loosely from the massive ceiling beams of the beguines' ancient assembly room. She has also carefully rolled some of the curly hair between her palms to make little balls which she then scattered on the floor. In the far corner of the room stands a pale green table with a small, handmade loom threaded into an intricate weave, again of human hair. *Recollection*. Hair everywhere, singled out, weightless almost to the point of invisibility.

Contemplating the blank space, 'empty' save for the table and void of any recognizable art objects, many viewers are placed in a predicament. Then, when the brown balls of hair which have merged with the dark knots of the floorboards begin to appear, you are compelled to make your way amongst them towards the high, grid-like windows. Perceptible because of its denser presence, the hair on the floor initially reveals a horizontal site of production. As you walk, careful not to crush these 'dust' balls, they stir lightly. Hair and air.

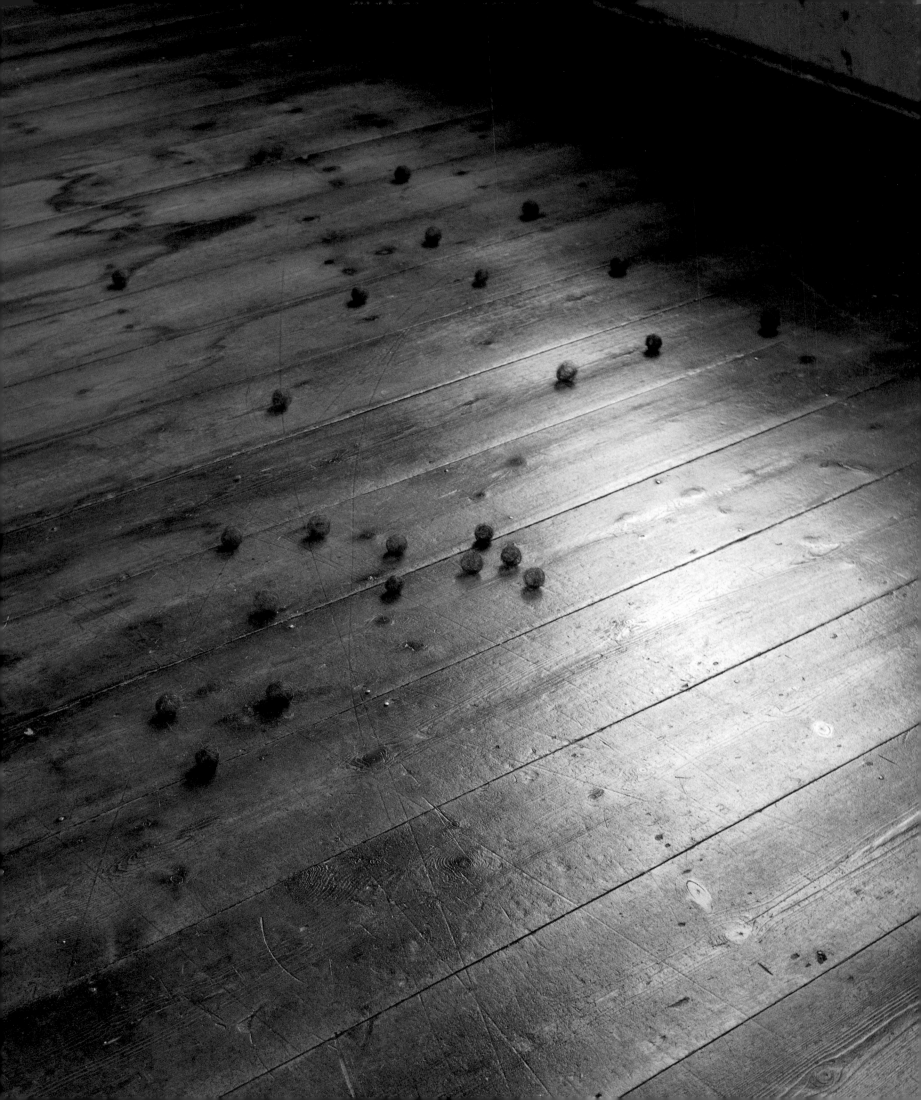

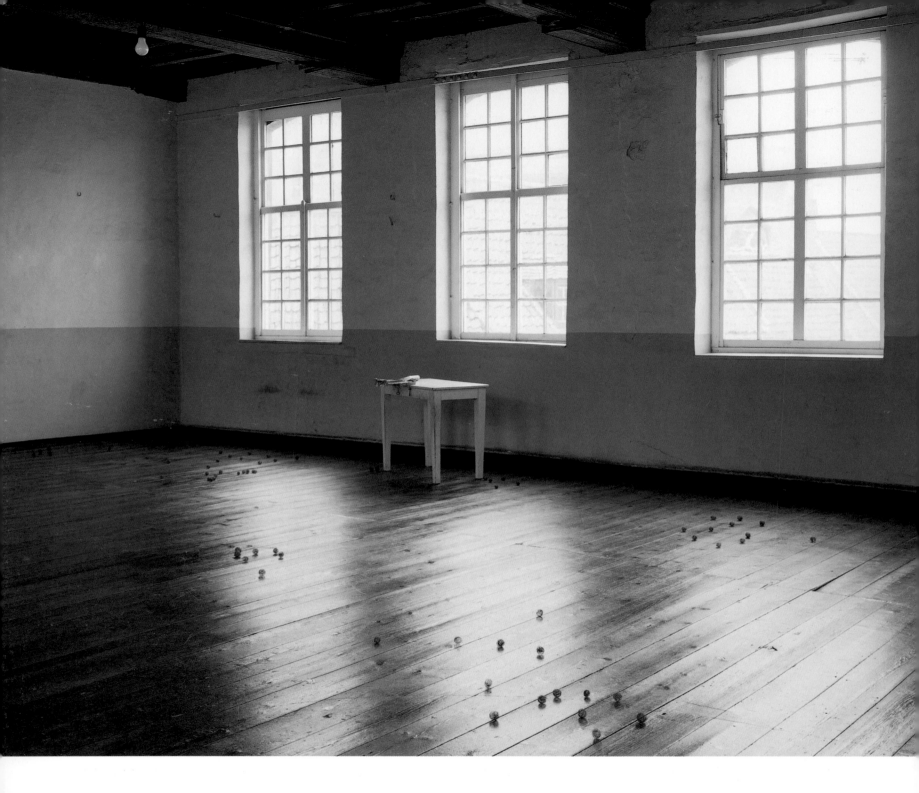

Meanwhile the pendent strands of hair gently but insistently brush against your face and catch in your mouth, perplexing at first and then discomforting, even repulsive. The eyes leave the horizontal plane to examine the surrounding vertical space, a 'hairspace' capturing light in time, only to return downward, to the hair on the floor. Up and down again. The gaze seems baffled by the *bassesse* (lowness) of both, the horizontality and the materiality of the work — the *bas matérialisme* also caught in a vertical field of vision. More hair everywhere ... why not sneeze? At first invisible, but now made apparent by means of a tactile sensation in the eye as 'striations on the surface of the retina',[3] the hair gets to you.

**Why Not Squeeze ...**
1996
Wood, wire, hair
16.5 × 21.5 × 12 cm

**Recollection**
1995
Hair balls, strands of hair hung
from the ceiling, wooden loom
with woven hair, table
Dimensions variable
Installation, Beguinage St.
Elizabeth, Kortrijk, Belgium
Collection, De Vleeshal,
Middelburg, the Netherlands

At that moment all progress in space is coupled with regression; hair invokes contradictory reactions from fascination to abjection, particularly when detached from the body. Sometimes *Recollection* moves viewers deeply, bringing to mind childhood games staged in an attic full of cobwebs; or grandmother's domestic habit of cleaning combs and brushes of the hair from her beloved children and grandchildren, rolling these remainders between her fingers in an attempt both to reject and retain them, secretly dispersing the little hair balls in the corners of the bedrooms.[4] The work horrifies some, who avoid contact with Hatoum's bodily rejects as if they threaten defilement. A stray hair on a shirt or a dress or a coat is instantly brushed away. While connoting beauty and identity, the most delicate, eroticized and lasting of human materials is also considered unclean, as 'matter out of place'. To quote Mary Douglas further, 'dirt is essentially disorder; there is no such thing as absolute dirt: it exists in the eye of the beholder'.[5] This approach implies two conditions: 'a set of ordered relations and a contravention of that order. Dirt then, is never a unique, isolated event. Where there is dirt there is system. Dirt is the by-product of a systematic ordering and classification of matter, in so far as ordering involves rejecting inappropriate elements'.[6] Leading us directly into symbolic systems of purity – and consequently towards issues of power and oppression – Hatoum's work is a complex reflection on bodily pollution, involving the relation of order to disorder, being to non-being, form to formlessness, life to death. In this sense as the screened yet excessive presence of an absent, dispersed body,

*Recollection* becomes a diagram of social structures. The work questions behavioural patterns of dirt-affirmation and dirt-avoidance as analogous to social ordering *vis à vis* degrees of symmetry or hierarchy, and the cultural obstructions between the inhabitant and the alien, the significant and the inconsequential. The daughter of Palestinian exiles in Lebanon and, since the outbreak of war in 1975, herself an exile in London, Mona Hatoum has had to re-collect herself, to reconceive herself through a set of fragile dependencies as '*subject* matter out of place'. Only by recollection could she adapt to her losses, estranged as she was from tradition, 'at the crossroads of dispossession'.[7]

Set in a transgressive relationship to the ethnic and gender dictates of society, her work assumes a singular value emanating from one centre of the bohemian diaspora. At once

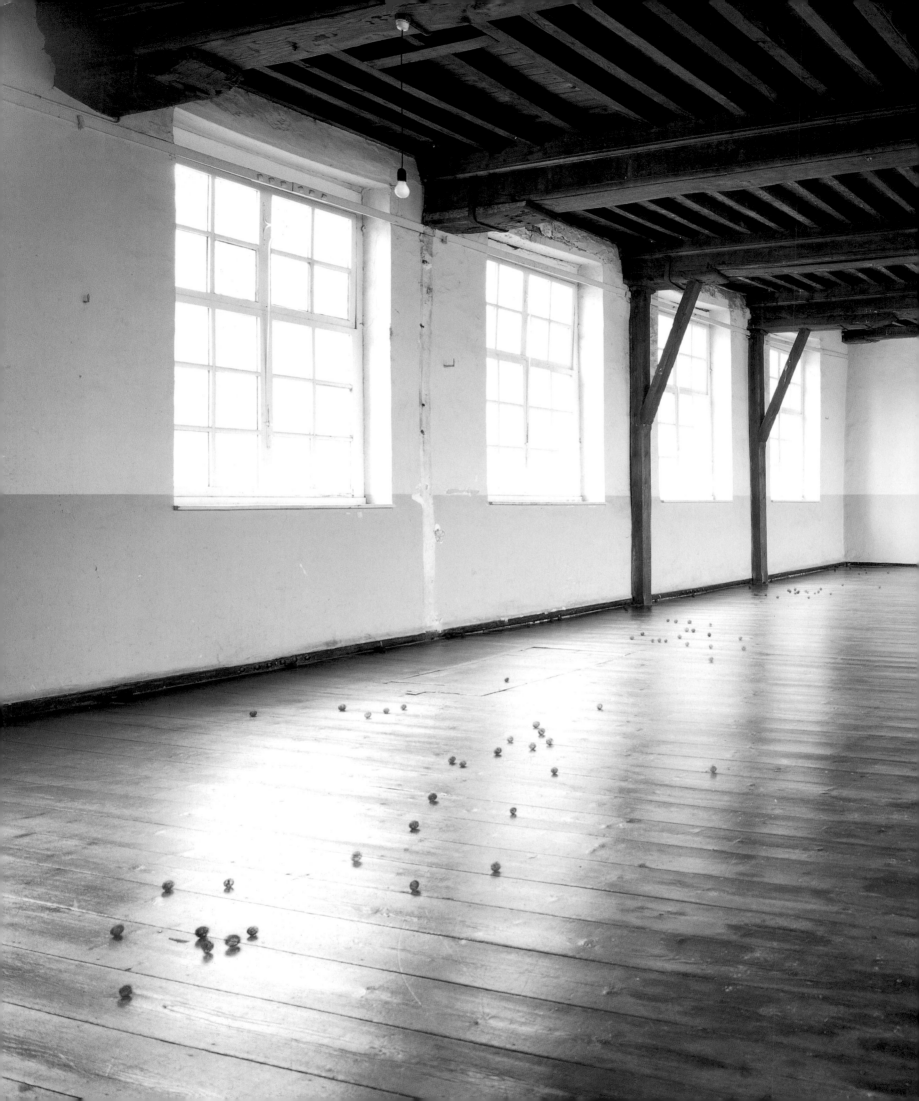

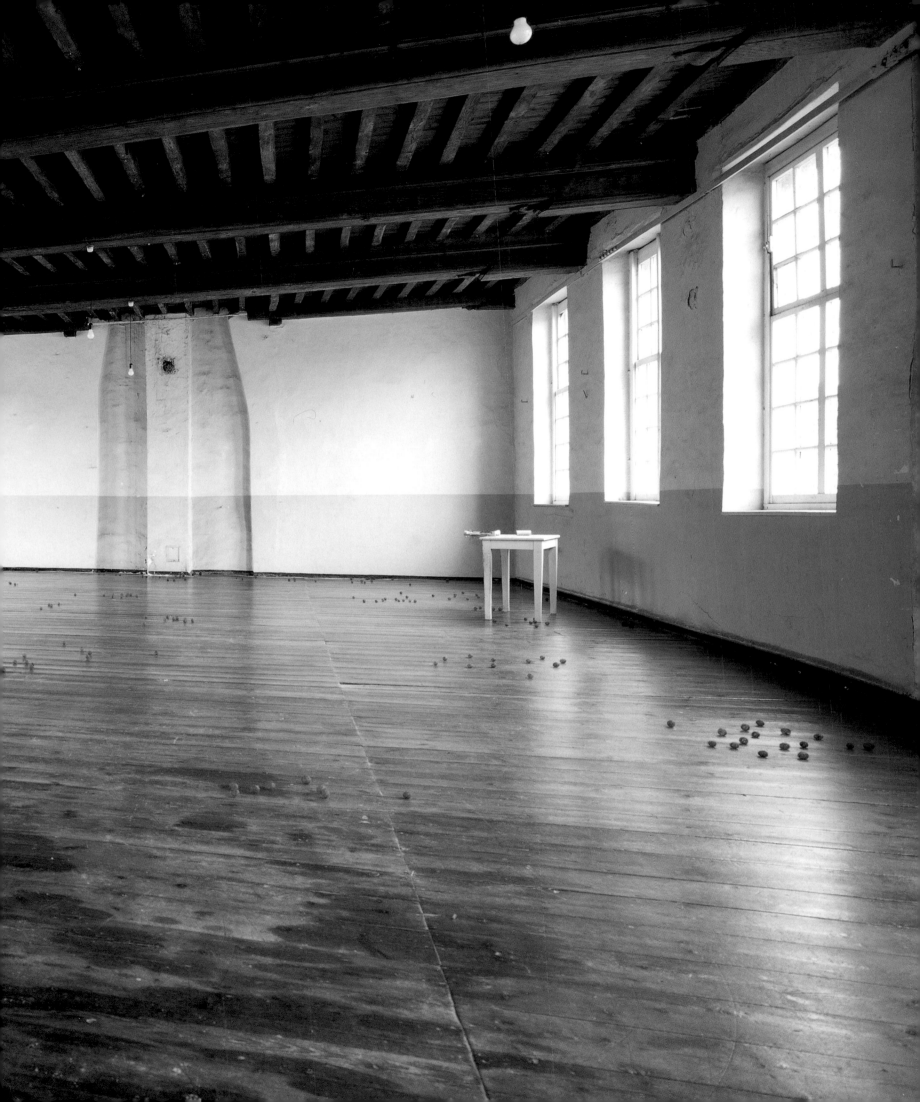

pointing to the act of remembering and to the spiritual gathering of oneself, *Recollection* suggests a sense of improvised ancestry and community. An earlier video work, *Measures of Distance* (1988), incorporates the many letters written by the artist's mother living in Beirut, to her daughter in London. This poignant work evokes not only the pains of separation and constriction but also the possibilities of displacement. Arabic script rolls over the screen and combines with the soundtrack to communicate the intimate dialogue of two family members in a situation of war, of grief and distance. As the script partially covers images of her mother, naked in the shower, language becomes the weave of a veil – or is it barbed wire – passing before the mind's eye like a dead letter. In a way the transparency of the veil of Arabic writing almost reads as a questioning of the fetishistic nature of representation, the disavowal of perceiving the maternal void. Furthermore, the scrolling 'graphic lines' in both these works serve to interfere with, yet never quite obliterate familial abandonment, ethnic rejection and national disinheritance. Similarly, the 'hairloom' in *Recollection*, like Victorian mourning jewellery containing a woven lock of hair from the dearly departed, dwells upon the lasting sense of estrangement from a loved one and asserts the role of personal relics in sustaining memory: 'not specific memories of past events necessarily, but myriad memories and associations made up of both fictions and realities'.[8]

In making isolated parts of her own body the object of displacement, Mona Hatoum substitutes the missing subject/object with 'mnemonic traces' in space. Because the ready-made lines of her hair refuse to hang straight but contain their own tensile energy, they constitute a particular 'drawing without paper'.[9] What seduces here is what Roland Barthes has termed 'the staging of an appearance-as-disappearance'.[10] To quote Emily Apter, 'Using this language of a gynotextual desire that recognizes the feminine relic as symbolizing something both more than and less than a simple compensatory object', there is a need to better 'understand the polysemic character of female fetishism'.[11] At once *fetishized* (her own splitting hairs stand in for the lost/transitional object — what Freud called the 'longed-for sight of the female member'[12]) and *fetishist* (as contemplating subject no longer 'split' by

**Measures of Distance**
1988
15-min. video
A Western Front Video Production, Vancouver
Collection, Art Gallery of Ontario, Toronto; Musée national d'art moderne, Paris; Museum of Contemporary Art, Chicago; Museum of Modern Art, Toyama; National Gallery of Canada, Ottawa

**Ann Hamilton**
Tropos
1994
Hair, table
Performance, Dia Center for the Arts, New York

the gaze of a male Other), the artist examines in an ambivalent way the notion of *disavowal*, or the urge to distance oneself from the sight and knowledge of difference. Similarly, she attempts 'to challenge the obsession with emasculation so frequently evinced in male-biased psychoanalysis, and to establish epistemological categories for thinking female loss as something other than mere penis envy or a masqueraded castration anxiety'.[13] Always suggestive of the aftermath of violence, her work deploys this strategy to depict an act of effacement but also of transgression. Following Naomi Schor, who endorses Sarah Kofman's Derridean notion of textual 'oscillation' or undecidability, transgression is preserved in the subversive term 'bisextuality' to characterize a 'perverse oscillation, a refusal … firmly to anchor woman – but also man – on either side of the axis of castration'.[14] In challenging fetishism's phallocentric orientation,[15] Kofman argues that 'a representation of a representation, itself representative of radical undecidability, the fetish is thus redeemed; formerly a degraded truth-value and icon of sexist psychoanalysis, it is now recast as the foundation for an ironic, gender-free metaphysics'.[16]

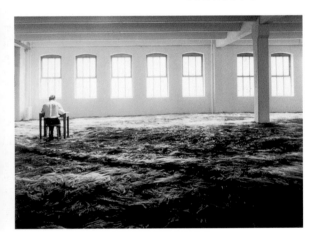

As a permanent rem(a)inder of sexual and ethnic prejudice in our societies, Hatoum's hair drawing in space – or is it a sculpture? – also intimately questions the *commemorizing fiction* of the monument and museum in the public domain. Here one could contrast Hatoum's work with Ann Hamilton's installation *Tropos* at the Dia Center for the Arts in New York (1994), which also consisted of hair on the floor – in this case, the tails from hundreds of slaughtered horses. As part of the work a woman sat for hours at a little reading table, erasing with a burning pen certain lines on the printed pages of a book. Delivering its import as soon as it has been seen – for perceiving is comprehending its destructive purpose – Hamilton's installation manifests the spectacularization of memory, while Hatoum's work harbours a contemplative, delectable duration. Hairs are like fragile links to loss; *Recollection* comments on the monument not only in its materiality, but in its appearance: its volume expands in an *absence* of solidity. Because hair is a symbol of remembrance, the timelessness of hair equals the timelessness of memory. On one hand, although hair may last as long as stone, paper or wood, it is either rejected as 'matter out of place' in traditional drawing and sculpture, or institutionalized in the predetermined conceptions of the ethnic and the primitivist. On the

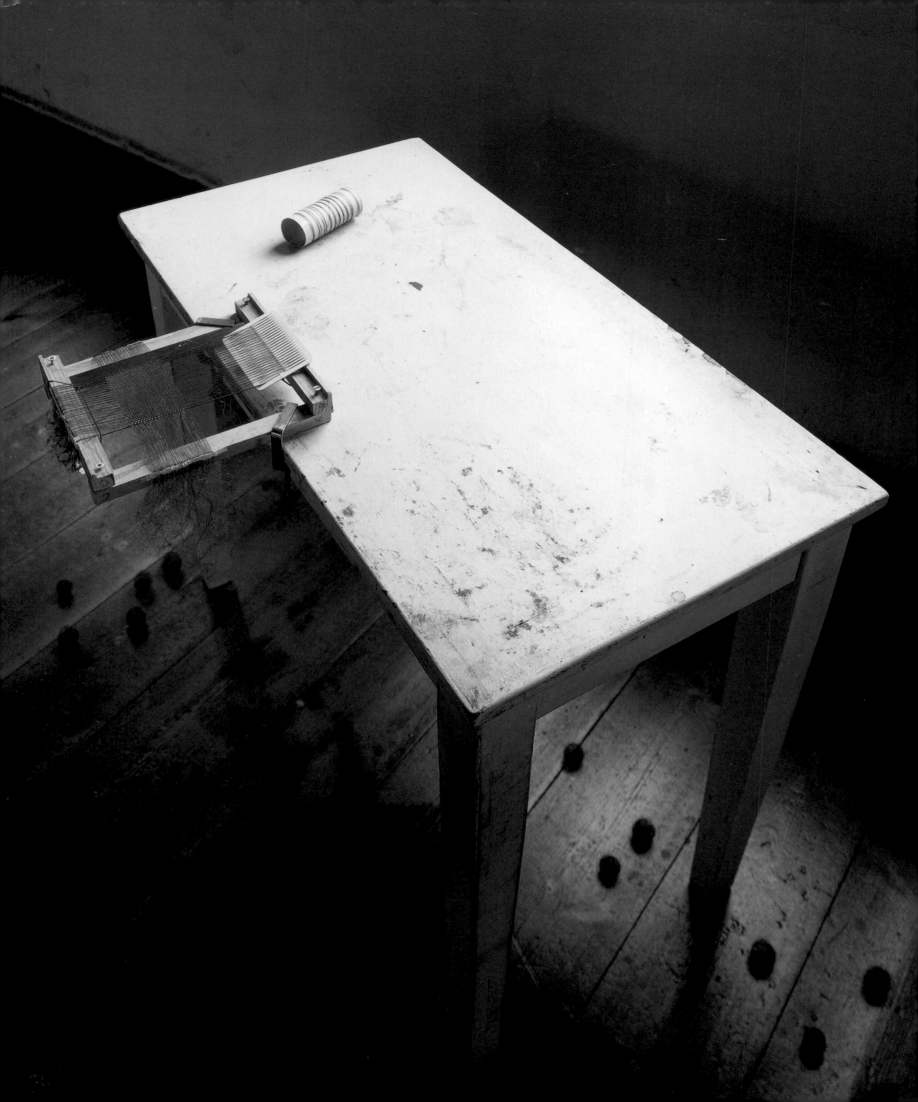

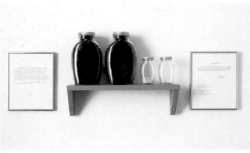

other hand, by prompting a dynamic point of view whereby all the senses of the visitor are set in motion, the work privileges the element of action over the stable 'commemorative volume'. Avoiding 'the logic of the monument' the spatio-temporal rhythm of this multi-dimensional work of art is made manifest not only through the movement of looking around, but also by the 'touch' of the sculpture/ drawing itself.[17] At the same time, questions concerning the artist's role in memorializing social and historical circumstances of loss and the fetishization of the artistic object are raised in terms of the politics of the museum. In this sense Mona Hatoum's work brings to mind Adrian Piper's 'notarized statement donating her cremated ashes along with the yet-to-be completed jars containing hair, nail clippings and skin to the Museum of Modern Art in New York upon her death, and referring to the concept that museums can endow artists with immortality by preserving their work. Piper calls our attention to the irony inherent in this belief system by including actual body remnants'.[18]

If dirt/disorder spoils pattern, for Hatoum it also supplies the source materials for pattern. On the floor's horizontal plane the randomly placed hair balls defining a 'smooth space' appear organized, while the ordered hair in the vertical field, hanging neatly from the ceiling exactly five inches apart and defining a 'striated space', is perceived as entangled. Nevertheless, the abject hair becomes the patterning matter. Meanwhile, seemingly opposed forces of straight lines intersect at right angles, resuming passages between the 'smooth' and 'striated space', echoing the intertextures of the small weave on the loom. Because order always indicates limitation, disorder has by implication limitless potential for patterning. A destructive force for any existing pattern, dirt also has this potential, and therefore symbolizes both danger and power.[19] One of the most fundamental principles for organizing space is the grid, which originated in the plain weave with its horizontal-vertical intersection of two separate systems of thread: the weft and the warp. Referring to the building's architectural and historical past, the precarious hair weavings also reverberate the writing and lace-making activities of the beguines, who once lived there in large numbers. To quote Mona Hatoum: 'The room was so beautiful, with light flooding in from a row of windows on both sides and the walls painted institutional green. Here I didn't want my intervention to be anything but subtle. The hair balls could be like the dust that settles in

unused spaces and contains the sheddings from all the women who have lived in that space through the centuries. It is about the feeling of a community of life where every little thing matters'.[20] It is about *reading the detail*.

However, in the seclusion of the Beguinage the quasi-compulsive gestures of tying and rolling the hair also echo the lapse of time in a penitentiary. As in Hatoum's *Short Space* (1992) where bedsprings hang from the ceiling in three rows that slowly move up and down at regular intervals; or *Light Sentence* (1992) where rows of lockers surround a single moving lightbulb throwing shadows of the wire grids on the walls, the grid structures in *Recollection* allude to corporal chastisement; its 'hard lines' paradoxically evoke the sadistic impulses of

*opposite,* **Recollection**
1995
Hair balls, strands of hair hung
from the ceiling, wooden loom
with woven hair, table
Dimensions variable
Installation, Beguinage St.
Elizabeth, Kortrijk, Belgium
Collection, De Vleeshal,
Middelburg, the Netherlands

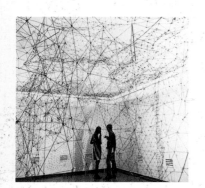

**Agnes Martin**
Untitled No 1
1988
Acrylic, pencil on canvas
183 × 183 cm

**Gego**
1969
Reticulârea (Ambientación)
Steel wire, iron wire
Dimension variable

the blank space, trapping the viewer in disorientation. While the grid can potentially provide a sense of security, its rigid structure also implies the compulsion to master three-dimensional space and to define both the land and the body as territory or property . Through the beholder's movements, Hatoum's regular tracings seem to dissolve or dematerialize. A careful phenomenological reading of her work even compares to the finely drawn grids of Agnes Martin's canvases or Gego's kinaesthetic wire structures *Reticulàrea (Ambientacion)* and *Dibujos sin papel (Drawings without Paper)* which reveal transformations in materiality as the viewing distance changes. The fabric of the grid, the very weft of the work, distorts, shifts or fractures, leaving the subject-viewer without a singular vantage point to provide a sense of control. Hers is a haptic rather than optical perception; the artist is unwilling to provide a precise focus for the eye, a unique locus from which to observe the Other. Drawing on the grid and its obsessive structure of repetition while subverting its logic of organization, her works embody multi-directional relations to a world where 'threatening' difference is mitigated and negotiated.

In *Recollection* Mona Hatoum unsettles the conventions of representation by taking up the grid as a 'celebratory/destabilizing framework' which refuses to allow the reader a scenario whereby he or she commands the other or aggrandizes the self. By *escaping* the margins, the gaze *returns* to the margins. However, to realize the work while dismantling the grid, she paradoxically uses bodily refuse which symbolizes danger and power. The artist

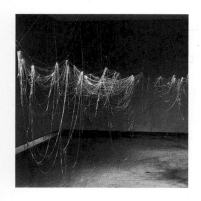

questions why and how bodily margins – such as skin, nails, hair clippings, sweat and urine – are invested in our culture with threat.[21] In conjunction with this decentring strategy of the *informe*,[22] her material and its display in space upset the established artistic categories, revealing that 'the "written signs" set within a pictorial field can not hold out against the fronto-parallel organization of the Gestalt, with its drive to verticalize everything as image, to align everything in accordance with the viewer's upright body'.[23] Involving all the beholder's senses, *Recollection* induces a permanent diffusion and oscillation in the 'narrowing' gaze; in the shift from far (the margins) to near (the centre), and from downwards (the horizontal) to upwards (the vertical), and vice versa. In this way the work succeeds in escaping both the axis of the human body and the idea of form, which as Rosalind Krauss describes has been counteracted particularly since Jackson Pollock (and later Eva Hesse). In contradistinction, a contemporary work such as Janine Antoni's *Loving Care ('I soaked my hair with dye and mopped the floor with it')* performed at Anthony D'Offay Gallery in London (1995) can only be read as a disguised transgressive act, or a reductive, iconographic transposition of the legacy of art from the 1960s to the 1990s. Ironizing the machismo of action painting, Antoni's hair-dye performance nevertheless re-phallicizes the fetish (female hair) and alludes, unlike *Recollection,* to the notion of victimhood.

Since the early 1980s Hatoum has used a great variety of media – drawing, performance, video, sculpture and installation. Yet she has inventively maintained a continuity in the issues addressed, among them the mapping of reality at the fringes of vision; a problematization of our understanding of space and time; the subversion of the formal properties of works of art, a procedure based on an economy of loss; and the reformation of female imagery (i.e., feminizing the fetish, the symbolization of mother-daughter relationships). Following Luce Irigaray, she asks us 'to consider this ambiguous boundary between the body and Otherness not with horror and disgust, but as providing a glorious opening onto a new form of identity-construction – a female divine'.[24] This becomes most

**Jackson Pollock**
1950

**Janine Antoni**
Loving Care ('I soaked my hair with dye and mopped the floor with it')
1995
Performance, Anthony D'Offay Gallery, London

**Eva Hesse**
Right After
1969
Fibreglass, cord, wire hooks
152 × 548 × 122 cm

**Recollection**
1995
Soap, pubic hair

obvious in *Corps étranger* (1994), which encloses the viewer in a circular space with a video projection of a journey through the orifices of the artist's body by an endoscopic camera. The camera registers with medical scrutiny the external and internal corporeal sights and sounds of the subject. Again, as a manifestation of the *informe* this disembodied and projected body, unveiling what remains hidden and invisible, suggests the terrifying horror of another, or a liberating mirror for oneself. A private view of margins is linked to public boundaries and thresholds. For Julia Kristeva, the abjection of contact, this 'hygiene' surrounding the viewing of the feminine, can be considered the basic cultural exclusion on which society is founded. In exile, Hatoum was forced to redistribute and re-collect herself outside the matrix of familial, national and ethnic traditions which in fact outlined her position as an 'outsider'. She recognizes the process that 'suppresses the irrational, incoherent and contingent dimensions to nations whose ancestry and boundaries are not emanations of an organic past but largely the products of repeated bureaucratic interventions'.[25] In an attempt to bypass nationality, she works as a transcultural artist holding onto living remembrances, fascinated by the impure, unsettled, precarious, reversible, incomplete, interval …

**For Charlene Engelhard, an essay in Bequia's quietude.**

Hatoum's *Recollection* (22 April – 28 May, 1995) was commissioned for the exhibition series 'Inside the Visible. Begin the Beguine in Flanders' organized by the Kanaal Art Foundation in Kortrijk. Further elaborated as a group exhibition by the Institute of Contemporary Art in Boston, 'Inside the Visible (An elliptical traverse of twentieth-century art in, of, and from the feminine)' was exhibited at the ICA, Boston; the National Museum of Women in the Arts, Washington D.C.; the Whitechapel Art Gallery, London; and the Art Gallery of Western Australia, Perth.

1    Anna Freud, 'About Losing and Being Lost', *The Psychoanalytic Study of the Child*, Vol. XXII, International Universities Press, Inc., New York, 1967, pp. 9-19

2    Founded in Flanders during the thirteenth century, the *béguinages* enclosed, in the centre of bustling towns, semi-religious congregations of beguines who were not bound by perpetual vows (except for chastity), and who dedicated their time to prayer, writing, welfare and lacework. Inspired by an apostolic life, these 'unruly' women opted for an existence in spiritual freedom, exempt from institutional structures and possessions.

3    Briony Fer, review of 'Inside the Visible', *Texte zur Kunst*, Cologne, August, 1996, pp. 169-172

4    It seems to me that this traditional gesture relates to Anna Freud's discussion of the latent content of dreams having much in common with the mental processes of someone who has lost a material possession: 'Here too a part is played by the interference of two opposite tendencies with each other, the simultaneous wishes to retain and to discard being replaced in this instance by the simultaneous urges to remain loyal to the dead and to turn towards new ties with the living'. Anna Freud, op. cit., p.15

5    Mary Douglas, *Purity and Danger: An Analysis of the Concepts of Pollution and Taboo*, Routledge, London and New York, 1966, 1992 edition, pp. 2-3

6    Ibid., p. 35

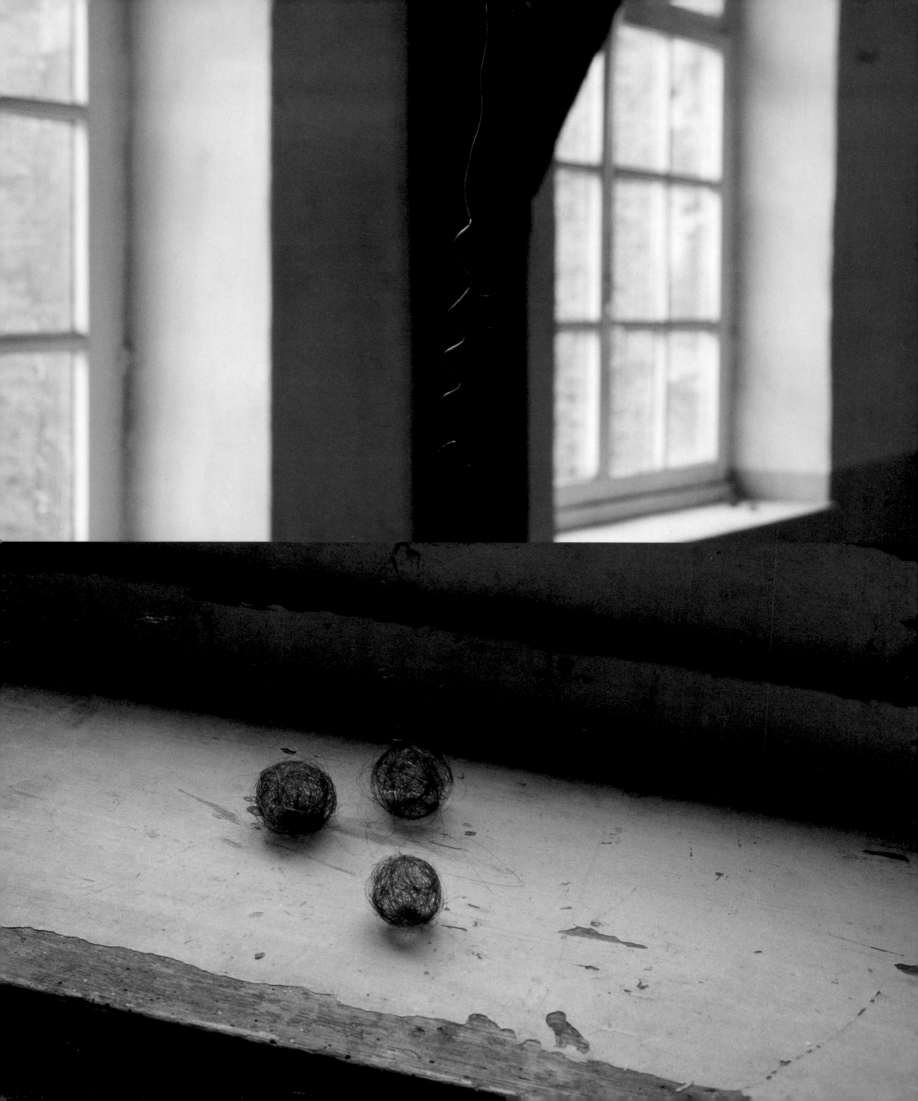

**Recollection**
1995
Hair balls, strands of hair hung
from the ceiling, wooden loom
with woven hair, table
Dimensions variable
Installation, Beguinage St.
Elizabeth, Kortrijk, Belgium
Collection, De Vleeshal,
Middelburg, the Netherlands

7   Rob Nixon, 'Refugees and Homecomings: Bessie Head and the End of Exile', *Travellers' Tales: Narratives of Home and Displacement*, ed. George Robertson, Routledge, London and New York, 1994, pp. 114-28. 'The formulation for perpetuating the cycles of dispossession is reminiscent of the catastrophic colonial designation of Palestine as "a land without a people" and Palestinians as "a people without a land". The argument begins by designating a people as nomadic, proceeds by claiming that this precludes them from owning land, and thereby deduces that such landless people cannot, by definition, suffer dispossession. The motive for and consequence of this rationale is the accelerated dispossession of the Palestinians'.

8   Alison Ferris, Introduction to *Hair*, John Michael Kohler Arts Center, Sheboygan, Wisconsin, pp. 1-2

9   Guy Brett, 'Mona Hatoum', Public Lecture, Tate Gallery, London, 1995

10  Roland Barthes, *The Pleasure of the Text*, Blackwells, Oxford, 1990

11  Emily Apter, *Feminizing the Fetish: Psychoanalysis and Narrative Obsession in Turn-of-the-Century France*, Cornell University Press, Ithaca and London, 1991, pp. 121-22

12  Sigmund Freud, 'Fetishism', 1927, in *On Sexuality*, Pelican Freud Library, Penguin Books, Harmondsworth, 1977, p. 335

13  Emily Apter, op. cit., pp. 122-23

14  Naomi Schor, 'Female Fetishism: The Case of George Sand', *The Female Body in Western Culture*, ed. Susan Suleiman, Harvard University Press, Cambridge, 1985, p. 369; cited in Emily Apter, op. cit., pp. 109-10

15  Ibid. 'Kofman seeks to raze the negative history of the fetish, removing it from its Kantian ascription as a degraded sublime ("a trifle"), erasing its Marxist connotations as a spectral figure of alienated value (commodity fetishism), and displacing it from the feminist lexicon where it denotes the exploitative, anatomically decorticating male gaze found in pornography, advertising and art'.

16  Ibid. 'Kofman succeeds in demasculinizing fetishism through theory but in the process dispenses almost entirely with sexual difference. Female fetishism, in so far as it could even be epistemologically distinguished according to her terms, is subsumed within the neutered modalities of textual indeterminacy'.

17  See my essay in *Inside the Visible*, MIT Press, Cambridge, Massachusetts and London, 1996, pp. 32-36; and Rosalind E. Krauss, 'Sculpture in the Expanded Field', *The Originality of the Avant-Garde and Other Modernist Myths*, MIT Press, Cambridge, Massachusetts, 1985, pp. 276-90

18  Alison Ferris, op. cit., p. 6

19  Mary Douglas, op. cit., p. 94

20  Mona Hatoum, in conversation with the author.

21  In the early 1980s Mona Hatoum was gathering these bodily rejects and fluids, and mixing them up with pulp to make paper. Those and many other body-based experiments were discontinued in favour of politically-based art. Having received no encouragement to develop these early works (probably because the Western art world had certain expectations of an artist who came from an 'embattled' background), she pursued this more abject art only much later.

22  Following Bataille, Rosalind Krauss defines *l'informe* in *The Optical Unconscious,* MIT Press, Cambridge, Massachusetts, 1993, p.167: 'Instead, let us think of *informe* as what form itself creates, as logic acting logically to act against itself within itself, form producing a heterologic. Let us think of it not as the opposite of form but as a possibility working at the heart of form, to erode it from within. Working, that is, structurally, precisely, geometrically, like clockwork.'

23  Rosalind E. Krauss, 'Horizontalité', *L'informe: Mode d'emploi*, with Yve-Alain Bois, Editions du Centre Pompidou, Paris, 1996, pp. 86-95

24  Christine Battersby, 'Just Jamming: Irigaray, Painting and Psychoanalysis', *New Feminist Art Criticism*, ed. Katy Deepwell, Manchester University Press, Manchester and New York, 1995, pp. 128-37

25  Rob Nixon, op. cit., p. 123

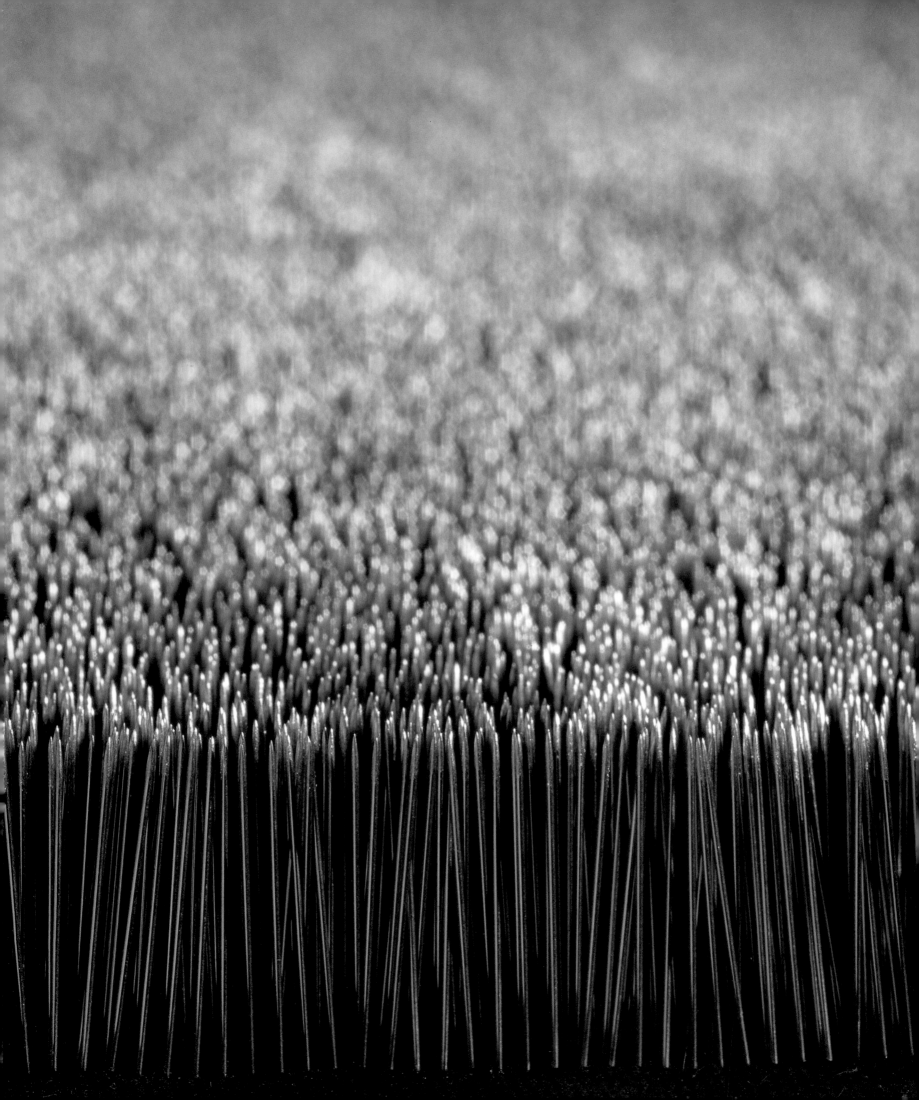

# Contents

For the Discovery of a Zone of Images, 1957
**Piero Manzoni**

A common vice among artists – or rather bad artists – is a certain kind of mental cowardice because of which they refuse to take up any position whatsoever, invoking a misunderstood notion of the freedom of art, or other equally crass commonplaces.

Since they have an extremely vague idea of art the result is generally that they finish up by confusing art with vagueness itself.

It's therefore necessary to clarify as far as possible what we mean by art, so that we can find a guideline along which to work and make judgements.

The work of art has its origin in an unconscious impulse that springs from a collective substrata of universal values common to all men from which all men draw their gestures, and from which the artist derives the 'archai' of organic existence. Every man of his own accord extracts the human element from this base, without realising it, and in an elementary and immediate way. Where the artist is concerned it is a question of the conscious immersion in himself through which, once he has got beyond the individual and contingent level, he can probe deep down to reach the living germ of total humanity. Everything that is humanly communicable is derived from this, and it is through the discovery of the psychic substrata that all men have in common that the relationship of author-work-spectator is made possible. In this way the work of art has the totemic value of living myth, without symbolic or descriptive dispersion: it is a primary and direct expression.

The foundations of the universal value of art are given to us now by psychology. This is the common base that enables art to sink its roots to the origins before man and to discover the primary myths of humanity.

The artist must confront these myths and reduce them, by means of amorphous and confused materials, to clear images.

Since these are atavistic forces that have their origins in the subconscious, the work of art takes on a magical significance.

On the other hand, art has always had a religious value, from the first artist-sorcerer to the pagan and Christian myth, etc.

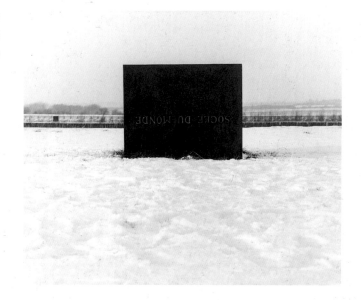

Piero Manzoni
Socle du Monde
1961
Iron
82 × 100 × 100 cm

The key point today is to establish the universal validity of individual mythology.

The artistic moment is therefore that in which the discovery of preconscious universal myths comes about, and in the reduction of these into the form of images.

It is clear that if the artist is to be able to bring to light zones of myth that are authentic and virginal he must have both an extreme degree of self-awareness and the gifts of iron precision and logic.

To arrive at such a discovery, fruit of a long and precious education, involves a whole field of precise technique. The artist must immerse himself in his own anxiety, dredging up everything that is alien, imposed or personal in the derogatory sense, in order to arrive at the authentic zone of values.

So it is obvious that at first glance there would seem to be a paradox: the more we immerse ourselves in ourselves, the more open we become, since the closer we get to the germ of our totality the closer we are to the germ of totality of all men.

We can therefore say that subjective invention is the only means of discovering objective reality, the only means that gives us the possibility of communication between men.

Socle du Monde
1992-93
Wooden structure, steel plates,
magnets, iron filings
164 × 200 × 200 cm
Collection, Art Gallery of Ontario,
Toronto

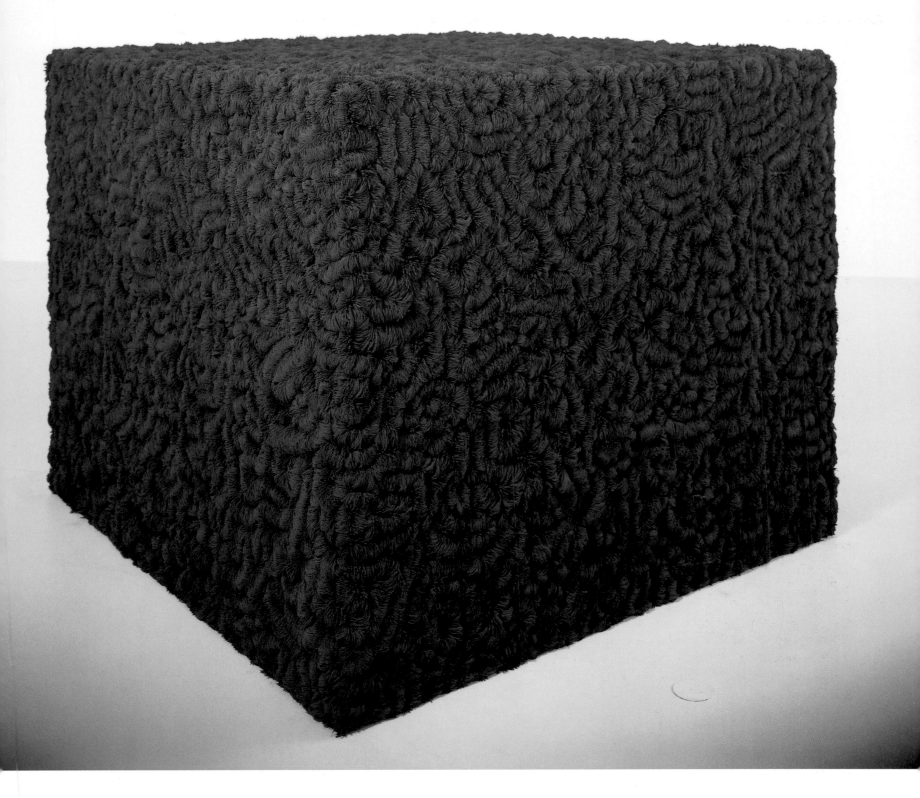

There comes a point where individual mythology and universal mythology are identical.

In this context it is clear that there can be no concern with symbolism and description, memories, misty impressions, of childhood, pictoricism, sentimentalism: all this must be absolutely excluded. So must every hedonistic repetition of arguments that have already been exhausted, since the man who continues to trifle with myths that have already been discovered is an aesthete, and worse.

Abstractions and references must be totally avoided. In our freedom of invention we must succeed in constructing a world that can be measured only in its own terms.

We absolutely cannot consider the picture as a space on to which to project our mental scenography. It is the area of freedom in which we search for the discovery of our first images.

Images which are as absolute as possible, which cannot be valued for that which they record, explain and express, but only for that which they are to be.

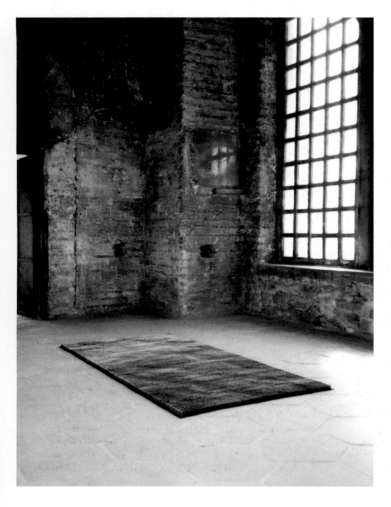

Because exile, unlike nationalism, is fundamentally a discontinuous state of being. Exiles are cut off from their roots, their land, their past. They generally do not have armies or states, although they are often in search of them. Exiles feel, therefore, an urgent need to reconstitute their broken lives, usually by choosing to see themselves as part of a triumphant ideology or a restored people. The crucial thing is that a state of exile free from this triumphant ideology designed to reassemble an exile's broken history into a new whole is virtually unbearable, and virtually impossible in today's world [ ... ]
This need to reassemble an identity out of the refractions and discontinuities of exile is found in the earlier poems of Mahmud Darwish, whose considerable work amounts to an epic effort to transform the lyrics of loss into the indefinitely postponed drama of return. Thus he depicts his sense of homelessness in the form of a list of unfinished and incomplete things:

> But I am the exile
> Seal me with your eyes.
> Take me wherever you are
> Take me whatever you are.
> Restore to me the colour of face
> And the warmth of body
> The light of heart and eye,
> The salt of bread and rhythm,
> The taste of earth ... the Motherland.
> Shield me with your eyes.
> Take me as a relic from the mansion of sorrow.
> Take me as a verse from my tragedy;
> Take me as a toy, a brick from the house
> So that our children will remember to return.
> The pathos of exile is in the loss of contact with the solidity
> and the satisfaction of earth: homecoming is out of the
> question [ ... ]

Exiles look at non-exiles with resentment. *They* belong in their surroundings, you feel, whereas an exile is always out of place. What is it like to be born in a place, to stay and live there, to know that you are of it, more or less for ever? [ ... ]

Much of the exile's life is taken up with compensating for disorienting loss by creating a new world to rule. It is not

**Pin Carpet**
1995
Stainless steel pins, canvas, glue
3 × 124.5 × 246 cm
Installation, Aya Irini, Istanbul
Biennial
Collection, Fabric Workshop and
Museum, Philadelphia

*opposite,* **Pin Carpet** (detail)
1995

Exile is strangely compelling to think about but terrible to experience. It is the unhealable rift forced between a human being and a native place, between the self and its true home: its essential sadness can never be surmounted. And while it is true that literature and history contain heroic, romantic, glorious, even triumphant episodes in an exile's life, these are no more than efforts meant to overcome the crippling sorrow of estrangement. The achievements of exile are permanently undermined by the loss of something left behind for ever [ ... ]

... Just beyond the frontier between 'us' and the 'outsiders' is the perilous territory of not-belonging: this is to where in a primitive time peoples were banished, and where in the modern era immense aggregates of humanity loiter as refugees and displaced persons [ ... ]

surprising that so many exiles seem to be novelists, chess players, political activists, and intellectuals. Each of these occupations requires a minimal investment in objects and places a great premium on mobility and skill. The exile's new world, logically enough, is unnatural and its unreality resembles fiction [ ... ]

No matter how well they may do, exiles are always eccentrics who *feel* their difference (even as they frequently exploit it) as a kind of orphanhood. Anyone who is really homeless regards the habit of seeing estrangement in everything modern as an affectation, a display of modish attitudes. Clutching difference like a weapon to be used with stiffened will, the exile jealously insists on his or her right to refuse to belong [ ... ]

The exile knows that in a secular and contingent world, homes are always provisional. Borders and barriers, which enclose us within the safety of familiar territory, can also become prisons, and are often defended beyond reason or necessity. Exiles cross borders, break barriers of thought and experience [ ... ]

Regard experiences as if they were about to disappear. What is it that anchors them in reality? What would you save of them? What would you give up? Only someone who has achieved independence and detachment, someone whose homeland is 'sweet' but whose circumstances makes it impossible to recapture that sweetness, can answer those questions. (Such a person would also find it impossible to derive satisfaction from substitutes furnished by illusion or dogma.)

**Divan Bed**
1996
Steel tread plate
60 × 192 × 77 cm

This may seem like a prescription for an unrelieved grimness of outlook and, with it, a permanently sullen disapproval of all enthusiasm or buoyancy of spirit. Not necessarily. While it perhaps seems peculiar to speak of the pleasures of exile, there are some positive things to be said for a few of its conditions. Seeing 'the entire world as a foreign land' makes possible originality of vision. Most people are principally aware of one culture, one setting, one home; exiles are aware of at least two, and this plurality of vision gives rise to an awareness of simultaneous dimensions, an awareness that to borrow a phrase from music is *contrapuntal*.

For an exile, habits of life, expression or activity in the new environment inevitably occur against the memory of these things in another environment. Thus both the new and the old environments are vivid, actual, occurring together contrapuntally. There is a unique pleasure in this sort of apprehension, especially if the exile is conscious of other contrapuntal juxtapositions that diminish orthodox judgement and elevate appreciative sympathy. There is also a particular sense of achievement in acting as if one were at home wherever one happens to be [ ... ]

* LIGHT COMES ON AND THERE IS ONLY THE STRAW CASE.

(SEQUENCE OF EVENTS FOR "MIND THE GAP") TO begin with

SOUND TRACK

① WALK IN DRESSED IN WHITE ~~carrying straw case~~ case is already there

② OPEN CASE AND GET TRAIN OUT AND PLAY WITH IT (?) LAY OUT ALL THE TOYS + the prick & the gorilla etc...

"DITES-MOI POURQ VERY SOFTLY Repeated +

ON SMALL TAPE RECORDER

③ GET SHAVING "IMPLEMENTS" OUT AND PROCEED TO PUT CREAM ON FACE THEN SHAVE

Look behind me to see if anyone is looking Then apply woke up + look at woman + then shave

④ TAKE OUT A LITTLE BUCKET AND THE LITTLE BROOM AND START "BROOMING" THE FLOOR

⑤ THEN DIP BROOM INTO BUCKET FULL OF RED LIQUID (?) AND PROCEED TO PAINT MY FINGERS IN RED

* KNIFE & SCISSORS.

State of confusion

COULD CUT OUT THE CENTRE OF DRESS WHERE RED SPOT IS with very any scissors

⑥ RED SPILLS ON DRESS (ON CROTCH)
* CUT OUT CENTRE OF DRESS
⑥A could then repeat the sequence of shaving but this time by dipping the shaving brush into bucket with red stuff on it and squeezing it all over my face.

LOUD SUDDEN SOUND OF RECORDING + MIND THE GAP.

⑦ SLIDES COME ON AND ARE PROJECTED ONTO A TRANSPARENT SCREEN

TAPE OF INTERVIEWS WITH MOTHER, LAUGHS

# Contents

Waterworks

1981

Ink, typewritten text, photocopy

collage on paper

29.5 x 21 cm

Rejected proposal for 'New

Contemporaries', the Institute of

Contemporary Arts, London

"WATERWORKS" INSTALLATION 1981

I.C.A. ENTRANCE FOYER

Women's toilets

Men's toilets

MONITOR SHOWING
LIVE ACTION + SOUNDS
IN WOMEN'S TOILET

MONITOR SHOWING
LIVE ACTION + SOUNDS
IN MEN'S TOILET

Mona Hatoum

Proposal for the New Contemporaries 1981:"WATERWORKS"(VideoInstallation)

My work is concerned with using the human body in a symbolic way. I am interested in the organic physiological processes of the body and the social taboos connected with some of these processes. I would like to challenge the hierarchical structure which is placed on the different orifices of the body, the upper orifices being considered more respectable than the lower ones and all the functions related to the lower ones being completely screened-off and tabooed.

The installation I am proposing  for the I.C.A. involves the siting of two video cameras in the Women's and Men's toilets located in the entrance foyer on either side of the book shop, and two monitors placed on stands  in the foyer or on brackets secured to the walls outside the respective toilets.

In each toilet one video camera is mounted at ceiling height inside one of the cubicles and directed to the lavatory. Each camera is connected in a live relay to it's own monitor situated in the foyer. The men's monitor outside the men's toilets and the women's outside the women's toilets. Those people watching the monitors will be able to see and hear men and women using the toilets. A note placed on each toilet door will inform the user that this particular cubicle is being observed by a video camera and should he/she not wish to be seen on the monitors in the foyer, he/she should use a lavatory not in shot. This insures that members of the public have a choice of whether or not they participate in the installation.

**Waterworks**
1981
Typewritten text on paper
29.5 x 21 cm
Text posted in the artist's studio
space at the Slade School of Art,
London

The work presented here was intended as an investigation
into the nature of the taboo surrounding the eliminatory
process and its direct relation to sexual taboos and our
general negative attitudes towards the body and its natural
processes which socialisation teaches us to keep under
control in order to maintain a formal social distance.

The proposal for the work was submitted to the "New Con-
temporaries 1981" show and selected for exhibition by the
"New Contemporaries" committee, but was later rejected by
the ICA.  This same work was proposed for the present show
here at the Slade, as a continuous installation within
which a live work similar to that performed in Newcastle
(documented here) and was again turned down.

The history of this piece of work has become an interesting
part of the work itself in the way it has reflected the
attitude of these art institutions towards work which de-
parts from the accepted forms of representation to question
established modes of behaviour.

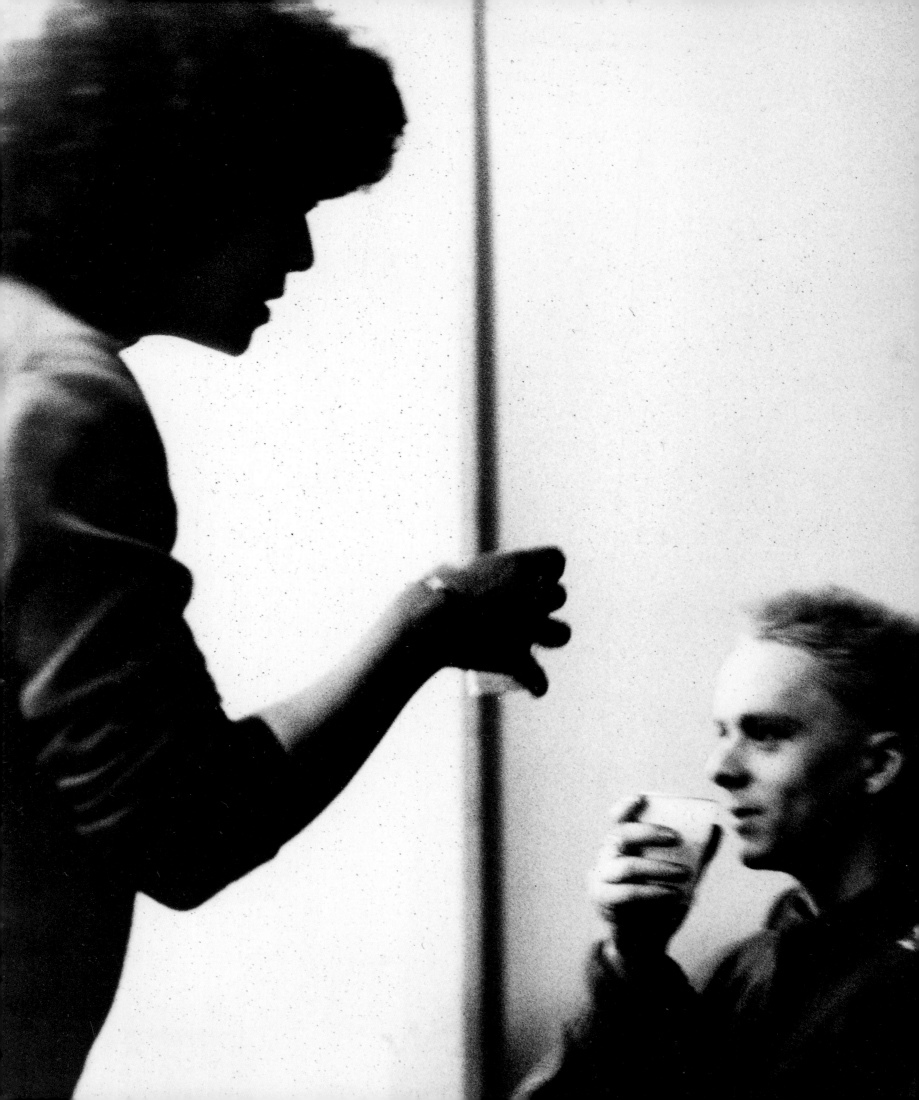

# Look No Body! 1981

**Look No Body!**
1981
40-min. performance, Basement
Gallery, Newcastle-upon-Tyne

**Look No Body!**
1981
Typewritten text on paper
29.5 x 21 cm
Description of action and extract
from soundtape of *Look No Body!*
performance

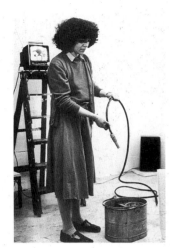

<u>A LIVE WORK</u>   -   March 28th, 1981, The Basement, Newcastle-Upon-Tyne

A video monitor showing a view from a high angle of the toilet
just outside the performance space.  Throughout the performance
a sound tape could be heard ...

    ... The repeated transient contraction waves at first
    are small and are not consciously felt, later, stimuli
    reach the brain and cause pain and a sharp rise of
    pressure ...

She goes out through the door on the left ... She comes back in
dragging along a green hose pipe (I've forgotten the cups) ...

    ... These later major contractions can be inhibited
    voluntarily, but eventually the desire to micturate
    becomes urgent and irrepressible.  Until this time,
    if it is socially inconvenient to urinate, voluntary
    inhibition of the detrusor and contraction of the
    perineal muscles keep the internal pressure as low as
    possible and prevent efflux ...

She disappears into the room next door ... reappears with a
two foot stack of white plastic cups and places them next to
the metal bucket ...

    ... emotional influences are important.  Anxiety
    inhibits the capacity of the bladder to relax on
    filling, so under conditions of stress - e.g., on the
    battlefield - there may be frequent involuntary passage
    of small quantities of urine ...

She goes out through the door on the left ... comes back into
the space, holds up the end of the hose pipe above the bucket ...

    ... adult females are generally credited with the
    ability to micturate less frequently than the adult
    male.  There is no greater bladder capacity in the
    female;  instead, it is assumed there is greater
    suppression of the emptying reflexes ... and I think
    this suppression works on other than the physiological
    level as well ...

She waits for a while for the water to come through ... She
follows the length of the hose pipe with her eyes ... no
water!

    ... it's just that I often wonder where my body
    ends ... I mean what my boundaries are ... whether
    it's the skin ... what about things like hair and
    nails, and you know, things that come out of the body
    in the form of urine, faeces, blood ... where does it
    actually end?

She goes out again, comes back into the space, holds up the
end of the hose pipe, waits for a few seconds ... still no
water!

    ... I very often wonder why women's loos are divided
    into cubicles with doors and locks, when men have
    large communal open urinals and the same for showers
    ... it's like another conspiracy against us women ...
    it makes us feel as if we've got something to hide,
    even from each other ...

She goes out for the third time, comes back in and holds up
the end of the pipe.  A thin stream of oily, smelly water
falls into the cup (I should have washed the pipe, can't
offer this to anybody).  She drinks the water.

    ... Talking about dreams ... there is this recurring
    dream I've been having for a long time now ... I
    was about thirteen or fourteen when I first started
    having it.  I keep finding myself in a situation
    where I'm desperately wanting to go to the loo for
    a pee and I'd be given instructions about how to get
    to the nearest loo but I keep finding myself getting
    lost ...

A woman gets up and says "can't bear it.  I'm going to the
toilet".

    ... all sorts of obstacles would be getting in my
    way and I'd have to travel long distances ...
    obstacles to overcome ... and the tension would be
    getting really unbearable and I finally find a loo
    ... rush in, close the door and sit on the loo ready
    to relieve myself ...

Another cup full of water, still not clean, she drinks it and
the next one, and the next one, and the next one ...

    ... and all of a sudden I look around me and the
    walls just sort of disappear ... I just find myself
    in this ridiculous situation sitting on the loo
    in the middle of a crowd of people all watching me
    sitting there and pointing their fingers at me and
    laughing ...

She offers the sixth cup to the man sitting in the front row ...
she drinks another cup of water.

     ... I have to get up again without having relieved
     myself of the tension, and the chase starts again.
     I have to find another loo ... these dreams are
     full of anxiety and tension ...

On the monitor the performer is seen entering the toilet ...
sounds of urinating and flushing of the toilet ...

     ... The last time I had this dream was last week
     actually, I was in Leeds.  I was due to do a
     performance the next morning and I spent the whole
     night having this unpleasant dream and not being
     able to sleep ...

She offers a cup of water to the woman with the bleached
hair ... she drinks another one herself.

     ... I suppose to find an explanation for all this
     anxiety in the dream I could go back to my toilet
     training days ... it is the time when we are taught
     to keep our bodily functions under control ... but
     I suppose in a wider social context it is the fear of
     losing control over one's involuntary actions or
     reactions which is not allowed in a formal social
     context ... it's to do with control and relaxation,
     the level of tolerance being defined by the society
     we live in ...

She forces another cup of water down her  ... she offers a
cup of water to the woman in the black sweater ...

     ... I couldn't have chosen a better place to do this
     performance.  Have you noticed the sound of all this
     water trickling above your heads ... it sounds like
     we're under a sewer or something ...

She spends the rest of the evening going to the toilet.

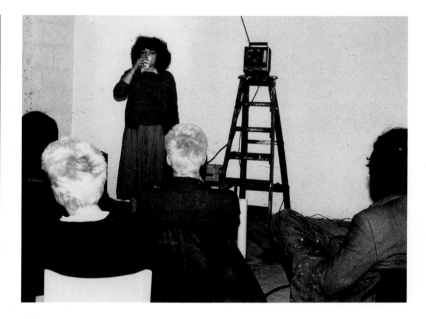

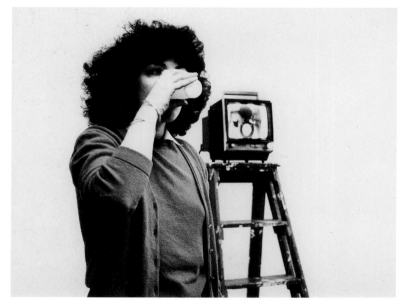

**Do-It, Home Version  1996**

**Do-It, Home Version**
1996
Ink on paper
29.5 x 21 cm
Proposal for Hans Ulrich Obrist's
'Do It'; censored from the
Reykjavík Municipal Art Museum's
exhibition catalogue

HOW TO TURN YOUR ORDINARY KITCHEN UTENSILS INTO
MODERN ELECTRICAL APPLIANCES

extract from *Surviving in the 90 s* by Mona Hatoum

Easy to follow step by step instructions:

- Take your favourite steel colander.

- Take a 2 meter length of dual
  electrical wire for a light bulb.

- Separate the cords of the electrical
  wire for a length of about 50 cm
  down the middle part.

- Cut one of the cords at centre point
  and connect one end of the cut
  cord to one handle of your steel
  colander.  Connect the other end to
  the opposite handle. (see diagram)

- Fit an electrical plug to one end of
  the wire and a light fitting and bulb
  to the other end of the wire.  The
  purpose of the light bulb is to
  indicate when your appliance is on.

- Plug in and enjoy!

NOT RECOMMENDED:
for anyone who hasn't got a clue!

RECOMMENDED:
for euthanasia enthusiasts.

Next week: hints from *How to Cook Yourself* cookbook by Gerry Collins

PLUG

STEEL
COLANDER

LIGHT BULB

# Under Siege 1983

*Extracts from an interview:*
M: I like to walk through London with friends.
*What do you talk about when you're walking?*
M: We don't talk, we shout.
*I'm sorry, I don't understand.*

*What do you think about the Western media?*
M: I like the entertaining and imaginative fiction programmes.
*For example?*
M: News reporting.

M: I spend day after day on the phone, dialling and redialling.
*Who are you calling?*
M: I'm trying to locate my parents.
*Why is it such a problem phoning home?*
M: I'm not phoning home.
*I'm sorry, I don't understand.*

*Do you visit your parents often?*
M: It's a nightmare when I do. I went to Beirut looking for my parents and in the wreckage of their home I found two plastic boxes – a pink one and a blue one. I opened the blue box and it was full of tiny toy soldiers that exploded out into the air around me becoming a cloud of flies that took on the shape of a black gravestone – 'We were only obeying orders!' I heard them say. There were two names on the stone, but as I strained to read them they began to pulsate in a rhythmic heartbeat that faded away. I struck out at the black stone, trying to smash it as agonizing screams rose up around me. When I turned back to the pink box, the lid was open disgorging human entrails in an endless stream. I heard my mother's voice saying, 'They were disembowelling pregnant women, that's why we had to leave'.

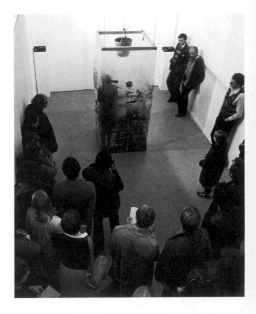

'Under Siege' London, 31 May 1982  (Description of work)
A human figure reduced to a form covered in clay, trapped, confined within a small structure, struggling to stand up again and again … slipping and falling again and again … The live action was repeated over a duration of seven hours and was accompanied by three different sound tapes repeatedly blasting the space from different directions creating a collage of sounds: revolutionary songs, news reports and statements in English, French and Arabic.

As a Palestinian woman this work was my first attempt at making a statement about a persistent struggle to survive in a continuous state of siege. Members of the audience, according to their own background, spoke of various powerful images of oppression: the Irish hunger strikes, prisoners in solitary confinement, Bantustans…

Thinking about this work in retrospect, I feel it marked a phase of transition and acted as *rite de passage* …

As a person from the 'Third World', living in the West, existing on the margin of European society and alienated from my own … this action represented an act of separation … stepping out of an acquired frame of reference and into a space which acted as a point of reconnection and reconciliation with my own background and the bloody history of my own people … A week later came the invasion of Lebanon, the siege of Beirut and the horrific events that followed, making the extent of their suffering clearly visible.

From a leaflet published by the artist to accompany her first performance tour in Canada, 1983.

Under Siege
1982
3-hour performance, Aspex
Gallery, Portsmouth

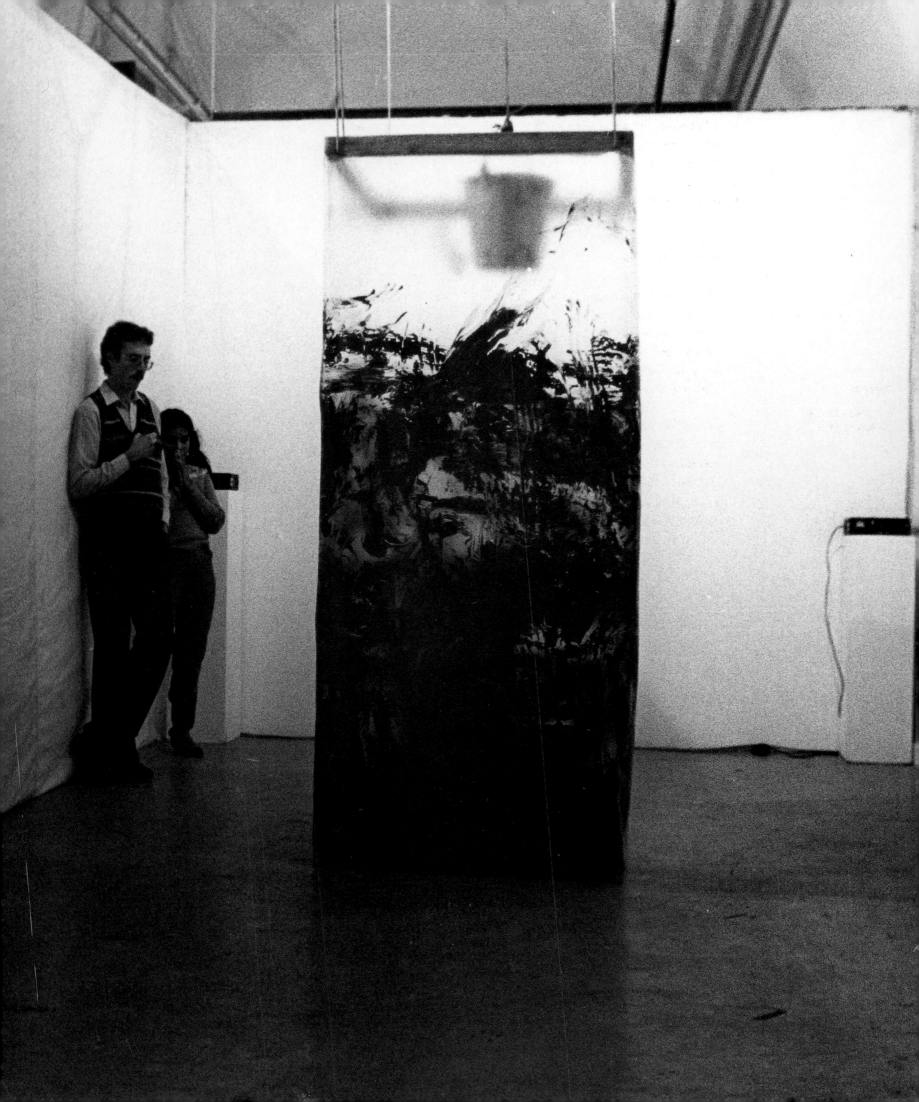

## Interview with Sara Diamond 1987

Mona Hatoum What I like about performance is that the work is impermanent and the emphasis is on communication and a direct rapport or interaction with the audience without the mediation of an art object. Afterwards, it's all dismantled and all that remains is a memory in the mind of the spectator. This is how things are in life: they come and go and the memory fades or gets transformed in time by people according to their own experience and background and what they bring to it and how they interpret it.

So I was really attracted to this challenge or critique of conventional art forms, and to the subversive element in performance. But I'm still aware that even with this kind of work there's still the mediation of the institution and this is becoming more and more the case since performance has become legitimized by the art world.

Sara Diamond Do you change every performance depending on the context?

Hatoum I have usually done a performance for a space and that's it. But the last time I came to North America, I had six galleries to work in (five in Canada and one in New York). I decided to do something that could be adapted to any space. Although there were lots of variations – it was entitled *Variation on Discord and Divisions* – after the fourth performance it became like a routine. I've never experienced that before because I don't usually like doing the same piece twice [ … ]

Diamond Your work deals with issues of displacement, war and the experience of victims of war. How do you keep working with and developing these themes?

Hatoum I keep hearing about 'Keeping the Peace'. We keep hearing this in relation to the Campaign for Nuclear Disarmament (CND). The implication is that we've had peace for forty years and we want to keep it. I feel very cynical about this concept of 'Keeping the Peace' because in my experience there hasn't been a year without war since the day I was born. It's not just the experience of Lebanon but many parts of the Third World, which makes me wonder sometimes whether their definition of the world is just the West. There's nothing more violent than dying of hunger. I don't call that a state of peace.

I am not a pacifist. I think that people who are pacifists accept the idea of nations as they are at the moment. They are the privileged ones who have an interest in keeping things as they are. They are basically saying 'The situation is okay, but we want to have a guarantee of peace'.

My work often refers to hostile realities, war, destruction, but it is not localized, it

<div style="text-align: right">

Variation on Discord and
Divisions
1984
40-min. performance, the
Western Front, Vancouver

</div>

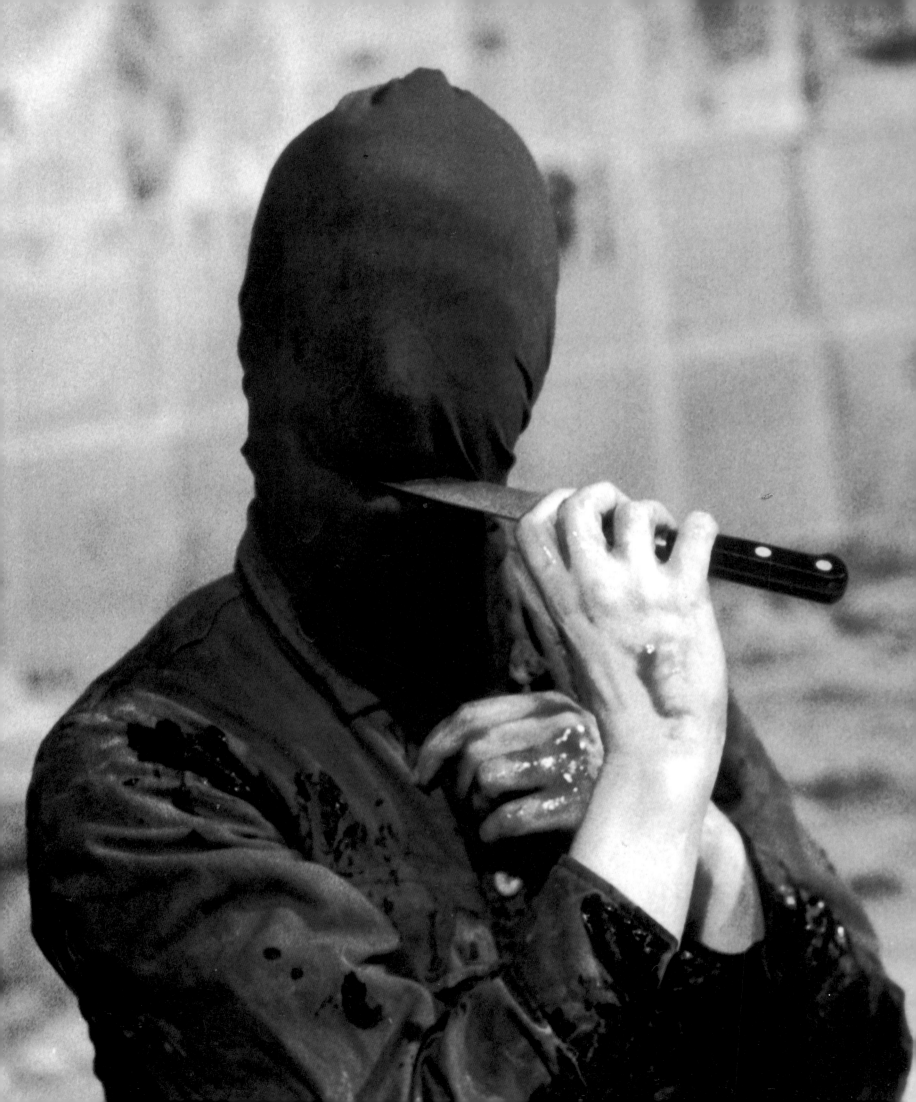

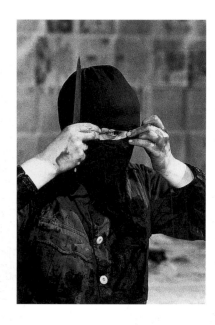

**Variation on Discord and
Divisions**
1984
40-min. performance, the
Western Front, Vancouver

refers to conflicts all over the world while hopefully pointing out the forces of oppression and resistance to these forces – cultural, historical, economic and social forces. In fact I can think of only one piece which referred specifically to the invasion of Lebanon. It was entitled *The Negotiating Table*, and it was more like a 'tableau vivant'. I was lying on a table covered with entrails, bandages and blood and wrapped up in a body bag. There were chairs around the table and sound tapes of speeches of Western leaders talking about peace. It was basically a juxtaposition of two elements, one referring to the physical reality and brutality of the situation and the other to the way it is represented and dealt with in the West. This piece was the most direct reference I had ever made to the war in Lebanon. I made this work right after the Israeli invasion and the massacres in the camps, which for me was the most shattering experience of my life.

But in general my work is about my experience of living in the West as a person from the Third World, about being an outsider, about occupying a marginal position, being excluded, being defined as 'Other' or as one of 'Them'. I work with black groups in London on shared issues of colonialism, imperialism, racism and the stereotyping of people from other cultures.

**Diamond** In producing the work that you did last year at the Western Front and the one you described previously, what do you want your audience to learn from the work?

Hatoum I want to remind the audience that there are different realities that people have to live through. The video, *Changing Parts*, which was produced at the Western Front during my residency last year, is about such different realities – the big contrast between a privileged space, like the West, and the Third World where there's death, destruction, hunger. But I don't think that any artist's work is going to move armies. I don't have any illusions about that. If the work creates an awareness of certain issues, a questioning in the mind of the spectator of certain assumptions, then that's something – I don't think that an art work will provoke political action.

**Diamond** Could you elaborate on that? I think some artists whose politics are very much engaged in what they produce do see their work as having almost an agitational role, that it will inspire people to act or deal with issues.

Hatoum I feel you can only inspire people to act if they share with you a common concern, if they are directly affected by the issues you are talking about. I have worked a lot

*following pages*,
**The Negotiating Table**
1983
3-hour performance, the Western
Front, Vancouver

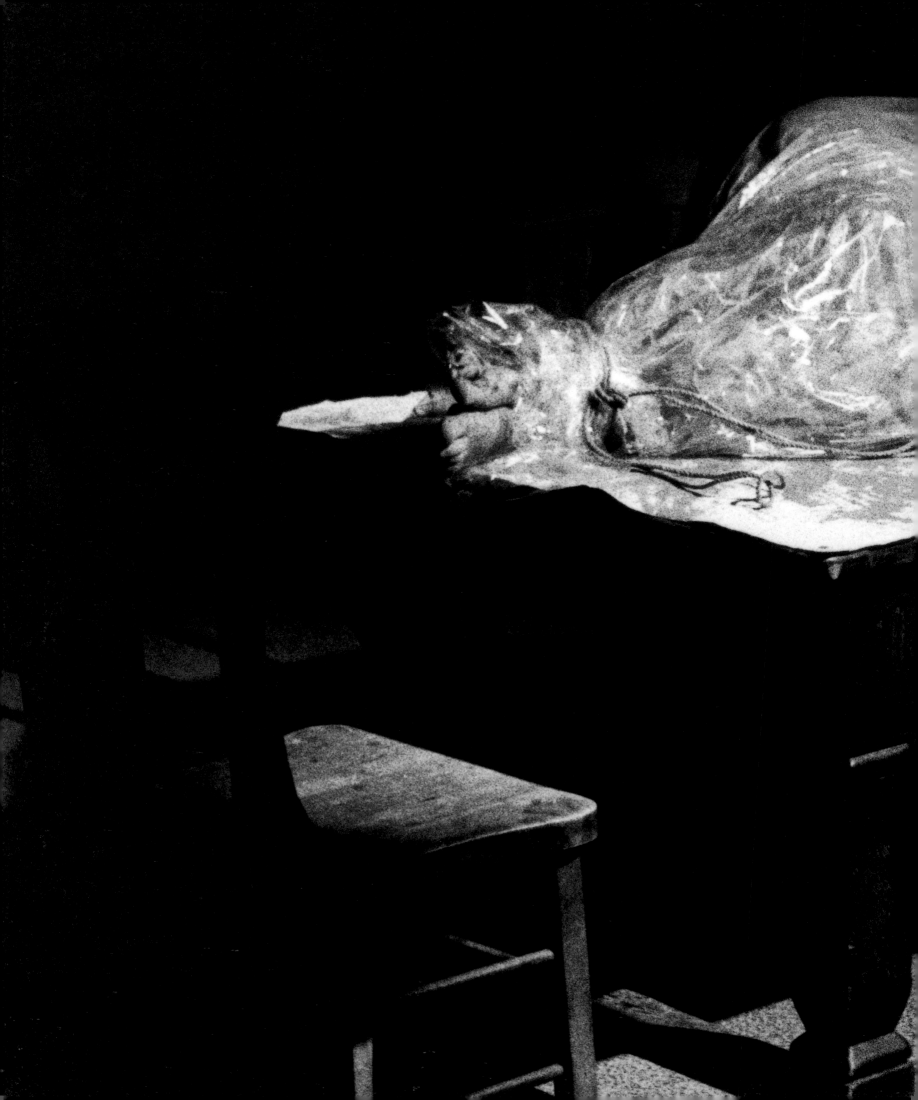

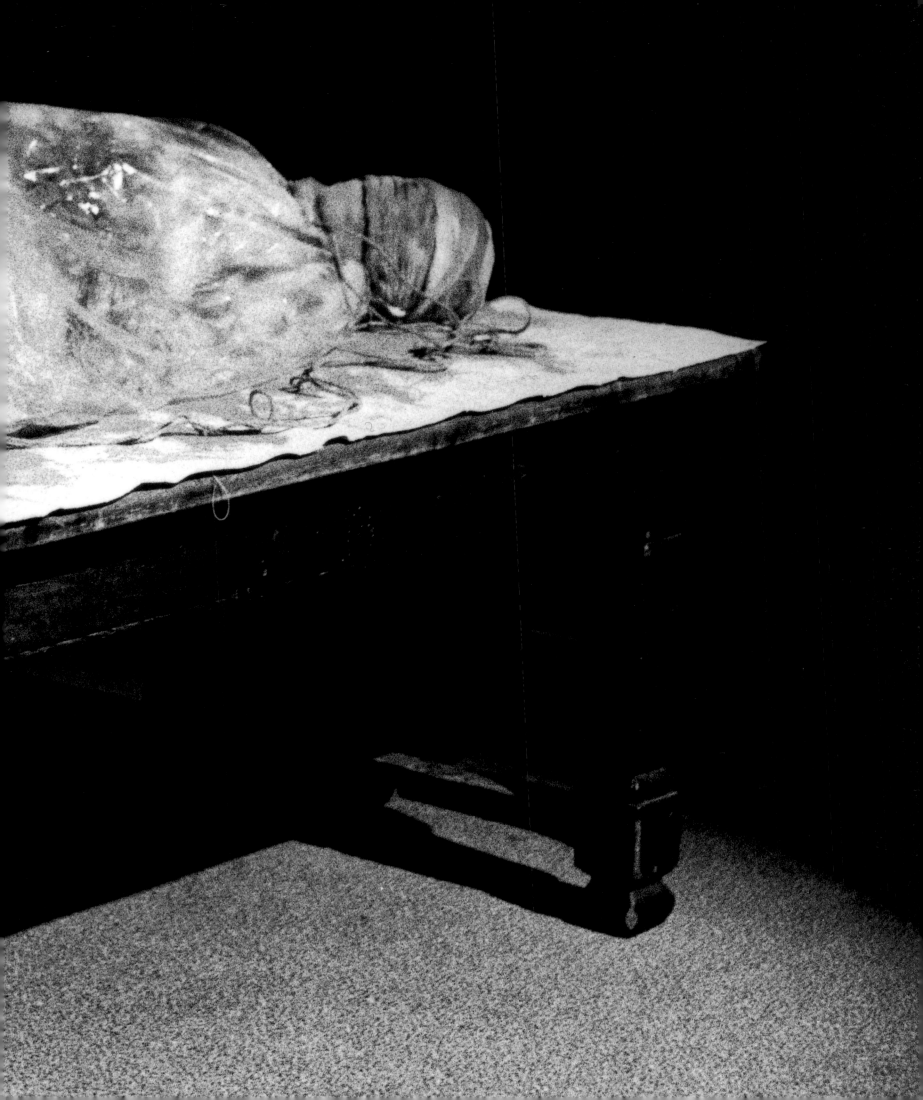

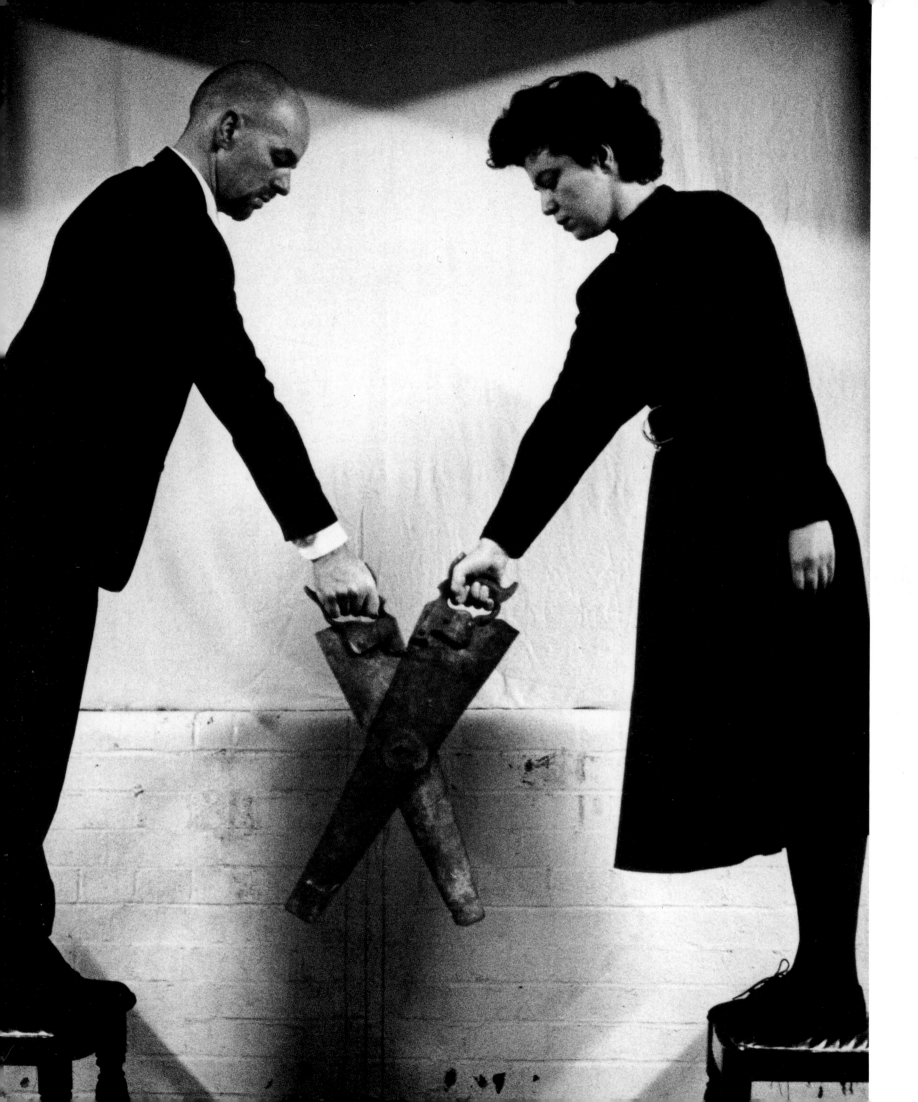

**Crosstalk,** with Stefan Szczelkun
1986
Two chairs, two saws bolted
together
30-min. performance, *opposite,*
Chisenhale Dance Space, London;
*right,* from 'Streets Alive',
Sheffield

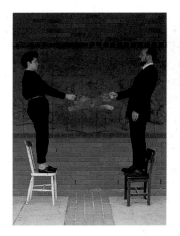
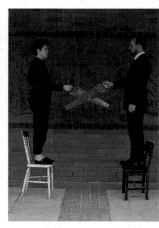

with political groups in the past and I found that you only get support from other groups
of people who are dealing with similar issues. So in a sense, there too you are preaching
to the converted. You don't win people over just by presenting them with a carefully
thought-out argument even if you are using the most direct and simple language.

I'd like to tie this in to the issue of working outside the art establishment. I recently
took part in an event called 'Roadworks' which was taking place in the streets of
Brixton. I found the freedom of working outside the confines of an isolating gallery
environment, and the very different nature of the audience, very satisfying. Basically
the audience was the people on the street, a non-specialized, chance audience casually
experiencing the artists' actions while passing by. But also because the Brixton
community is predominantly a black community, I found myself in this rare situation of
creating work which although personal/autobiographical, had immediate relevance to
the community it was addressing. I found that I was working 'for' the people in the
streets of Brixton rather than 'against' the indifferent, often hostile audiences I usually
encounter in the art world [ … ] In one of the pieces I walked around barefoot, dragging
a pair of Doc Marten boots attached to my ankles – that's what the police wear. These
boots have become a symbol of the fascists because the National Front wear them as
well. I just walked around an area of three blocks, in and out of the street market there. I
got very good comments.

Diamond  How did your audience respond? Did people follow you? Did they stick with you?

Hatoum  One comment I really liked was when a group of builders, standing having
their lunch break, said, 'What the hell is happening here? What is she up to?' And this
black woman, passing by with her shopping, said to them, 'Well, it's obvious. She's
being followed by the police'. Very cool, and just went off. One guy came up to me and
said, 'Excuse me. Do you know you're being followed?' And old people with their
shopping, stopping and watching as I went past would suddenly burst out laughing, or
people would come and look inside the boots to see what was in there.

Diamond  To what extent is your presence central to making the piece work as a
statement? Why do you always perform alone?

Hatoum  My presence is important because my attitude towards performance is that
the artist is being herself, making her own statement and not pretending to be

someone else, somewhere else. When you get people to do it for you it becomes a theatre piece. They are acting out something that you've scripted for them. I never script anything. I just have an idea and I hope for the best, and if while I am actually doing the performance things don't work out as I'd hoped, if the circumstances or the audience's reaction tell me that I should make changes, I am quite often open to that and work with it. For that reason it doesn't ever occur to me to ask someone to do my performances for me. I feel that the work is presenting my own view of the world according to my own history and past experience [ … ]

When I went to the States in 1983, I was amazed to see how much performance was entertainment-oriented. I felt the Hollywood influence was travelling right across the whole American culture. But this influence has travelled across the Atlantic and the situation in England is very much the same now. There are none of these unstructured, chaotic, anarchic interventions any more.

**Diamond** The role of choreography and scripting is much heavier. The level where it's random, or where that edge that you describe exists, is when artists don't have the budget or six months to rehearse.

Hatoum **Six years ago I used to send documentation of previous works to galleries and say I'd like to do something there. It was OK then to just turn up and do something and be invited on the strength of your previous work. Now they ask you for an advance, really precise description of what you will be doing and sometimes they want it six months ahead. So if you are creating a site-specific piece and you say that you'll be working on it till the last minute, that's not on at all. The Midland Group recently decided that it can't trust artists just by looking at the documentation they send, it doesn't want to take any risk so the Group organizes audition days – the performer goes, presents the actual performance and gets selected or rejected. It's just like theatre. They say, 'We want you to premiere your piece in our gallery'. The implication is that the performance gets repeated again and again and again.**

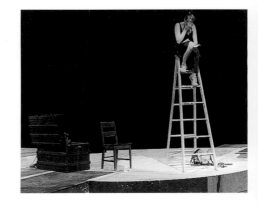

**Diamond** Your work is very disciplined and you combine formal elements of performance with political content. How have you trained yourself and how do you maintain your discipline?

Hatoum **Training has been the subject of much debate in England recently. I was trained**

**Live Work for the Black Room**
1981
45-min. performance, Reading University

as a visual artist and I consider myself to be a visual artist. I've never actually trained to walk or move or act in a specific way and I don't see the necessity of that. I don't think my performances are about exhibiting a skill that others don't have. I feel each performance requires different things of me and because I don't rehearse, it is always a challenge for me to see if I can actually perform the intended action for the length of time and within the conditions I set up. So it is very much a process of discovery; in a sense I learn about what I can do while I am doing it. I haven't had any formal training in movement, dance or theatre. I would like to have more technical knowledge, of how to make multi-track sound recordings for instance, and I will probably do a course about that or advanced video-editing techniques [ … ]

Performance artists have always brought different disciplines to their area, but I don't think it is necessary to have any extensive training or any special 'performing' skills. Generally there is a call for making things more polished, more skillful, more formally spot-on. But of course there are some people who have some skills and use them effectively without it becoming just a display of those skills. A very good example is Rose English. She's wonderful!

*Fuse*, Toronto, April 1987, pp. 46-52

**Rose English**
Plato's Chair
1983
Performance, Montréal

Interview with Claudia Spinelli  1996

[ … ] **Claudia Spinelli**  To what extent do your specific cultural background and your biography influence your work?

Mona Hatoum  **It is a question I am often asked and find difficult to answer. In my work in general and with very few exceptions, there isn't a conscious effort on my part to speak directly about my background and history. But the fact that I grew up in a war-torn country; the fact that my family was displaced, a Palestinian family that ended up living in exile in Lebanon, has obviously shaped the way I perceive the world. It comes into my work as a feeling of unsettledness. The feeling of not being able to take anything for granted, even doubting the solidity of the ground you walk on. In one installation entitled *Light Sentence* you feel as if the ground is shifting under your feet. It is only after I made this work that I started reading some possible connection with my background or my own experience of unsettledness and this feeling of a constantly shifting or even threatening environment. This is about the level in which my background or biography might come into my work.**

**Spinelli**  Political and social themes are very important in your work. Do you think your sensitivity to such matters has something to do with your background?

Hatoum  **My awareness of political social issues came, I suppose partly, from analysing and reflecting on my position and daily reality of existing in a Western culture which is not my own. In the early 1980s I was mostly working in the area of performance which at the time had a subversive edge to it. I was trying to make political comment through my work. I saw myself as a marginal person and I saw performance as a kind of intervention from the margins of the art world. But, by the mid 1980s, I felt that performance as a medium had become quite institutionalised and had lost its critical edge. Also, I was beginning to favour a more measured and considered approach where an idea could develop and go through a process of refinement before it is presented in public. I started making installations where, I feel, I was still dealing with the same issues but they became more implied in the work rather than directly stated. There was also at that point a shift from a situation of representation to a desire to create an actual and real situation that the audience could experience directly for themselves. I wanted to explore the phenomenology of the space and materials to create a direct physical interaction – a kind of gut reaction to the situation before the process of questioning and associations begins … For instance, in the installation *Light Sentence***

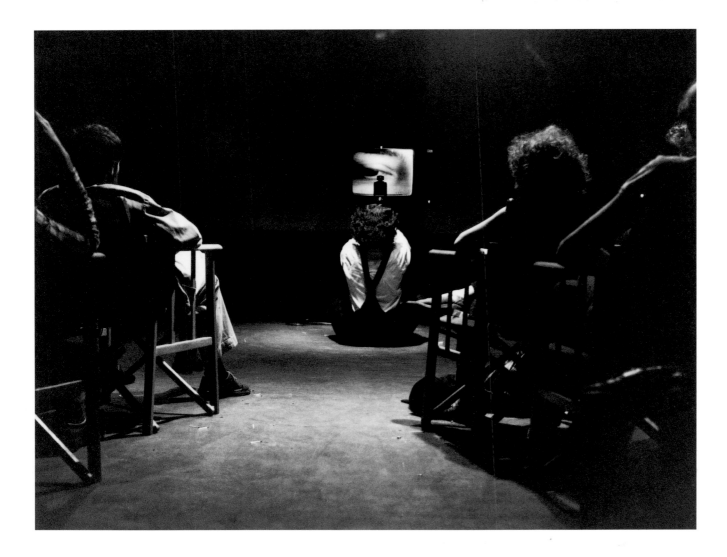

**Video Performance**
1980
Performance with live video
camera, monitor, video deck, pre-
recorded video tape, London
Filmmakers Co-op

the spectator becomes enmeshed in the shadows of the cages and imprisoned by the structure. And in an installation like *The Light at the End*, when you experience the intense heat projected by the electric heating elements forming the bars of a gate, you can almost feel the physical pain that someone in a situation of imprisonment and torture could feel. What I mean is that, here, I am not pointing my finger at a specific situation of imprisonment somewhere else, but creating a situation which would hopefully trigger those associations in the spectator's mind. So the political issues are quite important but I do not like to deal with them in a didactic way.

Spinelli  But wouldn't this direct interaction with the audience also be possible in the context of a performance … ?

Hatoum  I got disillusioned with the kind of confrontational performances I was making at the time because I realised after a while that the strategy of knocking people on the head with a message was not necessarily a good one. Also, at one point I was doing long and physically demanding performances. As in, for instance, *Under Siege* where I was struggling in the mud in an enclosed structure for a whole day – seven hours or so. It was of course a metaphorical action. The action was accompanied by a sound tape with fragments of news reports speaking of war, invasion and being under siege … but people didn't necessarily always make the connection to the wider political issues. They saw it as representing the angst of the struggling artist. It sort of became too romantic and that became difficult for me to take.

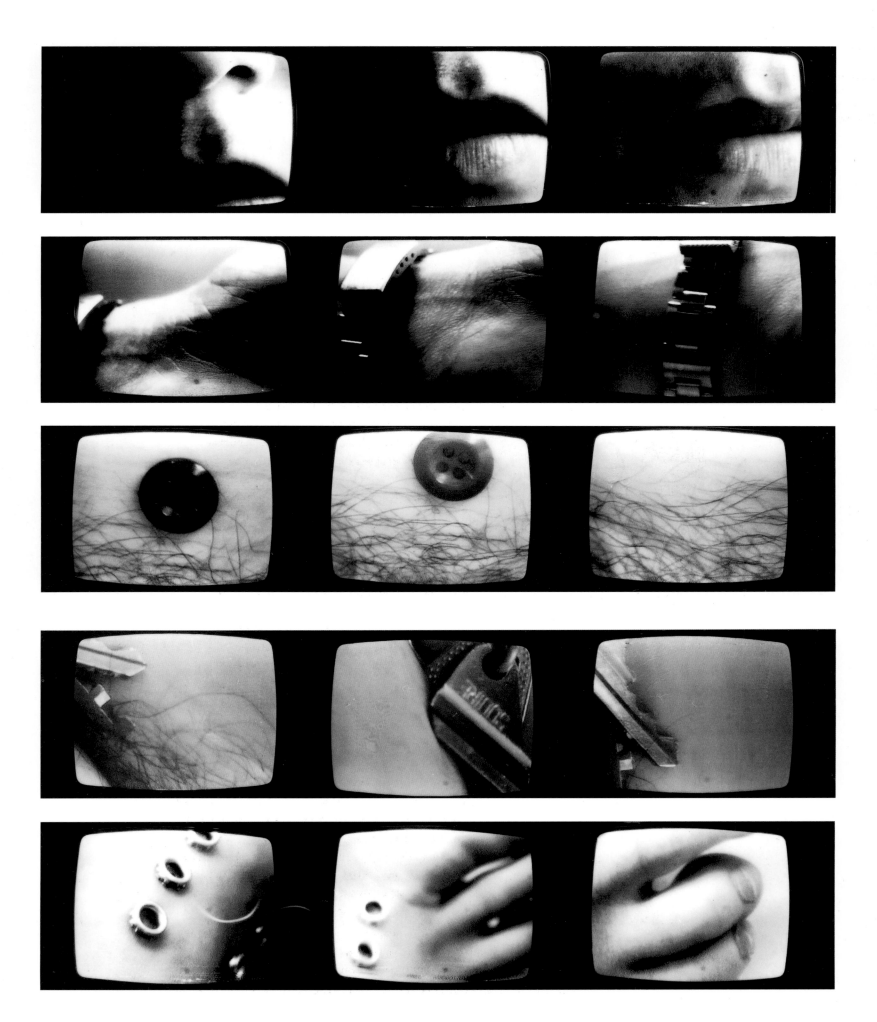

**Video Performance**
1980
Performance with live video
camera, monitor, video deck, pre-
recorded video tape, London
Filmmakers Co-op

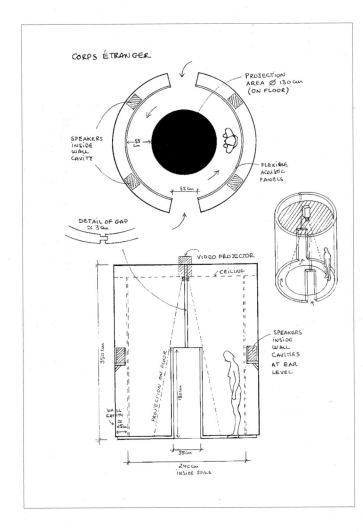

Corps étranger, technical
drawing
1994
Ink on paper
29.5 × 21 cm

**Spinelli**  Your *Corps étranger* is currently showing at the Contemporary Art Museum. How did this work come about?

**Hatoum**  **This piece has gone through many different changes and reasons for being. For a start, it is a piece I conceived when I was a student at the Slade School in London, and it was in the context of a number of other works I was making at the time which had to do with the issue of surveillance. Surveillance cameras, being observed, the eye of Big Brother ... This was in 1980. At the time, for instance, I was making works where I was putting surveillance cameras in toilets and then relaying the live image on a monitor in the bar area outside. So, people were sitting drinking at the bar and they could see themselves eventually pissing. Also, at that time, I made a series of performances where I would stand in front of an audience with a hand-held live video camera which I would point directly at them. They became the subject of the work. It was quite invasive. They could see themselves appearing on a large monitor. I had some helpers in another room who mixed the live images from my camera with naked torsos etc ... I was pretending that my camera could see through people's clothes. For instance I would focus on somebody's chest or crotch and the shirt or trousers would gradually fade away and you saw a naked chest, breasts or genitals on the video monitor. I was doing some 'gender bending' and mixing-up the genders, so that was fun ... but, basically there was this eery feeling that the camera could penetrate the layers of clothes and flesh, specially when I mixed in some X-ray images. It all came from a fantasy I had as a child. With a pair of binoculars, I used to spy on people passing by in the street. I used to wonder what would happen if my binoculars could see through the clothes and through the skin and through the flesh and through the bones. So in my imagination I would navigate through the layers of clothes and into the body.**

**It was during the time I was making these performances where I pretended I had a 'penetrating gaze', that I conceived the idea for *Corps étranger*. I actually made a formal**

proposal to my University – this was in 1980, and I managed to get some financial support to make a start. I shot some of the images of the outside surface of the body and did some sound recordings using specialized medical equipment (echography). Some of this sound I ended up using in the final version 13, 14 years later … But I could not, at the time, get any doctor to agree to do the endoscopic examination on me … so it was only in 1992 when a curator from the Centre Pompidou, who wanted to do a video production with me, actually managed to find an endoscopy specialist who agreed to film my insides that the whole thing became a reality. Of course some aspects of the work, specially on the level of the presentation, had changed since I first had the idea. I now wanted it to be a circular projection on the floor so you could actually walk on it. There is basically one sweeping short surveying the surface of the body in extreme close-up in a claustrophobic way. We then follow the camera as it penetrates inside the body through various orifices into the stomach, intestines, vagina … I wanted to give the feeling that the body becomes vulnerable in the face of the scientific eye, probing it, invading it's boundaries, objectifying it … on the other hand when you enter the room, in places, you feel like you are on the edge of an abyss that can swallow you up, the devouring womb, the vagina dentata, castration anxiety … there is a sense of threat which is something that is present in a lot of my work. But, as I said, it all started in the context of exploring ideas about surveillance. I felt that introducing the camera, which is a 'foreign body', inside the body would be the ultimate violation of a human being, not leaving a single corner unprobed. This is how it all developed.

**Spinelli** Apart from works dealing on a fundamental level with political themes, you've also produced the video *Measures of Distance*, which is closely connected with your own biography.

Hatoum  **Yes, for me it was not only the culmination of all the issue based work I had done up to that point but also the most narrative and the most complex work I have ever made. In the performance work, I was trying to make general statements about the relationship between the Third World and the West, and I was trying to keep my own story out of it. With *Measures of Distance* it was a conscious decision to take a very personal point of view, to use autobiography as a resource.**

**One reason for doing this work was because whenever I watched news reports about Lebanon, I was struck by how the Arabs were always shown en masse with mostly hysterical women crying over dead bodies. We rarely heard about the personal**

Corps étranger
1994
Video installation with
cylindrical wooden structure,
video projector, video player,
amplifier, four speakers
350 × 300 × 300 cm
Collection Musée national d'art
moderne, Centre Georges
Pompidou, Paris

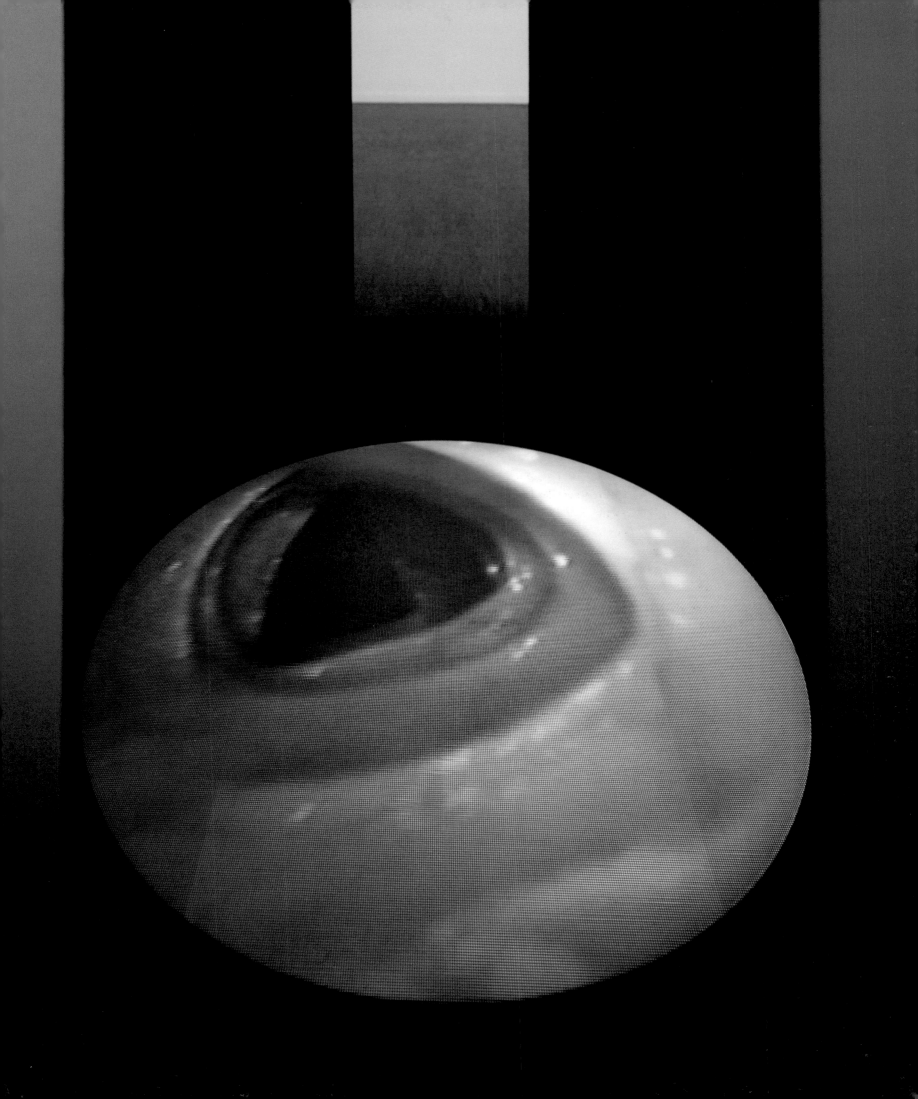

feelings of those who lost their relatives. It is as if people from the Third World are seen as a mass or a herd and not as individuals. Of course I was also influenced by the feminist slogan 'the personal is political'. The work was constructed around letters from my mother in Beirut to myself in London and a dozen slides I took of my mother under the shower. Although the main thing that comes across is a very close and emotional relationship between mother and daughter, it also speaks of exile, displacement, disorientation and a tremendous sense of loss as a result of the separation caused by the war. In this work I was also trying to go against the fixed identity that is usually implied in the stereotype of Arab woman as passive, mother as a non-sexual being … the work is constructed visually in such a way that every frame speaks of literal closeness and implied distance. The closeup images of my mother under the shower, a closeness also echoed by the intimacy of the exchange between my mother and myself, she is speaking openly of her feelings and answering some intimate questions about her sexuality. Her letters in Arabic appear over her image and look like barbed wire or a veil that prevents total access to the image yet they are the only means of communication. Letters also imply distance. The sound-track on the video is of me reading her letters in English, in a sad and monotonous voice which is contrasted with laughter and animated Arabic conversation that took place between us. The Arabic conversation is given as much emphasis as the English text creating a difficult and alienating situation for a Western audience who have to strain to follow the narrative. So this was a very complex and layered work. And, having put this complex story, my story, into one piece of work it became a relief from a burden. I felt I was able after that to get on with a different kind of work which I find more satisfying. I started making work which is more phenomenological and privileges the physical manipulation of materials to embody my concerns. And I felt that each work did not have to tell the whole complex story but could take only one little aspect of it.

**Spinelli** Almost all your works deal with the body, a central theme in today's artistic context. What's the relationship between your works and these trends?

**Hatoum** I think recently in Western culture, there is a heightened awareness of the body. I personally feel it is a direct result of the AIDS epidemic which has made us all reflect on our own vulnerability and mortality. We cannot pretend to be invincible any more. But for me, ever since the late 1970s when I was still a student, I was very much experimenting with the body as a source material (as in using hair, body fluids as

*following pages*, **Corps étranger**
1994
Video installation with
cylindrical wooden structure,
video projector, video player,
amplifier, four speakers
350 × 300 × 300 cm
Collection Musée national d'art
moderne, Centre Georges
Pompidou, Paris

material in the work) or using the body in my performance work as a site of struggle and a metaphor for social struggle. And generally speaking I have always insisted on the presence of the body in my work. I think it is because I come from a culture where there isn't that tremendous split between body and mind. When I first went to England it became immediately apparent to me that people were quite divorced from their bodies and very caught up in their heads, like disembodied intellects. So I was always insisting on the physical in my work. I did not want my work to be one-dimensional in the sense that it just appeals to the intellect. I wanted it to be a complete experience that involves your body, your senses, your mind, your emotions, everything. I think this has very much to do with the culture I grew up in where there is more of an integration between body and mind.

**Spinelli**  What's your relationship towards feminism and feminist theory?

Hatoum  **Well, in early feminism the attitude was that any way of representing a woman's body is exploitative and objectifying. This question had to be reassessed later on because women vacated the frame and became invisible in a sense. When I made *Measures of Distance*, the video with my mother, I was criticised by some feminists for using the naked female body. I was accused of being exploitative and fragmenting the body as they do in pornography. I felt this was a very narrow minded and literal interpretation of feminist theory. I saw my work as a celebration of the beauty of the opulent body of an aging woman who resembles the Venus of Willendorf – not exactly the standard of beauty we see in the media. And if you take the work as a whole, it builds up a wonderful and complete image of that woman's personality, needs, emotions, longings, beliefs and puts her very much in a social context.**

**I have to say that I do not think that much about the issue of sexual difference. For me my involvement in feminism was like a jumping-board towards investigating power structures on a wider level as in the relationship between the Third World and the West and the issue of race; and of course I very quickly realised that the issues and discussions within Western feminism were not necessarily relevant to women from less privileged parts of the world. So in my work I cannot say that I got involved in gender issues specifically.**

*Kunst-Bulletin*, Zurich, September 1996, pp. 16–23

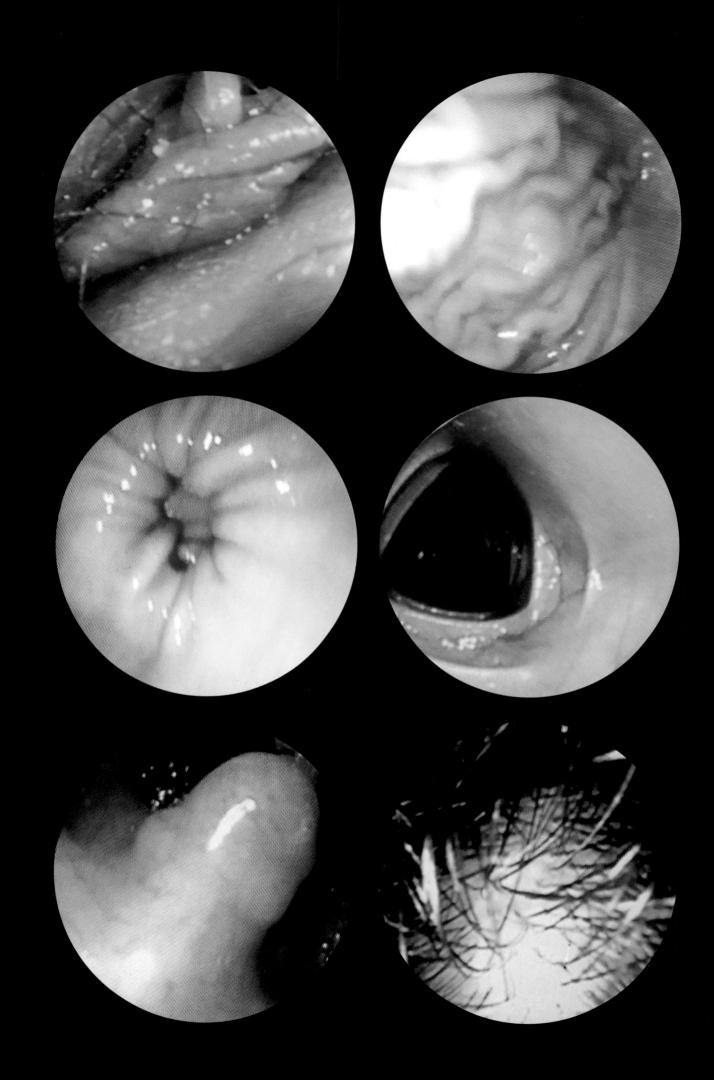

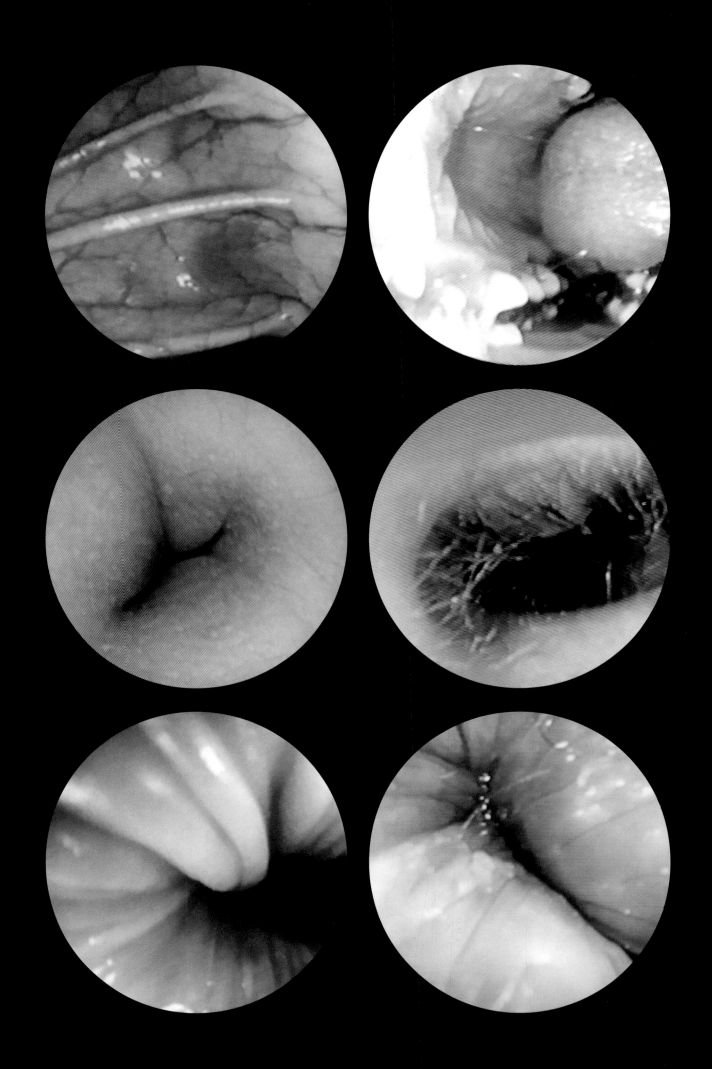

# Contents

## Selected exhibitions and projects
### 1970-83

**1970–72**
Beirut University College, Beirut

**1975–79**
The Byam Shaw School of Art, London

**1979–81**
The Slade School of Art, London

**1980**
Performance, 'Don't Smile You're on Camera',
'Five Days at Battersea', **Battersea Arts Centre**,
London, with Paul Jackson (group)

Performance, 'Video Performance',
'Summer Show '80',
**London Filmmakers Co-op**, London (group)

**1981**
Performance, 'Anything you can do...',
'Gender Views', **London Filmmakers Co-op**, London,
with Brenda Martin (group)

'New Contemporaries '81',
**Institute of Contemporary Arts**, London (group)
Cat. *New Contemporaries*, Institute of Contemporary
Arts, London, text Richard Francis

Performance, 'Look No Body!',
**Basement Gallery**, Newcastle Upon Tyne (solo)

'Video Maart',
**Jan Van Eyck Video Studio**, Maastricht, The
Netherlands (group)
Cat. *Video Maart*, Jan Van Eyck Video Studio,
Maastricht, The Netherlands, texts Elsa Stansfield,
David Hall et al.

Installation, 'Waterworks',
'Summer Show '81',
**London Filmmakers Co-op**, London (group)

**1982**
Performance, 'Under Siege', *
'Women Live', **London Filmmakers Co-op**, London
(group)

'Reflections',
**Aspex Gallery**, Portsmouth (group)
Cat. *Reflections*, Aspex Gallery, Portsmouth, artists'
statements

**1983**
Performance, 'An Hour in the Day of Another Bloody
Year',
'Blind Dates', **The Blackie**, Liverpool (group)

Performance, 'The Negotiating Table',
**Saw Gallery**, Ottawa, Canada; **N.A.C.**, St Catherines,

## Selected articles and interviews
### 1970-83

**1980**
Roberts, John, 'Five Days at Battersea Arts Centre', *Art Monthly*, No 36, London, May

Elwes, Catherine, 'Notes from a Video Performance by Mona Hatoum', *Undercut*, No 1, London, March/April

**1981**
Roberts, John, 'Madness at Home: Recent Performance', *Artscribe*, No 28, London, March

**1982**
'Naked in Red Slime', *The News*, Portsmouth, 29 September
Nurse, Keith, 'Row Over Vanishing Naked Artist', *Daily Telegraph*, London, 1 October
'Artist Mona's Naked Feat of Clay', *Daily Star*, London, 1 October
'Two New Schemes to Put a Drain on Your Money: And How Plunging into Clay Gets an Art Grant', *Daily Mail*, London, 1 October
'Nude has Ticket to Writhe', *The Sun*, London, 1 October
'Feat of Clay Struggling Naked in a Mess of Meaning', *The News*, Portsmouth, 4 October

**1983**
Erskine, Evelyn, 'Audience Feels Impact of Vigil-like Performance', *The Citizen*, Ottawa, Canada, 24

## Selected exhibitions and projects
### 1983-86

Canada; **The Western Front**, Vancouver (solo)

Text, 'Media Outrage', *Performance Magazine*, No 22, London, February/March

### 1984
Performance, 'Them and Us ... and Other Divisions', '2nd International Festival of Performance', **South Hill Park Arts Centre**, Bracknell, Berkshire (group)

Performance, 'Worlds Apart', **Rochdale Art Gallery**, Rochdale, United Kingdom (group)

Performance, 'The Negotiating Table', **Franklin Furnace**, New York (solo)

Performance, 'Variation on Discord and Divisions', **ABC No Rio**, New York; **A.K.A.**, Saskatoon, Canada; **The Western Front**, Vancouver; **Articule**, Montréal, (solo)

Residency, video 'Changing Parts', **The Western Front**, Vancouver (solo)

### 1985
Performance, 'Variation on Discord and Divisions', 'Dazzling Phrases: Six Performance Artists', **Forest City Gallery**, London, Canada; **Art Gallery of Windsor**, Canada (group)
Cat. *Dazzling Phrases: Six Performance Artists*, Forest City Gallery, London, Canada, text Robert McKaskell

'1985 Exhibition of Canadian Video Art', **S.A.W. Gallery**, Ottawa, Canada (group)

'Kunst Mit Eigen-Sinn', **Museum Moderner Kunst**, Vienna (group)
Cat. *Kunst Mit Eigen-Sinn*, Museum Moderner Kunst, Vienna, texts Valie Export, Luce Irigaray et al.

'Roadworks', Brixton, London (group)

'May Events', **Art and Research Exchange**, Belfast, Northern Ireland (group)

Performance, 'Between the Lines', **Orchard Gallery**, Derry, Northern Ireland (solo)

### 1986
Performance, 'Position Suspended' 'New Work, Newcastle '86', Festival of Performance Work organised by Projects U.K., **Laing Art Gallery**, Newcastle (group)
Booklet, *New Work, Newcastle '86*, Laing Art Gallery, Newcastle, texts Rob La Frenais et al.

## Selected articles and interviews
### 1983-86

November
Roussel, Dominique, 'Hatoum Approach Brings Urgence', *The Fulcrum*, Ottawa, Canada, 1 December

### 1984
Pollitt, Nigel, *City Limits*, No 144, London, 6–12 July
Briers, David, 'Highlands and Deserts: A Performance Pilgrimage', *Performance Magazine*, No 31, London, September/October

*The Windsor Star*, Windsor, Canada, 31 January
*The Gazette*, Montréal, 1 February
*The Saturday Windsor Star*, Windsor, Canada, 2 February
*Le Journal de Montréal*, 2 February
Rigby Watson, Petra, 'Review', *Vanguard*, Vancouver, March
Rans, Goldie, 'The Paradigmatic Phrase: Performance Art', *Vanguard Magazine*, Vancouver, October
Lee, Roger, 'Mona Hatoum', *Parallelogramme*, Vol 10, Toronto, April/May

### 1985

Pevere, Geoff, 'Collision in the Capital', *Fuse*, Vol 9, No 1/2, Toronto, Summer
Burwell, P. D., 'Hostile Realities', *High Performance*, Issue 30, Vol 8, No 2, Santa Monica

Brett, Guy, 'Roadworks at Brixton Art Gallery', *Artscribe*, No 53, London, July/August

### 1986

## Selected exhibitions and projects
## 1986-87

'Next: Tomorrow',
**Kettles Yard; Cambridge Darkroom**, Cambridge (group)
Booklet, *Next: Tomorrow*, Kettles Yard; Cambridge
Darkroom, Cambridge, texts Michael Newman, John
Stezaker, Liz Wells

'Third World Within',
**Brixton Art Gallery**, London (group)

Performance, 'Mind the Gap',
'Identity/Desire, Representing the Body',
**Collins Gallery**, University of Strathclyde, Glasgow;
**Aberdeen Art Gallery and Museum; Crawford Centre
for the Arts**, University of St Andrews, Edinburgh;
**Maclaurin Art Gallery**, Ayr (group)
Booklet, *Identity/Desire, Representing the Body*,
Scottish Arts Council, text Nigel Walsh

Performance, 'Untitled',
'Strategies for Survival: State of the Arts/the Art of
Alternatives',
International artists conference, Vancouver (group)

Residency, **9.1.1. Contemporary Arts Centre**, Seattle
(solo)

Performance, 'On Target',
'Live Video', Amsterdam Summer Festival, **Time Based
Arts**, Amsterdam, with Claudio Goulart (group)

'Streets Alive',
performance festival in the streets of Sheffield
(group)

'Channel 6',
'Festival of Video',
presented by London Video Arts at **Institute of
Contemporary Arts**, London (group)
Cat. *Channel 6*, London Video Arts, texts Nick
Houghton et al.

'Conceptual Clothing',
**Ikon Gallery**, Birmingham; **Harris
Museum and Art Gallery**, Preston; **Peterborough City
Museum and Art Gallery; Spacex Gallery**, Exeter;
**Stoke on Trent City Museum and Art Gallery;
Aberdeen Art Gallery; Huddersfield Art Gallery;
Cartwright Hall Art Gallery**, Bradford; **Camden Arts
Centre**, London (group)
Cat. *Conceptual Clothing*, Ikon Gallery, Birmingham,
texts Fran Cottell, Marian Schoettle

### 1986–87
Residency, Chisenhale Dance Space, London

### 1987
Performance, 'Forced Flight',
**Chisenhale Dance Space**, London (group)

Installation, 'Hidden from Prying Eyes',
'At the Edge: Live Artists at Air', **Air Gallery**, London
(solo)

## Selected articles and interviews
## 1986-87

Stathatos, John, 'Does the Future Have an Image?',
*Creative Camera*, No 7, London

Creighton-Kelly, Chris, 'Strategies for Survival', *Fuse
Magazine*, Toronto, No 41, Summer
Diamond, Sara, 'An Interview with Mona Hatoum', *Fuse
Magazine*, Vol 10, No 5, Toronto, April

Wright, Annie, 'Imput/Output talks to Mona Hatoum',
*Input/Output*, Amsterdam, Summer

Marjoram, Bol, 'Mona Hatoum, Not an Entertainer',
*Performance Magazine*, No 41, London, May/June
Brett, Guy, 'Chiz Chic', *City Limits*, No 267, London,
23–30 October 1986

### 1987

Brett, Guy, 'Experiment or Institutionalisation',
*Performance Magazine*, No 47, London, May/June
David, Rose, 'Refugee Camp is Built in EC1', *The
Independent*, London, 7 April
Biggs, Simon, 'Video and Architecture', *Mediamatic*

## Selected exhibitions and projects
### 1987-88

Text, 'Body and Text', *Third Text*, No 1, London, Autumn

Performance, 'Mind the Gap',
'Figures', **Cambridge Darkroom**, Cambridge; **Milton Keynes Exhibition Gallery**; **Arts Centre**, Darlington (group)
Cat. *Figures*, Cambridge Darkroom, Cambridge, text Pavel Büchler

Installation, 'Hidden from Prying Eyes',
'Trans-Positions', **Leeds City Art Gallery** (group)

Performance, 'Matters of Gravity',
'National Reviews of Live Art', **Riverside Studios**, London (group)
Booklet, *The National Review of Live Art*, Riverside Studios, London, text Naseem Khan

'New Work. No Definition',
**Third Eye Centre**, Glasgow (group)

'State of the Nation',
**Herbert Art Gallery and Museum**, Coventry
Booklet, *State of the Nation*, Herbert Art Gallery and Museum, Coventry, text Sarah Selwood

Installation, 'Hidden from Prying Eyes',
'Siting Technology',
**Walter Phillips Gallery**, Banff, Canada; **McKenzie Art Gallery**, Regina, Canada (group)
Cat. *Siting Technology*, Walter Phillips Gallery, Banff, Canada, texts Richard Kasis, Daina Augaitis

'The Elusive Sign: British Avant Garde Film and Video 1977–1987',
British Council and The Arts Council International touring exhibition
Cat. *The Elusive Sign: British Avant Garde Film and Video 1977–1987*, British Council and The Arts Council, London, texts David Curtis, Michael O'Pray, Catherine Lacey, Tamara Krikorian

'Dislocations',
**Kettle's Yard**, Cambridge (group)
Booklet, *Dislocations*, Kettle's Yard, Cambridge, text Veronica Ryan

'Confrontations: The Role of Controversy in Art',
**Laing Art Gallery**, Newcastle; **Cartwright Hall**, Bradford; **The Corner House**, Manchester (group)

### 1988
'The Essential Black Art',
**Chisenhale Gallery**, London; **Laing Art Gallery**, Newcastle Upon Tyne; **Huddersfield Art Gallery**; **Herbert Art Gallery**, Coventry; **Gardner Art Centre**, Sussex University, Brighton; **Cooper Gallery**, Barnsley (group)
Cat. *The Essential Black Art*, Chisenhale Gallery, London, Black Umbrella, Kala Press, London, text Rasheed Araeen

'Nationalisms: Women and the State',
**A Space**, Toronto, Canada (group)

'Metro Billboard Project '88',

## Selected articles and interviews
### 1987-88

*Amsterdam*, Vol 2, No 4, June 1988

Rogers, Steve, 'The National Review of Live Art', *Performance*, No 50/51, London, November 1987/January 1988

1988

Christakos, Margaret, 'Identity and Resistance', *Fuse*, Vol 2, No 6, Toronto, July

MONA HATOUM

"MATTERS OF GRAVITY"

THIRD EYE CENTRE + STUDIO THEATRE   14/15/16 OCTOBER + THROUGHOUT + FREE

NO DEFINITION

# Dislocations

You are invited to the opening
Saturday 12 December 6.00-8.00pm

Simone Alexander, Zarina Bhimji, Mona Hatoum, Ruth Lakofski, Derek Mawudoku, Peter Robinson and Veronica Ryan

**Performance**
'Matters of Gravity', by Mona Hatoum
Saturday 12 December 2.00–8.00pm and at various times throughout the exhibition (contact the Gallery for details)

**Talk**
'The Politics of Multi-Racial Education', by Madan Zarup
Wednesday 20 January 7.00pm

**Panel discussion**
Sonia Boyce, Guy Brett and Veronica Ryan
Saturday 23 January 7.00pm

**Gallery talk**
Sarat Maharaj
Wednesday 27 January 7.00pm

Kettle's Yard Gallery
Castle Street
Cambridge CB3 0AQ
Tel 0223 352124

12.30–5.30 Tuesday – Saturday
(late night until 7.00pm Thursday)
2.00–5.30 Sunday

12 December – 7 February
Closed 24 December – 3 January
Admission free

STATE
OF THE
NATION

## Selected exhibitions and projects
### 1988-89

commissioned by Projects U.K., Newcastle (group)

Installation, 'Reflections on Value',
'Edge '88', International Festival of Experimental Art,
Clerkenwell, London (group)
Cat. *Edge '88, Performance Magazine*, London, ed.
Marjorie Althorpe Guyton

Installation, 'Reflections on Value',
**The Cornerhouse**, Manchester (solo)

'In an Unsafe Light',
**Ikon Gallery**, Birmingham (group)
Cat. *In an Unsafe Light*, Ikon Gallery, Birmingham, text
Pennina Barnett

'Along the Lines of Resistance: An Exhibition of
Contemporary Feminist Art',
**Cooper Gallery**, Barnsley (group)
Cat. *Along the Lines of Resistance: An Exhibition of
Contemporary Feminist Art*, Cooper Gallery, Barnsley,
texts Juliet Steyn, Pratibha Parmar

'Hi-Beam. Recent Video and Film for the Big Screen',
**Tate Gallery**, London (group)

### 1989–92
Senior Research Fellow in Fine Art, **Cardiff Institute of
Higher Education**

### 1989
'Uprising',
**Artists Space**, New York (group)

'Dissecting Voices',
**London Filmmakers Co-op**, London (group)

Installation, 'The Light at the End',
**The Showroom**, London; **Oboro Gallery**, Montréal (solo)

'Intimate Distance',
**Photographers Gallery**, London and tour (group)
Cat. *Intimate Distance*, Photographers Gallery,
London, texts Audre Lord, Gilane Tawadros

'The Other Story: Afro-Asian Artists in Post-war
Britain',
**Hayward Gallery**, London; **Wolverhampton Art
Gallery**; **Manchester City Art Gallery**; **Cornerhouse**,
Manchester (group)
Cat. *The Other Story: Afro-Asian Artists in Post-War
Britain*, Hayward Gallery, London, texts Rasheed
Araeen et al.

## Selected articles and interviews
### 1988-89

Durland, Steven, 'Throwing a Hot Coal in a Bathtub:
London's Edge '88', *High Performance*, No 44, Santa
Monica, Winter
Bennet, Oliver, 'British Performance on the Edge', *The
New Art Examiner*, Chicago, February

Clark, Robert, 'Barnsley's Line of Most Resistance', *The
Guardian*, London, 30 December

### 1989

Wakely, Shelagh, 'Mona Hatoum: Showroom', *Time Out*,
No 987, London , 19-26 July
Currah, Mark, 'Mona Hatoum: Showroom', *City Limits*,
No 408, London, 27 July-3 August
Stathatos, John, 'Mona Hatoum', *Art Monthly*, London,
September
Watkins, Jonathan, 'World Chronicle: Odd Forms in
Everyday Places', *Art International*, No 9, Paris,
Winter
Brett, Guy, 'Mona Hatoum at the Showroom', *Art in
America*, New York, November
Carriere, Daniel, 'L'Appel du vide', *Le De Voir*, Montréal,
24 November
Dion, François, 'Le Corps Politique', *Voir*, Vol 4, No 2,
Montréal, 30 November–6 December

## Selected exhibitions and projects

### 1990-91

#### 1990

'The British Art Show 1990',
**McLellan Galleries**, Glasgow; **Leeds City Art Gallery**;
**Hayward Gallery**, London (group)
Cat. *The British Art Show*, The South Bank Centre,
London, texts David Ward, Caroline Collier, Andrew
Nairne

'TSWA Four Cities Project: New Works for Different Cities',
Newcastle-upon-Tyne (group)
Cat. *TSWA Four Cities Project: New Works for Different
Cities*, TSWA, texts Tony Foster, Jonathan Harvey,
James Lingwood

'Passage de l'Image',
**Musée national d'art moderne**, **Centre Georges
Pompidou**, Paris; **Fundacio Caixa de Pensions**,
Barcelona; **Power Plant**, Toronto; **Wexner Arts Center**,
Colombus; **Modern Art Museum**, San Francisco
(group)
Cat. *Passage de L'Image*, Centre George Pompidou,
Paris, texts Pascal Bonitzer et al.

'Technologies et imaginaires',
**Forum des Halles**, Paris (group)
Cat. *Technologies et Imaginaires*, Dis Voir, Paris, texts
Maria Klonans, Katerina Thomadak

#### 1991

**IV Bienal de la Habana**, Havana, Cuba (group)
Cat. *Cuarta Bienal de la Habana*, Centro Wilfredo Lam,
Editorial Letras Cubanas, Havana, Cuba, text Lillian
Llanes

'Shocks to the System: Social and Political Issues in
Recent British Art from the Arts Council Collection',
**Royal Festival Hall**, London; **Northern Centre for
Contemporary Art**, Sunderland; **Ikon Gallery**,
Birmingham; **Towner Art Gallery**, Eastbourne;
**Royal Albert Memorial Museum**, Exeter; **City
Museum and Art Gallery**, Plymouth; **Maclaurin Art
Gallery**, Ayr (group)
Cat. *Shocks to the System: Social and Political Issues in
Recent British Art from the Arts Council Collection*, The
South Bank Centre, London, text Neal Ascherson

'Interrogating Identity',
**Grey Art Gallery and Study Centre**, New York University,
New York; **Museum of Fine Arts**, Boston; **Walker Arts
Centre**, Minneapolis; **Madison Arts Centre**, Madison;
**Centre for the Fine Arts**, Miami; **Allen Memorial Art
Museum**, Oberlin College, Oberlin; **North Carolina
Museum of Fine Art**, North Carolina (group)
Cat. *Interrogating Identity*, Grey Art Gallery and Study
Centre, New York, texts Thomas W. Sokolowski, Kellie
Jones

'The Interrupted Life',
**The New Museum of Contemporary Art**, New York
(group)
Cat. *The Interrupted Life*, The New Museum of
Contemporary Art, New York, texts Sylvère Lotringer,
bell hooks et al.

'The Hybrid State',

## Selected articles and interviews

### 1990-91

#### 1990

Usherwood, Paul, 'TSWA: Newcastle', *Art Monthly*, No
141, London, November

Philippi, Desa, 'Mona Hatoum, The Witness Beside
Herself', *Parachute*, No 58, Montréal, April/June

#### 1991

Smith, Roberta, 'The Faces of Death', *The New York
Times*, 13 September

The Madison Art Center invites you to an
opening reception for the exhibition

**INTERROGATING
IDENTITY**

*a wide range of work by artists of color from Canada,
Great Britain and the United States
who investigate issues of identity*

Saturday, March 14, 6–8:30 PM
Madison Art Center
211 State Street
Madison, Wisconsin

*INTERNATIONAL FOOD AND MUSIC*

*also on view*

**A QUESTION OF CULTURE**
*video works that focus on issues
of cultural identity*

EXHIBITIONS ON VIEW MARCH 14–MAY 10, 1992

## Selected exhibitions and projects
### 1991-93

**Exit Art**, New York (group)
Cat. *The Hybrid State*, Exit Art, New York, ed. Coco Fusco

**1992**
'Fine Material for a Dream … ?',
**Harris Museum and Art Gallery**, Preston; **Ferens Museum and Art Gallery**, Hull; **Oldham Art Gallery** (group)
Cat. *Fine Material for a Dream … ?*, Harris Museum and Art Gallery, Preston, text Amrit Wilson

'Pour la Suite du Monde',
**Musée d'art contemporain de Montréal** (group)
Cat. *Pour la Suite du Monde*, Musée d'art Contemporain de Montréal, texts Gilles Godmer, Réal Lussier

'The Cutting Edge',
**Barbican Art Gallery**, London (group)
Cat. *The Cutting Edge*, Barbican Art Gallery, London, ed. Carol Brown

'Mona Hatoum',
**Mario Flecha Gallery**, London (solo)

'Dissected Space',
**Chapter**, Cardiff (solo)
Cat. *Dissected Space*, Chapter, Cardiff, text Guy Brett

'Vidéo and Orality',
**National Gallery of Canada**, Ottawa (group)
Cat. *Video and Orality*, National Gallery of Canada, Ottawa, Canada, text Jean Gagnon

'Manifeste. 30 ans de création en perspective 1960–1990',
**Centre Georges Pompidou**, Paris (group)

**1993**
'Forces of Change: Artists of the Arab World',
**The Museum of Women in the Arts**, Washington and tour (group)

'Mona Hatoum: Recent Work',
**Arnolfini**, Bristol (solo)
Cat. *Mona Hatoum*, Arnolfini, Bristol, texts Desa Philippi, Guy Brett

'Four Rooms',
**Serpentine Gallery**, London (group)
Cat. *Four Rooms*, Serpentine Gallery, London, text James Roberts

'Andrea Fisher. Mona Hatoum',
**South London Gallery**, London; **Spacex Gallery**, Exeter (group)
Cat. *Andrea Fisher. Mona Hatoum*, South London

## Selected articles and interviews
### 1991-93

**1992**

Pontbriand, Chantal, 'Pour la Suite du Monde', Parachute, No 68, Montréal, October/December

Jennings, Rose, 'Mona Hatoum: Mario Flecha', *Time Out*, London, 4–11 November
Archer, Michael, 'Mona Hatoum: Mario Flecha', *Artforum*, New York, December

Rendell, Clare, 'Mona Hatoum: New Installations, 1990–92', *Arts Review*, London, December
Faure Walker, Caryn, 'Mona Hatoum', *Art Monthly*, No 164, London, March

**1993**

Feaver, William, 'Inner Space Terrors', *The Observer*, London, 16 May
MacRichie, Lynn, 'Uncomfortable Installations', *The Financial Times*, London, 21 May
Hatton, Brian, 'Umspace', *Art Monthly*, No 167, London, June
Smith, Caroline, 'Lights Out', *Womens Art*, No 53, London, July/August
MacRichie, Lynn, 'Uneasy Rooms', *Art in America*, New York, October

dissected space

mona hatoum

chapter 31 october - 13 december 1992

You are invited to the opening of Dissected Space, an exhibition of new work by Mona Hatoum, at Chapter on Friday 30th October between 7 - 9pm

market road, canton, cardiff cf5 1qe  0222 396061
with the support of the Welsh Arts Council.

Nat Goodden
Mona Hatoum
Vong Phaophanit
Gladstone Thompson

7 MAY - 6 JUNE 1993

Four Rooms

Serpentine Gallery
Kensington Gardens
London W23XA
Telephone 0714026075

## Selected exhibitions and projects
### 1993-94

Gallery, London, texts David Thorp, Tory Dent

'Socle du monde',
**Galerie Crousel-Robelin**, Paris (solo)

'Grazer Combustion',
'Steirischer herbst '93 Festival', SchloBbergstollen, Graz, Austria (group)

'Positionings/Transpositions',
**Art Gallery of Ontario** (group)
Cat. *Positionings. Mona Hatoum and Barbara Steinman*, Art Gallery of Ontario, Canada, text Michele Thériault

'Eros, c'est la vie',
**Le Confort Moderne**, Poitiers, France (group)
Cat. *Eros, c'est la vie*, Le Confort Moderne, Poitiers, France, text Dominique Truco

### 1994
'Mona Hatoum',
**Galerie René Blouin**, Montréal (solo)

'Visione Britannica. Notions of Space',
**Galleria Valentina Moncada**, Rome (group)

'Espacios Fragmentados',
**V Bienal de la Habana**, Havana, Cuba (group)
Cat. *Quinta Bienal de la Habana*, Centro Wilfredo Lam, Editorial Letras Cubanas, Havana, Cuba, text Lillian Llanes, Guy Brett, Eugenio Valdés Figueroa

'Mona Hatoum',
**Centre Georges Pompidou**, Paris (solo)
Cat. *Mona Hatoum*, Centre Georges Pompidou, Paris, texts Christine van Assche, Nadia Tazi, Desa Philippi, Jacinto Lageira

'IK + de Ander: Dignity for all: Reflections on Humanity',
**Beurs van Berlage**, Amsterdam (group)
Cat. *IK + de Ander: Dignity for all: Reflections on Humanity*, Beurs van Berlage, Amsterdam, text Ine Gevers

'Sense and Sensibility: Women Artists and Minimalism in the Nineties',
**Museum of Modern Art**, New York (group)
Cat. *Sense and Sensibility: Women Artists and Minimalism in the Nineties*, Museum of Modern Art, New York, text Lynn Zelevansky

Andrea Fisher
Mona Hatoum

*New installations*

2 July-8 August

You are invited to the preview
on Thursday 1 July 6-8pm

**South London Gallery**
65 Peckham Road London SE5 8UH
Tel 071 703 6120    Fax 071 252 4730

With the support of the Henry Moore Sculpture Trust

MONA HATOUM

6 JANVIER - 19 FÉVRIER 1994

GALERIE RENÉ BLOUIN

Sense and Sensibility
Women Artists and Minimalism in the Nineties

## Selected articles and interviews
### 1993-94

Louppe, Laurence, 'Mona Hatoum', *Art Press*, No 186, Paris, December

Cameron, Dan, 'Mona Hatoum', *Artforum*, New York, April
Baert, Renée, 'Desiring Daughters', *Screen*, Vol 32, No 2, London, Summer

### 1994
Tougas, Colette, 'Mona Hatoum', *Parachute*, No 75, Montréal, July/August/September

Gisbourne, Mark, 'Visione Britannica: Notions of Space', *Art Monthly*, London, July/August

Lebovici, Elisabeth, 'Mona Hatoum, intérieur nuit', *Liberation*, Paris, 2-3 July
Vila Nova, Isabel, 'Corpos estranhos', *Publico*, 2 August
Collin, Françoise, 'Mona Hatoum, Voiles et grillages', *Blocnotes*, No 7, Paris, Autumn
Abrioux, Yves; Grant, Simon, 'Mona Hatoum at the Pompidou: Two Responses', *Untitled*, No 6, London, Autumn
Enguita, Nuria, 'Videos e Instalaciones de Mona Hatoum en el Centro Georges Pompidou', *Kalías*, No 12, Semester II
Berque, Tetsuko, 'Mona Hatoum', Ryusei, Tokyo, October
Brignone, Patricia, 'Mona Hatoum', *Art Press*, Paris, October

Hess, Elizabeth, 'Minimal Women', *The Village Voice*, New York, 5 July
Drucker, Johanna, 'Sense and Sensibility. Women Artists and Minimalism in the Nineties', *Third Text*, No 27, London, Summer
Heartney, Eleanor, 'Sense et sensibilité: Sense and Sensibility', *Art Press*, No 195, Paris, October

mona hatoum

Invitation card, Centre Georges Pompidou, Paris

## Selected exhibitions and projects
### 1994-95

'Trans',
**Galerie Chantal Crousel**, Paris (group)

'Le Saut Dans le Vide',
**TSDKH-Exhibitions Centre**, Moscow (group)

'Super Suburb',
**Museum City Tenjin '94**, Fukuoka, Japan (group)
Cat. *Super Suburb*, Museum City Tenjin '94, Fukuoka, Japan, text Raiji Kuroda

'Willie Doherty, Mona Hatoum, Doris Salcedo',
**Brooke Alexander**, New York (group)

'Mona Hatoum. You Are Still Here',
**CRG Art Incorporated**, New York (solo)

'Le Shuttle – Tunnelrealitäten Paris London Berlin',
**Künstlerhaus Bethanian**, Berlin (group)
Cat. *Le Shuttle – Tunnelrealitäten Paris London Berlin*, Künstlerhaus Bethanian, Berlin, texts Michael Haerdter, Christoph Tannert, Wolfgang Welsch

'Cocido y Crudo',
**Museo Nacional Centro de Arte Reina Sofia**, Madrid (group)
Cat. *Cocido y Crudo*, Museo Nacional Centro de Arte Reina Sofia, Madrid, texts Jerry Saltz, Mar Villaespesa, Gerardo Mosquera, Jean Fisher, Dan Cameron

'Art Unlimited: Multiples from the 1960s and 1990s from the Arts Council Collection',
**Centre for Contemporary Arts**, Glasgow; **Leeds Metropolitan University Gallery**, Leeds; **Royal Festival Hall**, London (group)
Cat. *Art Unlimited: Multiples from the 1960s and 1990s from the Arts Council Collection*, Arts Council of England, London, text Hilary Lane, Andrew Patrizio

### 1995
'Mona Hatoum, Socle du Monde',
**White Cube**, London (solo)

'Ars95',
**Museum of Contemporary Art**, **Finnish National Gallery**, Helsinki (group)
Cat. *Ars 95*, Museum of Contemporary Art, Finnish National Gallery, Helsinki, texts Arkio Tuula, Maaretta Jaukkuri

'Inside the Visible – Begin the Beguine in Flanders',
**Kunststichting Kanaal Art Foundation**, Kortrijk, Belgium (solo)

Performance, 'Pull',
'Körper Formen',
**Künstlerwerkstatt**, Munich (group)
Cat. *Ausstellung: Körper Formen*, Künstlerwerkstatt, Munich, text Achille Bonita Oliva

From October 15th through November 19th, 1994, a three person exhibition of photographs by Willie Doherty, sculpture and videos by Mona Hatoum and an installation by Doris Salcedo will be held at Brooke Alexander, 59 Wooster Street.

MONA HATOUM

22 april - 28 mei 1995

Open: donderdag, vrijdag, zaterdag en zondag
14 u. - 17.30 u.

Opening: zaterdag, 22 april
17 - 19 u.

in het Begijnhof Sint-Elizabeth
Kortrijk, Belgium

## Selected articles and interviews
### 1994-95

Miyamura Noriko, 'Mona Hatoum', *BT Magazine*, Tokyo, January 1995

Smith, Roberta, 'Three Who Know Political Conflict', *The New York Times*, 11 November

Mariño, Melanie, 'Mona Hatoum at CRG', *Art in America*, New York, January 1995

Berger, Laurel, 'Mona Hatoum In Between, Outside & in the Margins', *ArtNEWS*, New York, September

### 1995
Kingston, Angela, 'Mona Hatoum. White Cube', *Flash Art*, Vol 28, Milan, April
Rankin-Reid, Jane, 'Mona Hatoum', *Art + Text*, No 51, Sydney
Kent, Sarah, 'Mona Hatoum. White Cube', *Time Out*, London, 25 January–1 February
Anson, Libby, 'Mona Hatoum, White Cube', *Art Monthly*, London, March

Nilsson, John Peter, 'In Limbo', *Siksi*, Helsinki, January

Macri, Teresa, 'Mona Hatoum', *Virus*, No 6, Milan, October

Invitation card, 'Ars 95', Museum of Contemporary Art, Helsinki

## Selected exhibitions and projects

### 1995-96

'Identity and Alterity: Figures of the Body 1895/1995',
**Venice Biennale** (group)
Cat. *Identity and Alterity: Figures of the Body 1895/1995*, Venice Biennale, Marsilio Editori, Venice, text Jean Clair

'Rites of Passage: Art for the End of the Century',
**Tate Gallery**, London (group)
Cat. *Rites of Passage: Art for the End of the Century*, Tate Gallery, London, texts Stuart Morgan, Frances Morris

'Here & Now',
**Serpentine Gallery**, London (group)
Cat. *Here & Now*, Serpentine Gallery, London, text Sarah Kent

'Shopping',
Interventions in the shops around **capc Musée d'art contemporain**, Bordeaux (group)

'Mona Hatoum. Short Space',
**Galerie Chantal Crousel**, Paris (solo)

'féminimasculin –le sexe de l'art',
**Centre Georges Pompidou**, Paris (group)
Cat. *féminimasculin – le sexe de l'art*, Centre Georges Pompidou, Paris, texts Marie-Laure Bernadac, Bernard Marcadé

'The Turner Prize 1995',
**Tate Gallery**, London (group)
Cat. *The Turner Prize 1995*, Tate Gallery, London, text Waldemar Januszczak, Nicholas Serota, Virginia Button

'4th International Istanbul Biennial',
**Istanbul Foundation for Culture and Arts**, Istanbul (group)
Cat. *4th International Istanbul Biennial*, Istanbul Foundation for Culture and Arts, text N. Fulya Erdemci

'Mona Hatoum',
**British School at Rome**, Rome (solo)
Cat. *Mona Hatoum*, British School at Rome, text Michael Archer

### 1996

'L'art au corps, Le corps exposé de Man Ray à nos jours',
**Galeries contemporaines de Musées de Marseille** (group)
Cat. *L'art au corps, Le corps exposé de Man Ray à nos jours*, Galeries contemporaines de Musées de Marseille, text Philippe Vergne et al.

'Inside the Visible',
**Institute of Contemporary Arts**, Boston; **Museum of Women in the Arts**, Washington DC; **Whitechapel Art**

Booklet, British School at Rome

## Selected articles and interviews

### 1995-96

Cork, Richard, 'Alive in the Midst of Death', *The Times*, London, 20 June
Hall, James, 'Death-defying Feet', *The Guardian*, London, 20 June
Searle, Adrian, 'Until the End of the World', *Frieze*, No 24, London, September/October
Irvine, Jaki, 'Rites of Passage', *Third Text*, No 33, London, Winter 1995–96
Deepwell, Katy, 'Inside Mona Hatoum', *Tate Magazine*, Issue 6, London, Summer

Macdonald, Marianne, 'The Inside Story', *The Independent on Sunday*, London, 27 August
McRitchie, Lynn, 'Will it be the Demon or the Darling?', *The Guardian*, London, 24 November

Nur, Yesim, 'Glittering Carpets', *Yeni Yüzyil*, Istanbul, 13 October
Antmen, Ahu, 'Not One Firm Branch to Hold On to', *Cumhuriyet*, Istanbul, 19 November
Volk, Gregory, 'Report from Istanbul: Between East and West', *Art in America*, New York, May
Fricke, Harold, '4th International Istanbul Biennial', *Artforum*, New York, May 1996

Di Genova, Arianna, 'Guardate che stomaco', *L'Espresso*, Rome, 20 November
Cherubini, Laura, 'Mona Hatoum. Accademia Britannica', *Flash Art*, No 196, Milan, January/February 1996

### 1996

The Turner Prize 1995

Gerrard, Nicci, 'I Wanted to Add a Subtle Element and I Thought of my Hairballs', *The Observer Review*, London, 13 October

**Gallery**, London; **The Art Gallery of Western Australia**, Perth (group)
Cat. *Inside the Visible*, Institute of Contemporary Arts, Boston, texts Catherine de Zegher, Desa Philippi et al.

'Mona Hatoum',
**The Fabric Workshop and Museum**, Philadelphia (solo)

'Feed and Greed',
**MAK-Austrian Museum of Applied Arts**, Vienna (group)
Cat. *Feed and Greed*, MAK-Austrian Museum of Applied Arts, texts Annemarie Hürlimann, Alexandra Reininghaus

'Mona Hatoum',
**Gallery Anadiel**, Old City, Jerusalem (solo)

'Dimensions',
**Städtische Kunsthalle**, Mannheim (group)
Cat. *Dimensions*, Städtische Kunsthalle, texts Iwona Blazwick, Hans-Jürge Duderer, Sandra Wagner

'Fremdkörper – corps étranger – Foreign Body',
**Museum für Gegenwartskunst**, Basel (group)
Cat. *Fremdkörper – corps étranger – Foreign Body*, Museum für Gegenwartskunst, Basel, text Theodora Vischer

'Walking and Thinking',
part of 'Now Here',
**Louisiana Museum of Modern Art**, Humlebaek, Denmark (group)
Cat. *Now Here*, Louisiana Museum of Modern Art, Humlebaek, Denmark, texts Bruce Ferguson et al.

'Distemper: Dissonant Themes in the Art of the 1990s',
**Hirshhorn Museum and Sculpture Garden**, Washington (group)
Cat. *Distemper: Dissonant Themes in the Art of the 1990s*, Hirshhorn Museum and Sculpture Garden, texts Neal Benezra, Olga M. Viso

Residency, 'The Quiet in the Land: Everyday Life, Contemporary Art, and the Shakers',
**Sabbathday Lake**, Maine

'Toyama Now '96, The Sixth International Contemporary Art Exhibition',
**Museum of Modern Art**, Toyama (group)
Cat. *Toyama Now '96*, Museum of Modern Art, Toyama, texts Iwona Blazwick, Yusuke Nakahara

'Shopping',
Interventions in shops around SoHo, part of SoHo Arts Festival, New York (group)

'Inclusion/Exclusion',
Steirischer Herbst 96, Graz (group)

'Current Disturbance',

Garner, Lesley, 'The Last Word. Hair Today, Art Tomorrow', *The Express*, London, 15 October
Koslow Miller, Francine, 'Inside the Visible', *Artforum*, New York, May
Holm, Eva-Lotta, 'Inside the Visible, Whitechapel', *Material*, No 31, Stockholm, Winter 1997

Arning, Bill, 'Two Serious Ladies', *The Village Voice*, New York, 9 April

Shapira, Sarit, 'Mona Hatoum: Anadiel', *Flash Art*, Vol 29, No 190, Milan, October
'Mona Hatoum', *Studio Art Magazine*, No 72, Tel Aviv, May/June

Spinelli, Claudia, 'Interview with Mona Hatoum', *Das Kunst-Bulletin*, No 9, Zurich, September

Lewis, Jo Ann, 'At the Hirshhorn, New World Disorder', *The Washington Post*, 7 July

Bonetti, David, 'No Sweetness Here, Just Light', *San*

## Selected exhibitions and projects
## 1996-97

**Capp Street Project**, San Francisco (solo)
Pamphlet, *Current Disturbance*, Capp Street Project,
San Francisco, text Mary Ceruti

'Photographic and Sculptural Works',
**Alexander and Bonin**, New York (group)

'Life/Live: La scéne artistique au Royaume-Uni en
1996',
**Musée d'art moderne de la ville de Paris , Centro de
Exposiçoes do Centro Cultural de Belém**, Lisbon
(group)
Cat. *'Life/Live: La scéne artistique au Royaume-Uni en
1996*, Musée d'Art Moderne de la Ville de Paris, texts
Laurence Bossé, Hans Ulrich Obrist, Michael Archer

'Quarters',
**Viafarini**, Milan (solo)
Cat. *Quarters*, Viafarini, Milan, text Angela Vettese

'Mona Hatoum',
**De Appel**, Amsterdam (solo)
Cat. *Mona Hatoum*, De Appel, Amsterdam, text Din
Pieters

**1997**
'De – Genderism: détruire dit-elle/il',
**Setagaya Art Museum**, Tokyo (group)
Cat. *De – Genderism: détruire dit-elle/il*, Setagaya Art
Museum, Tokyo, text Yasuo Kobayashi, Robert Storr,
David Elliott, Noi Sawaragi, Yuko Hasegawa

'Artistes Palestiniens Contemporains',
**Institut du Monde Arabe**, Paris (group)
Cat. *Artistes Palestinienes Contemporaines*, Institut du
Monde Arabe, Paris, texts Guy Brett et al.

'Material Culture: The Object in British Art of the 80s
and 90s',
**Hayward Gallery**, London (group)
Cat. *Material Culture: The Object in British Art of the 80s
and 90s*, Hayward Gallery, London, texts Michael
Archer, Greg Hilty

'Inside',
**Henry Art Gallery**, University of Washington, Seattle
(group)

'A Quality of Light',
**St. Ives International, Newlyn Art Gallery**, Cornwall
(group)

'Mona Hatoum',
**Chicago Museum of Contemporary Art; New Museum
of Contemporary Art**, New York (solo)
Cat. *Mona Hatoum*, Chicago Museum of Contemporary
Art, texts Jessica Morgan, Dan Cameron

**Galerie René Blouin**, Montréal (solo)

'The Quiet in the Land',
**Institute of Contemporary Art**, Portland, Oregon
(group)

## Selected articles and interviews
## 1996-97

*Francisco Examiner*, 27 September
Baker, Kenneth, 'San Francisco: Mona Hatoum',
*ArtNews*, New York, December

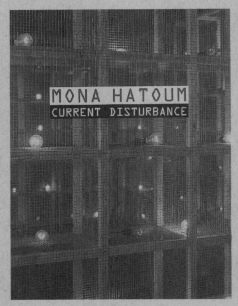

Vettese, Angela, 'Autoanalisi de Tutti', *Quadri e
Sculture*, No 22, Milan, October/November
Casapietra, Tiziana, 'Mona Hatoum: Viafarini', *Flash
Art*, No 201, Milan, December/January
Pasini, Francesca, 'I Quartieri di Mona Hatoum',
*Liberazione*, Rome, 28 November

Pieters, Din, 'Afstotend én luchthartig werk', *NRC
Handelsblad*, Amsterdam, 2 November

**1997**

Mona Hatoum

Quarters

Althorpe Guyton, Marjorie, 'Edge '88', *Performance Magazine*, London, 1988

Araeen, Rasheed, *The Essential Black Art*, Chisenhale Gallery, London, Black Umbrella, Kala Press, London, 1988

Araeen, Rasheed, et al, *The Other Story: Afro-Asian Artists in Post-War Britain*, Hayward Gallery, London, 1989

Archer, Michael, 'Mona Hatoum: Mario Flecha', *Artforum*, New York, December 1992

Archer, Michael, *Mona Hatoum*, British School at Rome, 1995

Arning, Bill, 'Two Serious Ladies', *The Village Voice*, New York, 9 April 1996

Ascherson, Neal, *Shocks to the System: Social and Political Issues in Recent British Art from the Arts Council Collection*, The South Bank Centre, London, 1991

van Assche, Christine, *Mona Hatoum*, Centre Georges Pompidou, Paris, 1994

Augaitis, Daina, *Siting Technology*, Walter Phillips Gallery, Banff, Canada, 1987

Baker, Kenneth, 'San Francisco: Mona Hatoum', *ArtNews*, New York, December 1996

Barnett, Pennina, *In an Unsafe Light*, Ikon Gallery, Birmingham, 1988

Bennet, Oliver, 'British Performance on the Edge', *The New Art Examiner*, Chicago, February 1988

Berger, Laurel, 'Mona Hatoum In Between, Outside & in the Margins', *ArtNews*, New York, September 1994

Bernadac, Marie-Laure, *féminimasculin – Le Sexe de l'Art*, Centre George Pompidou, Paris, 1995

Biggs, Simon, 'Video and Architecture', *Mediamatic Amsterdam*, Vol 2, No 4, June 1988

Blazwick, Iwona, *Dimensions*, Städtische Kunsthalle, Mannheim, 1996

Brett, Guy, 'Roadworks at Brixton Art Gallery', *Artscribe*, No 53, London, July/August, 1985

Brett, Guy, 'Chiz Chic', *City Limits*, No 267, London, 23–30 October 1986

Brett, Guy, 'Experiment or Institutionalisation', *Performance Magazine*, No 47, London, May/June, 1987

Brett, Guy, 'Mona Hatoum at the Showroom', *Art in America*, New York, November, 1989

Brett, Guy, *Dissected Space*, Chapter, Cardiff, 1992

Brett, Guy, *Mona Hatoum*, Arnolfini, Bristol, 1993

Büchler, Pavel, *Figures*, Cambridge Darkroom, Cambridge, 1987

Cameron, Dan, 'Mona Hatoum', *Artforum*, New York, April, 1993

Cameron, Dan, *Mona Hatoum*, Chicago Museum of Contemporary Art, 1997

Ceruti, Mary, *Current Disturbance*, Capp Street Project, San Francisco, 1996

Cherubini, Laura, 'Mona Hatoum. Accademia Britannica', *Flash Art*, No 196, Milan, January/February, 1996

Cork, Richard, 'Alive in the Midst of Death', *The Times*, London, 10 June, 1995

Cottell, Fran, *Conceptual Clothing*, Ikon Gallery, Birmingham, 1986

Currah, Mark, 'Mona Hatoum: Showroom', *City Limits*, No 408, London, 27 July–3 August, 1989

David, Rose, 'Refugee Camp is Built in EC1', *The Independent*, London, 7 April, 1987

Dent, Tory, *Andrea Fisher. Mona Hatoum*, South London Gallery, London, 1993

Diamond, Sara, 'An Interview with Mona Hatoum', *Fuse*, Vol 10, No 5, Toronto, April, 1987

Drucker, Johanna, 'Sense and Sensibility. Women Artists and Minimalism in the Nineties', *Third Text*, No 27, London, Summer, 1994

Duderer, Hans-Jürge, *Dimensions*, Städtische Kunsthalle, Mannheim, 1996

Durland, Steven, 'Throwing a Hot Coal in a Bathtub: London's Edge '88', *High Performance*, No 44, Santa Monica, Winter, 1988

Elwes, Catherine, 'Notes from a Video Performance by Mona Hatoum', *Undercut*, No 1, London, March/April, 1981

Faure Walker, Caryn, 'Mona Hatoum', *Art Monthly*, No 164, London, March, 1992

Feaver, William, 'Inner Space Terrors', *The Observer*, London, 16 May, 1993

Foster, Tony, *TSWA Four Cities Project: New Works for Different Cities*, TSWA, 1990

Fricke, Harold, '4th International Istanbul Biennial', *Artforum*, New York, May 1996

Fusco, Coco, *The Hybrid State*, Exit Art, New York, 1991

Gerrard, Nicci, 'I Wanted to Add a Subtle Element and I Thought of my Hairballs', *The Observer Review*, London, 13 October 1996

Gisbourne, Mark, 'Visione Britannica: Notions of Space', *Art Monthly*, London, July/August, 1994

Harvey, Jonathan, *TSWA Four Cities Project: New Works for Different Cities*, TSWA, 1990

Hatoum, Mona, 'Media Outrage', *Performance Magazine*, No 22, February/March, 1983

Hatoum, Mona, 'Body and Text', *Third Text*, No 1, London, Autumn, 1987

Hatton, Brian, 'Umspace', *Art Monthly*, No 167, London, June, 1993

Hess, Elizabeth, 'Minimal Women', *The Village Voice*, New York, 5 July, 1994

Houghton, Nick, *Channel 6*, London Video Arts, 1986

Irvine, Jaki, 'Rites of Passage', *Third Text*, No 33, London, Winter 1995–6

Jennings, Rose, 'Mona Hatoum: Mario Flecha', *Time Out*, London, 4–11 November, 1992

Jones, Kellie, *Interrogating Identity*, Grey Art Gallery and Study Centre, New York, 1991

Kent, Sarah, *Here & Now*, Serpentine Gallery, London, 1995

Kingston, Angela, 'Mona Hatoum. White Cube', *Flash Art*, Vol 28, Milan, April, 1995

Koslow Miller, Francine, 'Inside the Visible', *Artforum*, New York, May 1996

Krikorian, Tamara, *The Elusive Sign: British Avant Garde Film and Video 1977–1987*, British Council and The Arts Council, London, 1987

La Frenais, Rob, et al, *New Work, Newcastle '86*, Laing Art Gallery, Newcastle, 1986

Lageira, Jacinto, *Mona Hatoum*, Centre Georges Pompidou, Paris, 1994

Lee, Roger, 'Mona Hatoum', *Parallelogramme*, Vol 10, Toronto, April/May, 1984

Lingwood, James, *TSWA Four Cities Project: New Works for Different Cities*, TSWA, 1990

Lord, Audre, *Intimate Distance*, Photographers Gallery, London, 1989

Lotringer, Sylvère, *The Interrupted Life*, The New Museum of Contemporary Art, New York, 1991

Louppe, Laurence, 'Mona Hatoum', *Art Press*, No 186, Paris, December, 1993

MacRichie, Lynn, 'Uneasy Rooms', *Art in America*, New York, October, 1993

Marcadé, Bernard, *féminimasculin – le sexe de l'art*, Centre George Pompidou, Paris, 1995

Mariño, Melanie, 'Mona Hatoum at CRG', *Art in America*, New York, January 1995

Marjoram, Bol, 'Mona Hatoum, Not an Entertainer', *Performance Magazine*, No 41, London, May/June, 1986

McKaskell, Robert, *Dazzling Phrases: Six Performance Artists*, Forest City Gallery, London, Canada, 1985

Morgan, Jessica, *Mona Hatoum*, Chicago Museum of Contemporary Art, 1997

Morgan, Stuart, *Rites of Passage: Art for the End of the Century*, Tate Gallery, London, 1995

Morris, Frances, *Rites of Passage: Art for the End of the Century*, Tate Gallery, London, 1995

Newman, Michael, *Next: Tomorrow*, Kettles Yard; Cambridge Darkroom, Cambridge, 1986

Nilsson, John Peter, 'In Limbo', *Siksi*, Helsinki, January, 1995

Nurse, Keith, 'Row Over Vanishing Naked Artist', *Daily Telegraph*, London, 1 October, 1982

Philippi, Desa, 'Mona Hatoum, The Witness Beside Herself', *Parachute*, No 58, Montreal, April/June, 1990

Philippi. Desa, *Mona Hatoum*, Arnolfini, Bristol, 1993

Philippi, Desa, *Mona Hatoum*, Centre Georges Pompidou, Paris, 1994

Philippi, Desa, *Inside the Visible*, Institute of Contemporary Arts, Boston, 1996

Pieters, Din, *Mona Hatoum*, De Appel, Amsterdam, 1996

Rankin-Reid, Jane, 'Mona Hatoum', *Art + Text*, No 51, Sydney, 1995

Rendell, Clare, 'Mona Hatoum: New Installations, 1990–92', *Arts Review*, London, December, 1992

Roberts, John, 'Five Days at Battersea Arts Centre', *Art Monthly*, No 36, London, May, 1980

Roberts, John, 'Madness at Home: Recent Performance', *Artscribe*, No 28, London, March, 1981

Roberts, James, *Four Rooms*, Serpentine Gallery, London, 1993

Rogers, Steve, 'The National Review of Live Art', *Performance*, No 50/51, London, November 1987–January 1988

Schoettle, Marian, *Conceptual Clothing*, Ikon Gallery, Birmingham, 1986

Searle, Adrian, 'Until the End of the World', *Frieze*, No 24, London, September/October

Smith, Roberta, 'The Faces of Death', *The New York Times*, 13 September, 1991

Smith, Roberta, 'Three Who Know Political Conflict', *The New York Times*, 11 November, 1994

Sokolowski, Thomas W., *Interrogating Identity*, Grey Art Gallery and Study Centre, New York, 1991

Spinelli, Claudia, 'Interview with Mona Hatoum', *Kunst-Bulletin*, No 9, Zurich, September, 1996

Stathatos, John, 'Does the Future Have an Image?', *Creative Camera*, No 7, London, 1986

Stathatos, John, 'Mona Hatoum', *Art Monthly*, London, September, 1989

Stezaker, John, *Next: Tomorrow*, Kettles Yard; Cambridge Darkroom, Cambridge, 1986

Tawadros, Gilane, *Intimate Distance*, Photographers Gallery, London, 1989

Tazi, Nadia, *Mona Hatoum*, Centre Georges Pompidou, Paris, 1994

Thériault, Michele, *Positionings. Mona Hatoum and Barbara Steinman*, Art Gallery of Ontario, Canada, 1993

Thorp, David, *Andrea Fisher. Mona Hatoum*. South London Gallery, London, 1993

Vettese, Angela, *Quarters*, Viafarini, Milan, 1996

Wagner, Sandra, *Dimensions*, Städtische Kunsthalle, Mannheim, 1996

Wells, Liz, *Next: Tomorrow*, Kettles Yard; Cambridge Darkroom, Cambridge, 1986

de Zegher, Catherine, *Inside the Visible*, Institute of Contemporary Arts, Boston, 1996

Zelevansky, Lynn, *Sense and Sensibility: Women Artists and Minimalism in the Nineties*, Museum of Modern Art, New York, 1994